BAD NEW DAYS

BAD NEW DAYS: ART, CRITICISM, EMERGENCY

HAL FOSTER

VERSO

London • New York

First published by Verso Books 2015
© Hal Foster 2015

This publication is made possible in part from the Barr Ferree Foundation
Fund for Publications, Department of Art and Archaeology.

1 3 5 7 9 10 8 6 4 2

Verso
UK: 6 Meard Street, London W1F 0EG
US: 20 Jay Street, Suite 1010, Brooklyn, NY 11201
www.versobooks.com

Verso is the imprint of New Left Books

ISBN-13: 978-1-78478-145-3 (HC)
eISBN-13: 978-1-78478-146-0 (US)
eISBN-13: 978-1-78478-147-7 (UK)

British Library Cataloguing in Publication Data
A catalogue record for this book is available from the British Library

Library of Congress Cataloging-in-Publication Data
Foster, Hal, author.
Bad new days : art, criticism, emergency / Hal Foster.
pages cm
Includes index.
ISBN 978-1-78478-145-3 (hardback) — ISBN 978-1-
78478-146-0 — ISBN 978-1-78478-147-7
1. Art and society—History—20th century. 2. Art and society—
History—21st century. 3. Art—Political aspects—History—20th
century. 4. Art—Political aspects—History—21st century. I. Title.
N72.S6F665 2015
701'.030904—dc23
2015015515

Typeset in Sabon by Hewer Text UK Ltd, Edinburgh, Scotland
Printed and bound by CPI Group (UK) Ltd, Croydon, CR0 4YY

CONTENTS

IN SEARCH OF TERMS

Contemporary art is so vast, so diverse, and, yes, so present as to frustrate any historical overview, and none is offered here. However, a story can be told about some art of the past twenty-five years, coherent notions do exist for this work, and it remains one task of criticism to articulate such terms as best it can.[1] Part of the story told in this brief book turns on a recent move away from the primary assumptions of postmodernist art, in particular away from its privileging of the imagistic and the textual and toward a probing of the real and the historical. This shift was driven by motives intrinsic to art, to be sure, but it also speaks to conditions extrinsic to it, often extreme ones: hence the appearance of "emergency" in my subtitle.

I speak of terms because the ones taken up here—*abject*, *archival*, *mimetic*, *precarious*, and *post-critical*—do not qualify as paradigms; some are closer to strategies and others to predicaments.[2] Although they orient some practices, they do not regulate them, and though some follow others in time, they do not displace, much less disprove, one another; so, too, no one truth is at issue, only so many questions. That said, I want to retain a few connotations of the paradigm. Like paradigms, these terms have served as guidelines for some artists and critics, and in this way they imply that art is not merely a

matter of disconnected projects. Put more strongly, they suggest that, even if art is not driven toward any teleological goal, it still develops by way of progressive debate, and this means—why not say it?—that there is art that is more (and less) salient, more (and less) significant, more (and less) advanced.[3] It sounds only fair to assume that artists can choose freely art from a repertoire of subjects, themes, and forms, and that as a consequence all work is equal in interest or importance. To me that freedom is more like whatever-ness, and that equality is more like indifference; in any case I do not go in for them here.

In Chapter 1, I trace a shift in conceptions of reality during the late 1980s and early 1990s, a shift from the real understood as an effect of representation, as in much postmodernist art, to the real seen as an event of trauma, as in most abject art. Chapter 2 addresses art of the last two decades that is archival in impulse, which takes the form of historical probes into people, places, and practices that are lost, outmoded, or otherwise stranded. In Chapter 3, I focus on art after 9/11 that mimics—excessively, critically—both the capitalist junk-space and the terroristic politics around us. And Chapter 4 considers art that foregrounds its own insecure nature in order to address the precarious conditions of neoliberal society. In Chapter 5, I push back on recent rejections of the critical within the art world and beyond. Finally, a coda reflects on the implications of the current concern with performative and participatory modes of art. If my five terms signal any general turn, it is one—for good and for bad—away from the critique of representation that preoccupied a previous generation of postmodernist artists and critics.

"It is in the character of the critic," Leo Steinberg once remarked, "to say no more in his best moments than what everyone in the following season repeats; he is the generator of the cliché."[4] I am not the originator of most of the terms here (*pace* Steinberg, terminology is a collective project); rather, I aim only to test them on pertinent practices and vice versa, in the hope of clarifying a little what is at stake in recent art and criticism.[5] Of course, they are not the sole terms possible for this period—far from it—but this book is no more a survey than it is a history. My focus is limited, and if charged with parochialism (North America and Western Europe *again*?) I plead

guilty. What I lose in descriptive range I hope to make up in conceptual understanding.

The period of this book, the past twenty-five years, lies on the threshold of history: although not all of the art at issue here is contemporary, it is certainly not "a thing of the past" in the Hegelian sense. It is too early to historicize this art, but perhaps not too early to theorize it. My project, then, is a provisional attempt to come to terms with some of this work: not to apply theory, much less to impose it, but to extract some concepts embedded in some practices, and when appropriate to point to parallels in other disciplines along the way.[6]

I do not weigh in on current debates about the contemporary as a field of its own. Elsewhere I have suggested that contemporary art has, again for good and for bad, floated free not only of modernist models but also of postwar precedents; certainly a division, set variously circa 1960, 1980, or even 1989, has become standard in the academy.[7] One surprise for me is that this book points to connections that bridge these gaps: at moments in "Abject" I look back to Surrealism, in "Archival" I call up both prewar and postwar projects involving albums and atlases, in "Mimetic" I refer to postures and personae in Dada, and so on. In my account, then, art remains at least semi-autonomous in its interrelationships, but then this is also an effect of criticism that aims to be mindful of history and vice versa.

That said, my subject here is post-1989 art. After the events of 1989, especially the fall of the Berlin Wall and the uprising at Tiananmen Square, there was some optimism about the possibility of both a new Europe and a new world order different from the ones conjured by the Bushes and the Clintons; there was also a boom in architectural projects and art markets. Yet this was mostly the result of financial deregulation, and, in retrospect, 1989 represents the full dominance of neoliberalism more than anything else, which is to say an assault on the modern social contract, with welfare slashed, unions attacked, health care gutted, income inequality promoted, and so on. Disrupted by speculation and ravaged by AIDS, much of the art world did not fall for the early blandishments of neoliberalism. Indeed, some art of this period played back this assault in critical registers, and this is one focus of my attention here. Of course, after

9/11 conditions became even more extreme, as emergency did prove to be more the norm than the exception. The artistic response to this situation is another point of emphasis of this book. Paradoxically perhaps, this is why I keep faith with the old idea of an avant-garde, a position that requires some explaining. Typically, the avant-garde is defined in two ways only—as vanguard, in a position of radical innovation, or as resistant, in a position of stern refusal to the status quo. Typically, too, the avant-garde is understood to be driven by two motives alone: the transgression of a given symbolic order (as with Surrealism) or the legislation of a new one (as with Russian Constructivism). However, the avant-garde that interests me here is neither *avant* nor rear in these senses; rather, it is immanent in a caustic way. Far from heroic, it does not pretend that it can break absolutely with the old order or found a new one; instead it seeks to trace fractures that already exist within the given order, to pressure them further, even to activate them somehow. Far from defunct, this avant-garde is alive and well today.

Once again I thank family and friends for putting up with me, editors and publishers at Verso, *October*, *Artforum*, and the *London Review of Books* for supporting me, and colleagues and students at Princeton for stimulating me. I am especially grateful to those people who, as creative as they are committed, have reinvented a downtown New York for our time, bringing us the alternative spaces that continue to make the city a special place for innovative art and independent thought: Artists Space, *Cabinet Magazine*, Dia Art Foundation, Issue Project Room, the Kitchen, Light Industry, *n+1*, the New Museum, Storefront for Art and Architecture, *Triple Canopy*, the Whitney Museum Independent Study Program, White Columns, and there are many more. I am also thankful to the Cullman Center for Scholars and Writers at the New York Public Library for providing me with a haven in midtown.

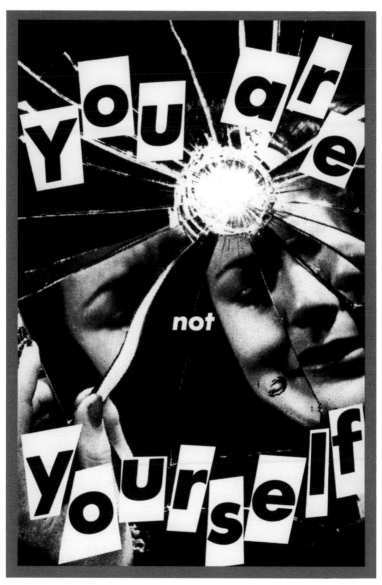

Barbara Kruger, *Untitled (You Are Not Yourself)*, 1982. Photograph. 72 x 48 inches. © Barbara Kruger. Courtesy of the artist and Mary Boone Gallery.

ONE

ABJECT

In the late 1980s and early 1990s, there was a shift in much art and theory, a shift in conceptions of the real—from the real understood as an effect of representation to the real seen as an event of trauma. One way to think about this shift is in terms of Lacanian psychoanalysis, which was prominent in critical discourse of the time; specifically, this shift might be mapped in relation to the discussion of the gaze in *The Four Fundamental Concepts of Psychoanalysis* (1973). In this difficult text Jacques Lacan understands the gaze in counterintuitive ways, for, in his view, the gaze is not embodied in a subject at all, at least not in the first instance. To an extent like Jean-Paul Sartre in *Being and Nothingness* (1943), Lacan distinguishes between the look (or the eye) and the gaze, and to an extent like Maurice Merleau-Ponty in *The Phenomenology of Perception* (1945), he locates this gaze in the world. As with language for Lacan, then, so with the gaze: it preexists the subject, who, "looked at from all sides," is but a "stain" in "the spectacle of the world." Positioned under the gaze, as it were, the subject can feel it only as a threat, as though it queried him or her; and so it is, Lacan writes, that the gaze "comes to symbolize this central lack expressed in the phenomenon of castration."[1]

Even more than Sartre and Merleau-Ponty, Lacan challenges the presumed mastery of the subject in sight; more, his account of the gaze mortifies this subject, especially so in his famous anecdote of the sardine can that the young Lacan glimpsed one summer while on a fishing boat off the coast of Normandy. Afloat on the sea and aglint in the sun, this can seemed to look at Lacan "at the level of the point of light, the point at which everything that looks at me is situated." Thus seen as (s)he sees, pictured as (s)he pictures, the Lacanian subject is fixed in a double position, and this leads Lacan to superimpose on the usual cone of vision that emanates from the subject another cone that emanates from the object, at the point of light. It is this regard that he calls "the gaze."

The first cone is familiar enough from Renaissance treatises on perspective: the object is focused as an image for the subject positioned at a specific point of viewing. But, Lacan adds immediately, "I am not simply that punctiform being located at the geometral point from which the perspective is grasped. No doubt, in the depths of my eye,

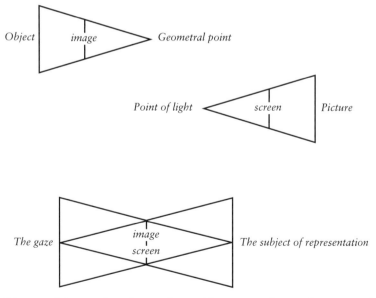

Diagram of the gaze from Jacques Lacan, *The Four Fundamental Concepts of Psychoanalysis*.

the picture is painted. The picture, certainly, is in my eye. But I, I am in the picture."² That is to say, the subject is also under the regard of the object, "photographed" by its point of light, turned into a picture. Hence the superimposition of the two cones in order to produce the third diagram, where the object is also at the point of the light (which together make up "the gaze"), the subject is also at the point of the picture (now called "the subject of representation"), and the image is also in line with the screen (now called "the image screen").

The meaning of "the image screen" is obscure. I understand the term to stand for the cultural reserve of which every image is but one instance. Inclusive of the conventions of art history as well as the codes of visual culture, this screen mediates the gaze of the world for us and, in so doing, protects us from it, capturing the gaze, "pulsatile, dazzling and spread out" as it is, and taming it in images.³ This last formulation is key. For Lacan, animals are simply caught in the gaze of the world; they are only on display there. Humans are not so reduced to this "imaginary capture," for we have access to the symbolic, in this case to the screen as the site of the register of representations by means of which we can manipulate and moderate the gaze.⁴ In this way the image screen allows the subject, at the point of the picture, to behold the object at the point of light. Otherwise this would be impossible, for to see without the image screen would be to be blinded by the gaze or touched by the real.

Thus, even as the gaze can trap the subject, the subject can tame the gaze, at least provisionally. This is the function of the image screen: to negotiate a "laying down" of the gaze in the sense of a laying down of a weapon. Here Lacan not only gives the gaze a strange agency but also positions the subject in a paranoid way; indeed, he imagines the gaze as maleficent, even violent, a force that can arrest, even kill, if it is not disarmed first in images.⁵ At its more urgent, then, picture-making is apotropaic; that is, its gestures are made to arrest the gaze before the gaze can arrest the viewer (there might be a theory of Expressionist painting to extract from this hypothesis). At its more "Apollonian," picture-making is placating: its perfections are intended to pacify the gaze, to "relax" the viewer from its grip (think of Neoclassical painting, perhaps, or geometric abstraction). Such is aesthetic contemplation according to Lacan:

while some painting attempts a *trompe-l'oeil*, a tricking of the eye, all painting aspires to a *dompte-regard*, a taming of the gaze.

Some art in the late 1980s and early 1990s came to refuse this age-old mandate to pacify the gaze. It is as though this art wanted the gaze to shine, the object to exist, the real to appear, in all the glory (or the horror) of its pulsatile desire, or at least to evoke this sublime condition. To this purpose, relevant artists aimed not only to attack the image but also to tear at its screen, or to suggest that it was already torn. This shift from the image screen, the focus of much art in the early and middle 1980s, to the object gaze, the focus of much art thereafter, is most clearly registered in the work of Cindy Sherman. In fact, if we divide the trajectory of her art over this period into three stages, it seems to move across the three positions of the Lacanian diagram: from the subject of representation, to the image screen, and on to the gaze of the world, that is, to the realm of the real.

Thus, in her early work of 1975–82, from her initial film stills through her rear projections to her centerfolds and her color tests, Sherman evoked the subject under the gaze, the subject-as-picture, which was also the principal site of other feminist artists involved in appropriation art at the time, such as Sarah Charlesworth, Silvia Kolbowski, Barbara Kruger, Sherrie Levine, and Laurie Simmons. Although her subjects see, of course, they are also *seen*, captured by the gaze, and conspicuously so. Often, in her film stills and centerfolds, this gaze seems to come from another subject, with whom the viewer (perhaps the heterosexual male viewer in particular) is implicated. Sometimes, especially in her rear projections, the gaze seems to come from the spectacle of the world at large. Yet sometimes, too, the gaze seems to come from within, to be interior to the subject. Here Sherman shows her female subjects to be self-surveilled, not in a state of phenomenological reflexivity ("I see myself seeing myself") but in a condition of psychological estrangement ("I am not what I imagined myself to be"). For example, in the distance between the made-up woman and her mirrored face in *Untitled Film Still #2* (1977), Sherman points to the gap between imagined and actual bodies that yawns within this subject, indeed within each of us. This is the gap of misrecognition that we attempt to fill with fantasy images of our ideal selves, drawn primarily from entertainment and fashion industries, every day and every night of our lives.

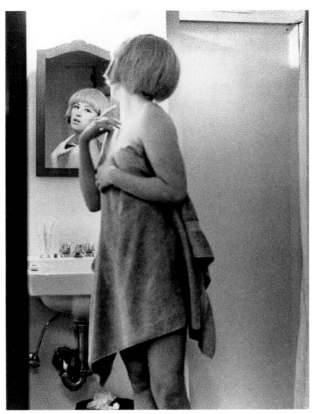

Cindy Sherman, *Untitled Film Still #2*, 1977. Gelatin silver print. 10 x 8 inches.
Sherman images © Cindy Sherman. Courtesy of the artist and Metro Pictures.

Then, in her intermediate work of 1987–90, from her fashion
photographs through her fairy tale illustrations and her art history
portraits and on to her disaster pictures, Sherman moves to the image
screen, to its repertoire of representations. (This is a matter of empha-
sis only: she addresses the image screen in her early work too, and the
subject-as-picture hardly disappears in her intermediate work.) Her
fashion and art history series take up two files from the image screen
that have influenced our self-fashionings profoundly. Here Sherman
parodies vanguard design with a long runway of fashion victims, and
pillories art history with a long gallery of grotesque aristocrats (her

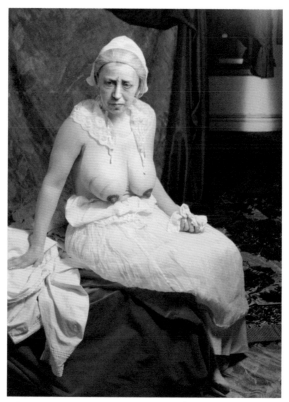

Cindy Sherman, *Untitled #222*, 1990. C-print. 60 x 40 inches.

ersatz portraits range across types associated with Renaissance, Baroque, Rococo, and Neoclassical art). Yet this play turns perverse when, in some fashion photographs, the gap between imagined and actual bodies becomes almost psychotic (one or two of her sitters seem to have no ego awareness at all) and when, in some art history photographs, her challenge to the ideal figure is pushed to the point of utter desublimation: with scarred sacks for breasts and funky carbuncles for noses, these bodies break down the upright posture not only of proper portraiture but of proper subjecthood in general.[6]

Sherman confirms this turn to the real in her fairy tale and disaster images, some of which show horrific accidents of birth and freaks of nature—a young woman with a pig snout, for example,

or a doll with the head of a dirty old man. Here, as often in horror movies and bedtime stories alike, horror means, first and foremost, horror of the maternal body made strange, even repulsive, in repression. This body is the primary site of the *abject* as well, a category of (non)being defined by Julia Kristeva as neither subject nor object, but somehow before one is the first (before full separation from the mother) or after one is the second (as a corpse given over to objecthood).[7] Sherman evokes these extreme conditions in some disaster scenes that are suffused with signifiers of menstrual blood and sexual discharge, vomit and shit, decay and death. Such images verge on a representation of the body as though it were turned inside out, of the subject literally *ab-jected*, thrown out of itself. Yet this is also the condition of the outside turned in, of the invasion of the subject-as-picture by the gaze of the world, that is, by the real. At this point some of her images pass beyond the abject, not only toward the *informe*, a condition described by Georges Bataille in which significant form dissolves because the fundamental distinction between figure and ground, self and other, breaks down, but also toward the *obscene*, which can be understood here as a condition in which the gaze is presented as though there were no scene to stage it, no frame of representation to contain it, no image screen at all.[8]

Sherman makes this extreme condition the domain of her work after 1991 as well, in her civil war and sex pictures, with the former photographs dominated by close-ups of simulated damaged and dead body-parts, and the latter by sexual and excretory body-parts. Sometimes in these photos the image screen seems so torn that the gaze not only invades the subject-as-picture but altogether overwhelms it. Indeed, in a few of her disaster and civil war images, we glimpse what it might be like to occupy the impossible third position in the Lacanian diagram, to behold the pulsatile gaze, to touch the obscene object, without any image screen for protection. In one image (*Untitled #190*) Sherman goes so far as to give this evil eye a horrific visage of its own.

In this tripartite scheme of her art through the early 1990s, then, the impulse to erode the subject and to tear at the image screen has driven Sherman from her first period, where the subject is caught in

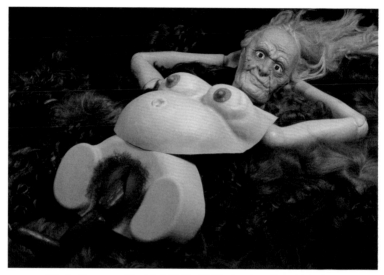

Cindy Sherman, *Untitled #250*, 1992. C-print. 50 x 75 inches.

the gaze, through her second period, where it is invaded by the gaze, to her third period, where it is obliterated by the gaze. Yet this double attack on subject and screen was hardly hers alone; it occurred on several fronts in art at this time, where it was waged, almost openly, in the service of the real.

"Obscene" implies an attack on the scene of representation, on the image screen, and in turn this attack suggests a way to understand the aggression against the visual that is evident in much art of the late 1980s and early 1990s: one can understand it as an imagined rupture of the image screen, an impossible opening onto the real.[9] For the most part, however, this aggression was thought under the rubric of the abject, which has a different valence in psychoanalytical theory.

As defined by Kristeva in *Powers of Horror* (1980), the abject is what a subject must get rid of in order to be a subject at all. It is a fantasmatic substance that is both alien to the subject and intimate with it, too much so in fact, and this overproximity produces a panic in the subject. In this way, the abject touches on the fragility not only of our boundaries, of the distinction between our insides and

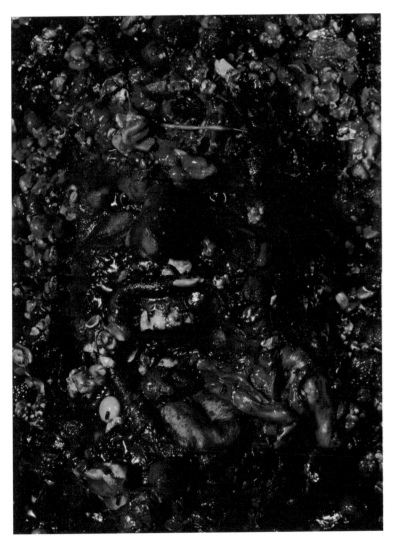

Cindy Sherman, *Untitled #190*, 1989. C-print. 71½ x 47½ inches

outsides, but also of the passage from the maternal body to the paternal law. Both spatially and temporally, then, abjection is a condition in which subjecthood is troubled, "where meaning collapses"; hence its attraction, at different times, for avant-garde artists, writers, and others who have aimed to disturb the given orderings of subject and society alike.[10]

The notion of the abject is rich in ambiguities, and these ambiguities affect the cultural-political import of abject art.[11] Can the abject be represented at all? If it is opposed to culture, can it be exposed in culture? If it is unconscious, can it be made conscious and remain abject? In other words, can there be such a thing as conscientious abjection, or is this all there can be? At the extreme, can abject art ever escape an instrumental, even moralistic, evocation of the abject?[12] A crucial ambiguity in Kristeva is her slippage between the operation "to abject" and the condition "to be abject." For Kristeva, the operation "to abject" is fundamental to the maintenance of subject and society, while the condition "to be abject" is subversive of both formations. Is the abject, then, disruptive of subjective and social orders or foundational of them, a crisis in these orders or a confirmation of them? If subject and society abject what they deem to be alien, is abjection then not a regulatory operation? That is, might abjection stand in relation to regulation as transgression stands in relation to taboo—an exceeding that is also a reaffirming? ("Transgression does not deny the taboo" runs the famous formulation of Bataille, "but transcends and completes it.")[13] Or can the condition of abjection be mimed in a way that calls out the operation of abjection in order to disturb it?

At one point in *Powers of Horror*, Kristeva suggests that a cultural shift has occurred in recent decades. "In a world in which the Other has collapsed," she states enigmatically, the task of the artist is no longer to sublimate the abject but to plumb it—to fathom "the bottomless 'primacy' constituted by primal repression."[14] "In a world in which the Other has collapsed": Kristeva implies that the paternal law that underwrites the social order has fallen into crisis.[15] This suggests a crisis in the image screen as well, and, as I intimated with Sherman, some artists of this period did attack it, while others, under the assumption that it was already torn, probed behind it as though

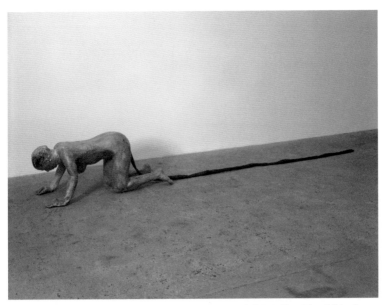

Kiki Smith, *Tale*, 1992. Wax, pigment, papier-mâché. 160 x 23 x 23 inches.
Courtesy of the artist and Pace Gallery.

to touch the real. Meanwhile, in terms of the Kristevan abject, still other artists explored the prime object of paternal repression—the maternal body—in order to exploit its disruptive effects (a representative example is Kiki Smith).

If the image screen is deemed intact, the attack on it might well possess a transgressive value. However, if it is thought to be already torn, then such transgression is almost beside the point, and this old vocation of the avant-garde is at an end. But there is a third option, and that is to reformulate this vocation, to rethink transgression not as a rupture produced by a heroic avant-garde posited somehow outside the symbolic order but as a fracture traced by a strategic avant-garde inside this order.[16] In this view, the goal of the avant-garde is not to break with the symbolic order absolutely (the dream of absolute transgression is dispelled) but to reveal it in crisis—to register its points not only of breakdown but also of breakthrough, that is, to register the points at which new possibilities are opened up by this very crisis.

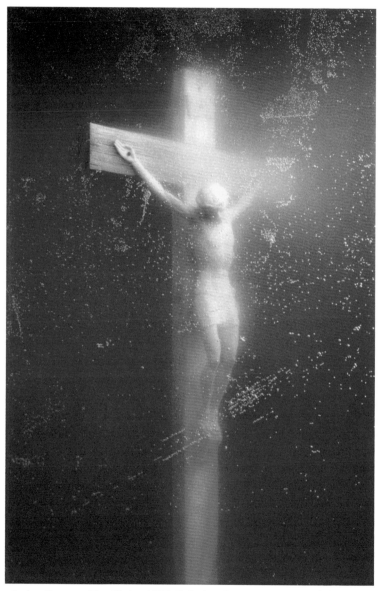

Andres Serrano, *Piss Christ*, 1987. © Andres Serrano. Courtesy of the artist.

For the most part, however, abject art tended in two other directions. The first was to approach the abject, even to identify with it—to probe the wound of trauma, to touch the obscene real. The second was to represent the condition of abjection in order to provoke its operation—to catch abjection in the act, as it were, to expose it, even to make it repellent in its own right. The danger here was that this mimesis might only confirm a given abjection; that is, just as the transgressive Surrealist once called out for the police, so the abject artist might call out for the politician. (This did happen on a number of occasions during this period, most famously when Jesse Helms took up *Piss Christ* (1987) by Andres Serrano, a photograph that the senator read literally as Jesus plunged into urine, and used it effectively in his campaign against all art and all sexuality that he deemed deviant.) Moreover, as Left and Right might agree on the social representatives of the abject (at the time this meant, above all, gay men with AIDS), they might shore each other up in a public exchange of mutual disgust, and this spectacle might inadvertently support the normativity of image screen and symbolic order alike.[17]

Often, then, these strategies of abject art were problematic, as they were in Surrealism many decades before. Surrealism also used the abject to test the limits of sublimation; in fact, André Breton claimed the coming together of desublimatory and sublimatory impulses to be the very point of his movement.[18] Yet it was at this point, too, that Surrealism broke down, that it split into the two factions headed by Breton and Bataille, respectively. According to Breton, Bataille was an "excrement-philosopher" who refused to rise above mere matter, who failed to elevate the low to the high.[19] For Bataille, on the other hand, Breton was a "juvenile victim" who was involved in an Oedipal game, an "Icarian pose" that was taken up less to undo the law than to provoke its punishment: despite his celebration of desire, Breton was as committed to sublimation as the next aesthete.[20] Elsewhere Bataille termed this aesthetic *le jeu des transpositions*, and he dismissed this "game of substitutions" as no match for the power of perversions: "I defy any amateur of painting to love a picture as much as a fetishist loves a shoe."[21]

I recall this old opposition for the historical perspective that it might offer on abject art of the late 1980s and early 1990s. In part,

Breton and Bataille were both right, especially about each other. Often Breton and his associates did act like "juvenile victims" who provoked the paternal law less to transgress it than to test that it was still there—at best in a semi-neurotic plea for punishment, at worst in a semi-paranoid demand for order. And this "Icarian pose" was adopted by some artists in the late 1980s and early 1990s who were almost too eager to talk dirty in the museum, almost too ready to be chastised by neoconservative critics. On the other hand, the Bataillean ideal—to opt for the smelly shoe over the beautiful picture, to be fixed in perversion or stuck in abjection—was adopted by other artists of the time who became discontent not only with the refinements of sublimation but also with the floating signifiers celebrated by post-structuralism. Often enough, this seemed to be the limited option that abject art offered: Oedipal naughtiness or infantile perversion; to act dirty with the secret wish to be spanked, or to wallow in shit with the secret faith that the most defiled position might reverse into the most sacred, the most perverse position into the most potent.[22]

This mimesis of regression was pronounced in abject art, where it was presented as a strategy of perversion or, more precisely, a strategy of *père-version*, of a turning away from the father that was also a twisting of his law. In the early 1990s this defiance was manifest in a general flaunting of the excremental. According to Freud, civilization was founded in a primordial opposition to the anal, and in *Civilization and Its Discontents* (1930) he offered an origin myth to show us why. This famous story turns on the erection of man, his rising up from all fours to two feet, from the horizontal to the vertical. With this change in posture, Freud argued, came a revolution in sense: smell was degraded and sight privileged, the anal was repressed and the genital pronounced. And the rest was literally history: with his genitals exposed, man learned shame; in contradistinction to animals, his sexual frequency became continuous, not periodic; and this coming together of permanent shame and regular sex impelled him to seek a mate, to form a family, in short, to found a society. Zany as this heterosexist tale is, it does reveal a normative conception of civilization—not only as a general sublimation of instincts but also as a specific reaction against anal eroticism (which is also a specific abjection of male homosexuality).

In this light the excremental impulse in abject art might be seen as a symbolic reversal of this first step into civilization, of the repression of the anal and the olfactory. And in this art there was a symbolic reversal of the phallic visuality of the erect body as the primary model of traditional painting and sculpture—the human figure as both subject and frame of representation in Western art. This double defiance of visual sublimation and vertical form was a strong subcurrent in twentieth-century art (this transgressive line of work might be called "Visuality and Its Discontents"), and often it was expressed in a flaunting of anal eroticism.[23] "Anal eroticism finds a narcissistic application in the production of defiance," Freud wrote in his 1917 essay on the subject, and this is the case in avant-gardist defiance too, from the chocolate grinders of Marcel Duchamp, through the cans of *merde* by Piero Manzoni, to the scatological sculptures and performances of Mike Kelley, Paul McCarthy, and John Miller.[24] Anal-erotic

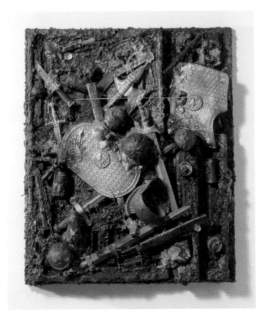

John Miller, *We Drank Some Cokes and Beat Our Toys into Ploughshares*, 1992. Mixed media. Courtesy of the artist and Metro Pictures.

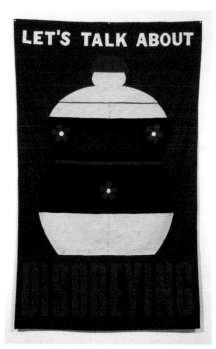

Mike Kelley, *Let's Talk*, 1987. Kelley images © Mike Kelley Foundation for
the Arts. All rights reserved/licensed by VAGA, New York.

defiance is often self-conscious, even self-parodic, in abject art: it tests
the anally repressive authority of traditional culture, but it also mocks
the anally erotic narcissism of the vanguard rebel-artist. "Let's Talk
About Disobeying" reads a well-known banner emblazoned with a
cookie jar by Kelley. "Pants Shitter & Proud" reads another deriding
the self-congratulation of the institutionally incontinent.²⁵

 This defiance can also be perverse, precisely in the sense of a twist-
ing of the paternal law, the paternal law of differences that are sexual
and generational as well as ethnic and social. Again, this perversion
is often performed through a mimetic regression to "the anal universe
where all differences are abolished."²⁶ Such is the fictive space that
Kelley, McCarthy, and Miller set up for critical play. "We inter-
connect everything, set up a field," Kelley has his bunny rabbit say to
his teddy bear as they face each other on a blood-red blankie in

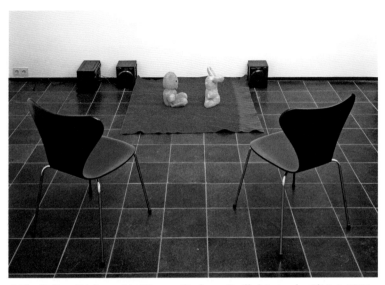

Mike Kelley, *Dialogue #1 (Theory, Garbage, Stuffed Animals, Christ)*, 1991.
Blanket, stuffed animals, CD player, CD.

Theory, Garbage, Stuffed Animals, Christ (1991), "so there is no longer any differentiation."[27] Like McCarthy and Miller, Kelley explored this anal space where symbols are not yet stable, where, as Freud writes, "the concepts *faeces* (money, gift), *baby* and *penis* are ill-distinguished from one another and are easily interchangeable."[28] All three artists pushed this symbolic interchange toward aformal indistinction—pushed the figures of baby and penis, as it were, toward the lump of shit. However, this was done less to celebrate mere indistinction than to trouble symbolic difference. *Lumpen*, the German word for "rag" that appears in *Lumpensammler*, the ragpicker that intrigued Walter Benjamin, as well as *Lumpenproletariat*, the mass too ragged to form a class that interested Marx, "the scum, the leavings, the refuse of all classes," was a crucial word in the Kelley lexicon too, which he developed as a third term between the *informe* of Bataille and the abject of Kristeva.[29] In a sense Kelley did what Bataille urged: he based his materialism "on psychological or social facts."[30] The result was an art of lumpen things, subjects, and

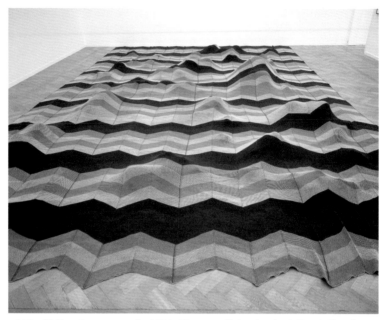

Mike Kelley, *Lumpenprole*, 1991. Yarn, stuffed animals. 240 x 360 inches.

personae that resist shaping, let alone sublimating or redeeming. Unlike the *Lumpen* exploited by tyrants from Napoleon III through Hitler and Mussolini to the present, the *Lumpen* of Kelley resists molding, much less mobilizing.

Was there a cultural politics in abject art? Often in the general culture of abjection in the late 1980s and early 1990s, this posture of indifference expressed a fatigue with the politics of difference. Yet sometimes, too, this posture intimated a more fundamental fatigue: a strange drive to indistinction, a paradoxical desire to be desireless, a strong call of regression that went beyond the infantile to the inorganic.[31] In a well-known text that became essential to the Lacanian discussion of the gaze, Roger Caillois, an associate of the Bataillean Surrealists, considered this drive to indistinction in terms of the visual; specifically, he argued that some insects assimilate to the space around them through an automatic mimicry.[32] This assimilation by camouflage, Caillois thought, allows for no agency, let alone

subjecthood (these organisms are "dispossessed of [this] privilege," he wrote), and in one extraordinary passage he likened this condition of indistinction to schizophrenia:

To these dispossessed souls, space seems to be a devouring force. Space pursues them, encircles them, digests them in a gigantic phagocytosis [consumption of bacteria]. It ends by replacing them. Then the body separates itself from thought, the individual breaks the boundary of his skin and occupies the other side of his senses. He tries to look at himself from any point whatever in space. He feels himself becoming space, *dark space where things cannot be put*. He is similar, not similar to something, but just *similar*. And he invents spaces of which he is "the convulsive possession."[33]

The breaching of the body, the gaze attacking the subject, the subject becoming space, the state of mere similarity: these are conditions evoked in much art of the late 1980s and early 1990s. But to understand this "convulsive possession" in recent art, it must be split into its two constituent registers: on the one hand, an ecstasy in the imagined breakdown of image screen and symbolic order; on the other hand, a horror at this breakdown followed by a despair about it. Early definitions of postmodernism evoked the first structure of feeling, the ecstatic one, sometimes in analogy with schizophrenia. Indeed, for Fredric Jameson, the primary symptom of postmodern culture was a quasi-schizophrenic breakdown in language and time that produced a compensatory investment in image and space—a capture in the endless present of spectacle.[34] And, in the 1980s, many artists did create images that featured simulacral intensities and ahistorical pastiches. In elaborations in the 1990s, however, the second structure of feeling, the melancholic one, dominated, and sometimes, as in Kristeva, it too was associated with a symbolic order in crisis. Here, artists were drawn not to the highs of the simulacral image but to the lows of the depressive thing. In this respect, if some modernist artists transcended the referential, and some postmodernist artists delighted in the imaginary, some abject artists approached the real.

As the 1990s proceeded, this bipolar postmodernism was pushed toward a qualitative change: many artists appeared to be driven by

an ambition to inhabit a place of total affect on the one hand and to be drained of affect altogether on the other—or, even more extremely, to possess the obscene vitality of the wound on the one hand and to occupy the radical nihility of the corpse on the other.[35] Why this fascination with trauma, this envy of abjection, during this time? To be sure, motives existed within art, writing, and theory alike. As suggested at the outset, there was a dissatisfaction with the given model of reality as so much text or image only; it was as though the real, repressed in this poststructuralist version of postmodernism, had returned in traumatic guise. Then, too, there was a disillusionment with the celebration of desire seen as an open passport for a mobile subject; here it was as though the real, dismissed in this performative version of postmodernism, were marshaled against a world of fantasy now felt to be compromised by consumerism. But

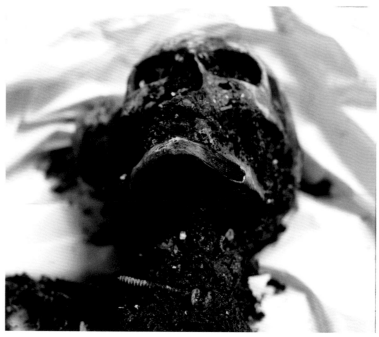

Andres Serrano, *The Morgue (Burnt to Death)*, 1992. © Andres Serrano. Courtesy of the artist.

more important were the forces at work in society at large: rage about the persistent AIDS crisis (which devastated the art world), anger about the destroyed welfare state, and anxiety about a social contract that appeared broken, as the rich opted out in a revolution from the top and as the poor were dropped out in an immiseration from the bottom (these were the early years of neoliberalism). Together, these factors, both intrinsic and extrinsic, drove the fascination with trauma and abjection.

And one result was this: a special truth came to reside in abject states, in damaged bodies. To be sure, the violated body is often the evidentiary basis of important witnessings to truth, of necessary testimonials against power. But there were dangers with this siting of truth as well, such as the restriction of our political imagination to two camps, the abjecter and the abjected. If there was a subject of history for the culture of abjection, it was not the worker, the woman, or the person of color, but the corpse. This was a politics of difference pushed beyond indifference, a politics of alterity pushed toward nihility. ("Everything goes dead," says the teddy bear in the aforementioned Kelley piece. "Like us," replies the bunny.)[36] But is this point of nihility a critical epitome of impoverishment where power cannot penetrate, or is it a place from which power emanates in a strange new form? Is abjection a refusal of power or its reinvention in a new guise, or is it somehow both at once?[37] Finally, is abjection a space-time beyond redemption, or is it the fastest route for contemporary rogue-saints to grace?

In the 1990s, there was a general tendency to redefine experience, individual and historical, in terms of trauma: a *lingua trauma* was spoken in art and literary worlds, academic discourse, and popular culture alike. At the time, key novelists (e.g., Paul Auster, Dennis Cooper, Steve Erickson, Denis Johnson, Ian McEwan) conceived experience in this paradoxical modality: experience that is not experienced, at least not punctually, that comes too early or too late, that must be acted out compulsively (as in neurosis) or reconstructed after the fact (as in analysis). Often in novels of the period narrative runs in reverse or moves erratically, and the peripeteia is an event that happened long ago or not at all (as per the logic of trauma, this is often ambiguous).

On the one hand, especially in art, writing, and theory, trauma discourse continued the poststructuralist critique of the subject by other means, for, strictly speaking, there is no subject of trauma—the position is evacuated—and in this sense the critique of the subject seems to be most radical here. On the other hand, especially in therapy culture, talk shows, and tell-all memoirs, trauma was treated as an event that guarantees the subject, and in this register the subject, however disturbed, rushed back as survivor, witness, testifier. Here a traumatic subject does indeed exist, and it has absolute authority, for one cannot challenge the trauma of another: one can only believe it, even identify with it, or not. In trauma discourse, then, the subject was evacuated and elevated at one and the same time. And in this way it served as a magical resolution of contradictory imperatives in the culture of the period: the imperative of deconstructive analyses on the one hand, and the imperative of multicultural histories on the other; the imperative to acknowledge the disrupted subjectivity that comes of a broken society on the one hand, and the imperative to affirm identity at all costs on the other. In the 1990s, thirty years after the death of the author announced by Roland Barthes and Michel Foucault, we were witness to a strange rebirth of the author as zombie, to a paradoxical condition of absentee authority.

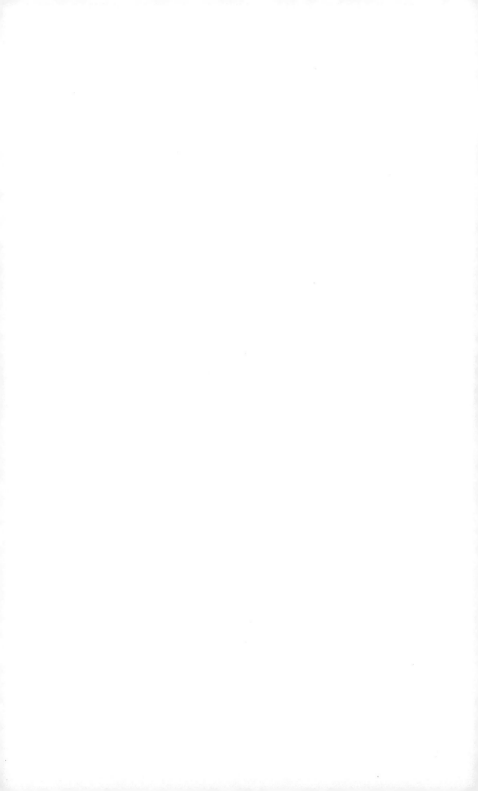

Joachim Koester, *Message from Andrée*, 2005 (detail). 16mm film loop, 3 minutes 4 seconds. Koester images © Joachim Koester. Courtesy of the artist and Greene Naftali Gallery.

ARCHIVAL

Consider a temporary display cobbled together out of workaday materials like foil and tape, and filled, like a homemade study-shrine, with a chaotic array of images, texts, and testimonials devoted to a radical artist, writer, or philosopher. Or a brief meditation in film on the huge acoustic receivers built on the Kentish coast in England between the world wars but soon abandoned as an outmoded piece of military technology. Or an elliptical reflection in various mediums on a doomed expedition to the North Pole led by a foolhardy Swedish balloonist at the end of the nineteenth century. Or a funky installation that juxtaposes a model of a lost earthwork from 1970 with slogans from the civil rights movement and recordings from the legendary rock concerts of the same period. However disparate in subject, appearance, and effect, these works—by the Swiss Thomas Hirschhorn, the English Tacita Dean, the Dane Joachim Koester, and the American Sam Durant, respectively—share a model of artistic practice as an idiosyncratic probing into a particular figure, object, or event in modern art, philosophy, or history.

These examples could be multiplied many times over (a list of practitioners in this mode might also include Yael Bartana, Matthew Buckingham, Tom Burr, Gerard Byrne, Moyra Davey, Jeremy Deller,

Mark Dion, Stan Douglas, Omer Fast, Joan Fontcuberta, Liam Gillick, Douglas Gordon, Renée Green, Pierre Huyghe, Zoe Leonard, Josiah McElheny, Christian Philipp Müller, Philippe Parreno, Walid Raad, Danh Vo, the Otolith Group, and Raqs Media Collective, among others), but the aforementioned artists are enough to indicate an archival impulse at work, internationally, in recent art. Hardly new, this impulse was active in different forms in the prewar period when the possible repertoire of artistic sources was extended both politically and technologically (e.g., the photo files of Alexander Rodchenko, the photomontages of John Heartfield, the photo album of Hannah Höch); and it was lively again in the postwar period, especially as appropriated images and combinatory formats became common idioms (e.g., the pinboard aesthetic of the Independent Group, the Combines of Robert Rauschenberg, the essay films of Chris Marker and others, the informational structures of Conceptual art, the documentary modes of institution critique, the research videos of Dan Graham and others, the purloined pictures of feminist art). Yet an archival impulse returned with special force in the early 2000s, to the point where it could be considered a distinctive tendency in its own right.

In the first instance, these archival artists are drawn to historical information that is lost or suppressed, and they seek to make it physically present once more. To this end they elaborate on the devices of the found image, object, and text, and often favor the installation format as they do so, the nonhierarchical spatiality of which they use to advantage. Some practitioners, such as Douglas Gordon, gravitate toward "time readymades," that is, given visual narratives that are sampled in image projections, as in his glacial versions of films by Alfred Hitchcock, Martin Scorsese, and others.[1] Drawn from the archives of mass culture, these sources are familiar enough to ensure a legibility that can then be disturbed or redirected. Yet often, too, the sources are obscure, retrieved in a gesture of alternative knowledge or counter memory. Such work will be my focus here.

Sometimes, archival samplings push the postmodernist complications of originality and authorship to an extreme. Consider the collaborative project *No Ghost Just a Shell* (1999–2002) led by Pierre Huyghe and Philippe Parreno. When a Japanese animation company

Douglas Gordon, *24 Hour Psycho*, 1993 (detail). Video Installation. Dimensions variable. © Studio lost but found / VG Bild-Kunst, Bonn 2014. Courtesy of Studio lost but found. Photo Bert Ross. From *Psycho* (1960), directed by Alfred Hitchcock and distributed by Paramount Pictures. © Universal City Studios.

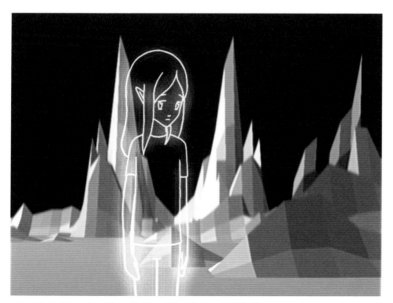

Pierre Huyghe, *One Million Kingdoms*, 2001 (detail). Animated film, 6 minutes. Courtesy of the artist and Marian Goodman Gallery.

offered to sell some of its minor *manga* characters, the two French artists bought one such person-sign, a girl named "AnnLee," elaborated this glyph in various pieces, and invited other artists to do the same. The project became "a dynamic structure," Parreno commented, a "chain" of projects; it also turned into "the story of a community that finds itself in an image," an image archive in the making.[2] At the time, the critic-curator Nicolas Bourriaud championed such art under the rubric of "postproduction," which underscores the secondary manipulations visited on such found forms, yet the term suggests the changed status of the artwork in an age of digital information as well—information that often appears as virtual readymades, as so much data to be reprocessed and sent on.[3] It is in keeping with this order of information that many artists came to "inventory," "sample," and "share" as ways of working.

This last point might imply that the ideal medium of archival art is the mega-archive of the Internet, and several terms that evoke the electronic network, such as "platforms" and "stations," did appear in art parlance of the 2000s; the Internet rhetoric of "interactivity" was also pervasive at the time.[4] However, in most archival art, the actual means applied to these relational ends are far more direct and tactile than any Web interface. The archives at issue here are not databases in this sense: they tend to be funkily material and recalcitrantly fragmentary, and as such they call out for human interpretation, not machinic processing.[5] Although the contents of this art are hardly indiscriminant, they are often indeterminate, like the contents of most archives, and often they are presented in this fashion too—as promissory notes for elaboration or as enigmatic prompts for scenarios.[6] In this regard archival art is as much "preproduction" as it is "postproduction," that is, it is often drawn to unfulfilled beginnings or incomplete projects—in art and in history alike—that might offer points of departure again. Hence the complicated temporality of much archival art.

If archival art differs from database art, it is also distinct from art focused on the museum. Certainly, the figure of the artist as archivist follows that of the artist as curator, and some archival artists continue to play on the notion of the collection. Yet they are not as concerned with critiques of the representational order or institutional ethics of the museum. That the museum is mostly ruined as a coherent system

in a public sphere is generally assumed, not triumphantly proclaimed or melancholically pondered; and some of these artists suggest other kinds of ordering both within this institution and without. In this respect, the orientation of archival art is more "institutive" than "destructive," more "legislative" than "transgressive," though the best examples overcome these oppositions as well.[7] The artist as archivist should also be distinguished from the artist as ethnographer: for the most part, the latter is concerned with marginal cultural forms, in a synchronic register of fieldwork, while the former turns to minor historical materials, on a diachronic axis of research.[8]

The art at issue here is archival in a few senses. First, it not only draws on informal archives but also produces them, and does so in a way that underscores the hybrid condition of such materials as found and constructed, factual and fictive, public and private. Then, too, this art often arranges these materials according to a matrix of citation and juxtaposition, and sometimes presents them in an architecture that can be called archival: a complex of texts, images, and objects. Thus, in terms of method, Dean speaks of "collection," Koester of "comparison," Durant of "combination," and Hirschhorn of "ramification"—and much archival art does appear to ramify, through these operations, like a weed or a "rhizome."[9] Perhaps all archives develop in this way, through mutations of connection and disconnection, a process that this art also serves to disclose. "Laboratory, storage, studio space, yes," Hirschhorn remarks, "I want to use these forms in my work to make spaces for the movement and endlessness of thinking."[10] Such is artistic practice in an archival field.

Sometimes strained in effect, archival art is rarely cynical in intent; its lively motivation of sources contrasts with the detached quotation prevalent in postmodern pastiche. Moreover, the artists involved in archival practice often aim to fashion distracted viewers into engaged discussants. In this regard, Hirschhorn, who once worked in a communist collective of graphic designers in Paris, sees his makeshift dedications to artists, writers, and philosophers—which partake equally of the obsessive-compulsive Merzbau of Kurt Schwitters and the agitprop kiosks of Gustav Klucis—as a species of passionate pedagogy in which the lessons on offer concern love as

much as knowledge.[11] Hirschhorn seeks to "distribute ideas," "liberate activity," and "radiate energy" all at once: he wants to expose different audiences to alternative archives of public culture, and to charge this relationship with affect.[12] In this way his work is not only institutive but also libidinal; at the same time the subject–object relations of advanced capitalism have transformed whatever counts as libido today, and Hirschhorn works to register this transformation and, where possible, to reimagine these relations as well.

Hirschhorn produces interventions in public space that probe how this category might still function today. Many of his projects play on vernacular forms of marginal barter and incidental exchange, such as the street display, the market stall, and the information booth—arrangements that typically feature homemade offerings, refashioned products, improvised pamphlets, and so on. As is well known, he has divided much of his practice into four categories—"direct sculptures," "altars," "kiosks," and "monuments"—all of which manifest an engagement with archival materials that is both eccentric and everyday.

The direct sculptures tend to be models placed in interiors, frequently in exhibition spaces. The first piece was inspired by the

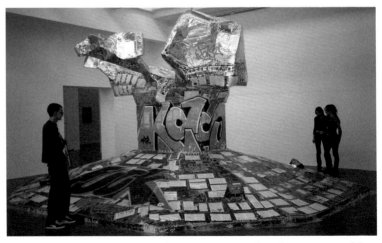

Thomas Hirschhorn, *Direct Sculpture*, 1999. Mixed media. Courtesy of the artist and Galerie Chantal Crousel.

spontaneous shrine produced near the spot in Paris where Princess Diana died; as her mourners recoded the banal monument to liberty already at the site, they transformed an official structure into a "just monument," according to Hirschhorn, precisely because it "issue[d] from below." His direct sculptures aim for a related effect: designed for "messages that have nothing to do with the original purpose of the actual support," they are offered as provisional mediums of *détournement*, for acts of reinscription "signed by the community" (this is one meaning of "direct" here).[13]

The altars stem from the direct sculptures. At once modest and outlandish, these motley displays of images and texts commemorate cultural figures of special importance to Hirschhorn; he has dedicated four such pieces—to the artists Otto Freundlich and Piet Mondrian and the writers Ingeborg Bachmann and Raymond Carver. Often dotted with kitschy mementoes, votive candles, and other emotive signs of fan worship, the altars are placed "in locations where [the honorees] could have died by accident, by chance: on a sidewalk, in the street, in a corner."[14] Passersby, often accidental in another sense, are invited to witness these homely but heartfelt acts of commemoration, and to be moved by them or not, as the case may be.

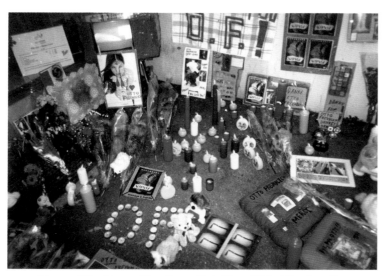

Thomas Hirschhorn, *Otto Freundlich Altar*, 1998. Mixed media.

As befits the name, the kiosks are more informational than devotional. Here, Hirschhorn was commissioned by the University of Zürich to erect eight works over a four-year period, with each one installed for six months within the Institute of Brain Research and Molecular Biology. Once more, the kiosks are concerned with artists and writers, all removed from the activities of the Institute: the artists Freundlich (again), Fernand Léger, Emil Nolde, Meret Oppenheim, and Liubov Popova; and the writers Bachmann (again), Emmanuel Bove, and Robert Walser. Less open to "planned vandalism" than the direct sculptures and the altars, the kiosks are also more archival in appearance.[15] Made of plywood and cardboard nailed and taped together, these structures typically include images, texts, cassettes, and televisions, as well as furniture and other everyday objects, in a hybrid of the seminar room and the clubhouse that is both discursive and social.

Finally, the monuments, dedicated to philosophers also embraced by Hirschhorn, effectively combine the devotional aspect of the altars

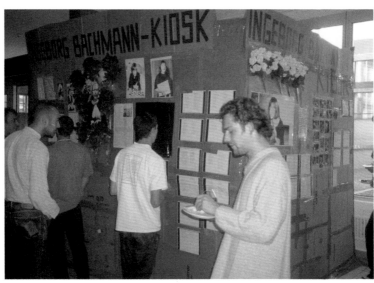

Thomas Hirschhorn, *Ingeborg Bachmann Kiosk*, 1999. Mixed media.
Courtesy of Hochbauamt des Kantons, Zürich.

and the informational aspect of the kiosks. Hirschhorn executed four monuments—for Spinoza, Bataille, Deleuze, and Gramsci—placing each at a remove from the usual sites of official commemoration such as squares and parks. Thus the Spinoza monument (1999) appeared in the red-light district of Amsterdam, the Deleuze monument (2000) in a mostly North African quarter of Avignon, the Bataille monument (2002) in a largely Turkish neighborhood in Kassel, Germany (during documenta 11), and the Gramsci monument (2013) in a Bronx housing project in New York City. These locations were fitting: the radical status of the guest philosopher corresponded to the marginal status of the host community, and the encounter thus suggested a temporary refunctioning of the monument from a univocal structure that obscures antagonisms (philosophical, political, social, and economic) to a counter-hegemonic archive that might be used to articulate such differences.

The consistency of the artists, writers, and philosophers selected by Hirschhorn is not obvious: though most are modern Europeans,

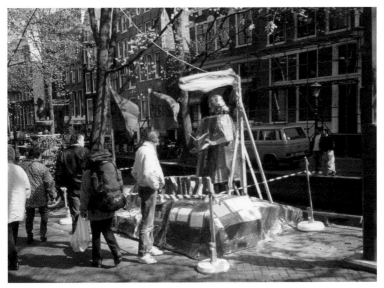

Thomas Hirschhorn, *Spinoza Monument*, 1999. Mixed media.
Courtesy of the artist.

they vary from obscure to canonical and from esoteric to *engagé*. Among the artists of the altars, the reflexive abstractions of Mondrian and the emotive representations of Freundlich are nearly antipodal, while the positions represented in the kiosks range from a French Purist who was a Communist (Léger) to a German Expressionist who belonged to the Nazi Party (Nolde). However, all the figures propose aesthetic models with political ramifications, and the same is true of the monument philosophers, who encompass such disparate concepts as hegemony (Gramsci) and transgression (Bataille). The consistency of the subjects, then, lies in the very diversity of their transformative commitments—so many visions, however contradictory, to change the world, all connected, indeed cathected, by "the attachment" Hirschhorn feels for each one. This attachment is both his motive and his method: "To connect what cannot be connected, this is exactly what my work as an artist is."[16]

Hirschhorn announces his signal mix of information and devotion in the terms *kiosk* and *altar*; here again he aims to deploy both the publicity of agitprop à la Klucis and the passion of assemblage à la Schwitters.[17] Yet, rather than an academic resolution of this avant-garde opposition, his purpose is pragmatic: Hirschhorn applies these mixed means to incite his audience to (re)invest in radical practices of art, literature, and philosophy—to produce a cultural cathexis based not on official taste, vanguard literacy, or critical correctness, but on political use driven by artistic love.[18] In some ways, his project recalls the transformative commitment imagined by Peter Weiss in *Die Aesthetik des Widerstands* (1975–8). Set in Berlin in 1937, this novel tells of a group of engaged workers who coach each other in a skeptical history of European culture; in one instance they deconstruct the classical rhetoric of the Pergamon Altar, whose "chips of stone . . . they gather together and reassemble in their own milieu."[19] Of course, Hirschhorn is concerned not with the classical tradition abused by the Nazis, but with an avant-garde past threatened with oblivion; and his collaborators consist not of motivated members of a political movement, but of distracted viewers who might range from international art cognoscenti to local merchants, children, and soccer fans. Yet such a shift in address is necessary if an "aesthetics of resistance" is to be made relevant to an amnesiac society

dominated by culture and sport industries. This is why his work, with its throwaway structures, kitschy materials, jumbled references, and fan testimonials, often suggests a grotesquerie of our immersive environment of commodities and media: such are the elements and energies that exist to be reworked and rechanneled. In short, rather than pretend that a clear medium of communicative reason exists today, Hirschhorn works with the clotted nature of mass-cultural languages. In effect, he aims to *détourne* the celebrity-spectacle complex of advanced capitalism, which he replays in a preposterous key: Ingeborg Bachmann in lieu of Princess Di, Liubov Popova instead of American Idol, and so on.[20]

Sometimes, Hirschhorn lines his extroverted archives with runaway growths, which are often fashioned in aluminum foil. Neither human nor natural in appearance, these forms point, again in a grotesque register, to a world in which neat distinctions between organic life and inorganic matter, production and waste, even desire and death, no longer apply—a world at once roiled and arrested by information flow and product glut. Hirschhorn calls this sensorium of junkspace "the capitalist garbage bucket."[21] Yet he insists that, even within this prison pail, radical figures might be recovered and libidinal charges rewired, that this "phenomenology of advanced reification" might still yield an intimation of utopian possibility, or at least a desire for systematic transformation, however damaged or distorted that desire might be.[22] Certainly this move to (re)cathect cultural remnants comes with its own risks: it is also open to reactionary deployments, even atavistic ones, most catastrophically with the Nazis. In fact, in the Nazi period evoked by Weiss, Ernst Bloch warned against Rightist remotivations of "the nonsynchronous"; at the same time he argued that the Left opts out of this libidinal arena of cultural politics at its own great cost.[23] Hirschhorn suggests that this continues to be the case today.

If Hirschhorn recovers radical figures in his archival work, Tacita Dean recalls lost souls in hers, and she does so in a variety of forms—photographs, blackboard drawings, sound pieces, and short films and videos often accompanied by narrative asides. Drawn to mediums as well as people and places that are stranded, outmoded, or

Tacita Dean, *Girl Stowaway*, 1994 (detail). 16mm color and black and white
film, optical sound, 8 minutes. Dean images © Tacita Dean. Courtesy of the
artist, Marian Goodman Gallery, and Frith Street Gallery.

otherwise sidelined, Dean offers one such account in *Girl Stowaway*
(1994), an eight-minute 16mm film in color and black and white with
a narrative aside. Dean happened on a photograph of an Australian
girl named Jean Jeinnie, who in 1928 stowed away on a ship named
The Herzogin Cecilie bound for England; the ship later wrecked at
Starehole Bay on the Devon coast.

From this single document, *Girl Stowaway* develops as a tissue of
coincidences, ramifying into an archive as though of its own aleatory
accord. First Dean lost the photograph when her bag was mishandled

at Heathrow Airport (it turned up later in Dublin). Then, as she researched Jean Jeinnie, she heard echoes of the name everywhere—in a conversation about Jean Genet, in the pop song "Jean Genie," and so on. Finally, when she traveled to Starehole Bay to investigate the shipwreck, a girl was murdered on the harbor cliffs on the very night that Dean spent there.

In an artistic equivalent of the uncertainty principle in scientific experiment, *Girl Stowaway* is an archive that implicates the artist as archivist within it. "Her voyage was from Port Lincoln to Falmouth," Dean writes.

> It had a beginning and an end, and exists as a recorded passage of time. My own journey follows no such linear narrative. It started at the moment I found the photograph but has meandered ever since, through unchartered research and to no obvious destination. It has become a passage into history along the line that divides fact from fiction, and is more like a journey through an underworld of chance intervention and epic encounter than any place I recognize. My story is about coincidence, and about what is invited and what is not.[24]

In a sense, her archival work is an allegory of archival work—sometimes melancholic, often vertiginous, always incomplete. It also suggests an allegory in the strict sense of the literary genre that often features a subject astray in a world of enigmatic signs that test her. Here the subject has nothing but (un)invited coincidence as a guide: no God or Virgil to follow, no revealed history or stable culture to go by. Even the conventions of her reading have to be made up as she moves along.

In another film-and-text piece, Dean tells the story of another lost-and-found figure, and it too involves "unchartered research." Donald Crowhurst was a failed businessman from Teignmouth, a coastal town in Devon hungry for tourist attention. In 1968 he entered the Golden Globe Race, driven by the desire to be the first sailor to complete a solo voyage nonstop around the world. Yet neither sailor nor boat, a trimaran christened *Teignmouth Electron*, was adequately prepared, and Crowhurst quickly faltered: he faked his log entries

Tacita Dean, *Disappearance at Sea I*, 1996 (detail). 16mm color anamorphic
film, optical sound, 14 minutes.

(for a time race officials positioned him in the lead), then broke off
radio contact. Soon he "began to suffer from 'time-madness,'" Dean
tells us, and his incoherent entries turned into a "private discourse on
God and the Universe." Eventually, Dean speculates, Crowhurst
"jumped overboard with his chronometer, just a few hundred miles
from the coast of Britain."[25]

Dean treats the Crowhurst archive obliquely in three short films.
The first two, *Disappearance at Sea I* and *II* (1996 and 1997), were
shot at different lighthouses in Berwick and Northumberland. In the
first film, blinding images of the lights alternate with blank views onto
the horizon; in the second, the camera rotates with the lights and so
provides a continuous panorama of the sea. In the first film darkness
slowly descends; in the second there is only void to begin with.

In the third film, *Teignmouth Electron* (2000), Dean travels to
Cayman Brac in the Caribbean to document the remains of the tri-
maran. It has "the look of a tank or the carcass of an animal or an
exoskeleton left by an arrant creature now extinct," she writes.
"Whichever way, it is at odds with its function, forgotten by its
generation and abandoned by its time."[26] In this extended medita-
tion, then, "Crowhurst" is a term that draws others into its archive,
one that points to an ambitious town, a misbegotten sailor, a meta-
physical seasickness, and an enigmatic remnant. And Dean lets this
text of traces ramify further. While on Cayman Brac she happens on
another derelict structure dubbed "the Bubble House" by locals, and

documents this "perfect companion" of the *Teignmouth Electron* in another short film-and-text piece. Designed by a Frenchman jailed for embezzlement, the Bubble House is "a vision for perfect hurricane housing, egg-shaped and resistant to wind, extravagant and daring, with its Cinemascope-proportioned windows that look out onto the sea." Never completed and long deserted, it now sits in ruin "like a statement from another age."[27]

Consider, as a final example of a "failed futuristic vision" that Dean recovers archivally, the immense "sound mirrors" built in concrete at Denge near Dungeness in Kent between 1928 and 1930. Conceived as a warning system of air attack from the Continent, these acoustic receivers were faulty from the start; they did not discriminate adequately among sounds, and "soon they were abandoned in favour of the radar." Stranded between world wars and technological modes, "the mirrors have begun to erode and subside into the mud: their demise now inevitable."[28] (In some

Tacita Dean, *Teignmouth Electron*, 2000 (detail). 16mm color film, optical sound, 7 minutes.

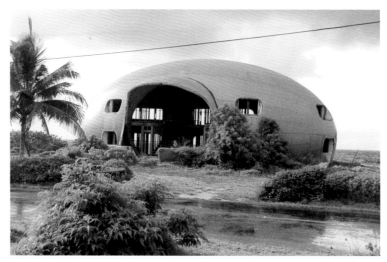

Tacita Dean, *Bubble House*, 1999 (detail). 16mm color film, optical sound,
7 minutes.

photographs, the concrete hulks resemble old earthworks, the stranded status of which also intrigues Dean; she has made a few pieces based on two works by Robert Smithson, *Partially Buried Woodshed* and *Spiral Jetty*, a fascination shared by Durant and others.)[29] "I like these strange monoliths that sit in this no place," Dean writes of the sound mirrors, no doubt aware that "no place" is the literal meaning of "utopia." They exist in a "no time" for her too, though here "no place" and "no time" also mean a multiplicity of both: "The land around Dungeness always feels old to me: a feeling impossible to explain, other than it is just 'unmodern' . . . To me it feels 1970s and Dickensian, prehistoric and Elizabethan, Second World War and futuristic. It just doesn't function in the now."[30]

In a sense, all of these archival objects—the *Teignmouth Electron*, the Bubble House, the sound mirrors, and there are many more—serve as found arks of lost moments in which the here-and-now of the work functions as a possible portal between an unfinished past and a reopened future.[31] The possibility of precise interventions in surpassed times also captivated Walter Benjamin, yet Dean lacks his

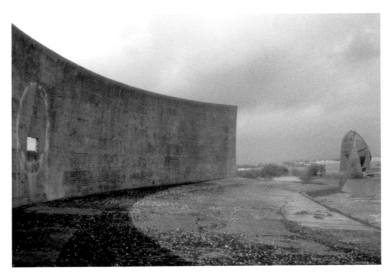

Tacita Dean, *Sound Mirrors*, 1999 (detail). 16mm black-and-white film, optical sound, 7 minutes.

intimation of messianic redemption; and though her outmoded objects might offer a "profane illumination" into historical change, they do not possess "the revolutionary energies" that Benjamin hoped to find there.[32] In this regard her work is affined instead with W. G. Sebald, about whom Dean has written incisively.[33] Sebald surveyed a modern world so devastated by history as to appear "after nature"; many of its inhabitants (including the author) are "ghosts of repetition" who seem at once "utterly liberated and deeply despondent."[34] These remnants are enigmatic, but they are enigmas without resolution, let alone rescue. Sebald even questioned the humanist commonplace about the restorative power of memory; the ambiguous epigraph of the first section of *The Emigrants* (1992) reads: "and the last remnants memory destroys."[35] Dean also looks out on a forlorn world, yet for the most part she avoids the melancholic fixation that was the price that Sebald paid for his courageous refusal of redemptive illusion. The risk in her work is different: a romantic fascination with "human failing."[36] Yet, within the "failed futuristic visions" that she recovers archivally, there is also an intimation of the utopian—not as the other of

reification, as in Hirschhorn, but as a concomitant of her archival presentation of the past as fundamentally heterogeneous and always incomplete.[37]

Like Dean, Joachim Koester undertakes a passage into history along the hazy line that separates fact from fiction. Typically, he begins with an obscure story bound up with a particular place, a sited tale that is somehow broken or layered in time. Then, usually in a photo sequence or a film installation, he works to piece the story together, but never to the point of resolution. A historical irony persists, one that can be elaborated further, or an essential enigma remains, one that can be used to test the limits of what can be seen, represented, narrated, known. Like others involved in archival art, Koester often accompanies his images with texts, but these serve less as factual captions than as imaginative legends of his own mapping of spaces, his own "ghost-hunting" of subjects.[38]

Often Koester travels to far-flung places and investigates long-gone subjects, including late-nineteenth-century explorers, early-twentieth-century occultists, and post-1968 radicals. Again like Dean, he is especially drawn to adventurers whose quests have failed, sometimes disastrously so. For example, in a 2000 photo sequence he takes up the story of the Canadian arctic town of Resolute, which begins with the search for the Northwest Passage, passes through the politics of the Cold War, and deteriorates with the discordant claims of planners, Inuits, and other residents in the present. Even as the borders that concern Koester have become historical, they remain political.

Koester has also treated Christiania, a former military base in his native Copenhagen that was proclaimed a free city by anarchist squatters in 1971. In *Day for Night, Christiania* (1996) he photographed different sites with a blue filter (used in film to shoot night scenes during the day), split the titles between the old military designations and the new squatter names, and so remarked the transformations of Christiania at the level of image and language alike. Then, in *Sandra of the Tuliphouse or How to Live in a Free State* (2001), a five-screen video installation produced with Matthew Buckingham, Koester used black-and-white photos

Joachim Koester, *Day for Night, Christiania*, 1996 (detail). C-print on
aluminum. 26 x 38½ inches.

drawn from archives and color footage shot on location in order to
present, through the voiceover of the fictional Sandra, a range of
ruminations on such topics as Christiania, Copenhagen at large,
the fate of armor in the age of gunpowder, the rise of heroin, and
the decline of wolves. The piece is perspectival in a Nietzschean
sense, with the audience forced to sort out the disparate viewpoints
on the fly. Both works juxtapose the utopian promise of Christiania
with its gritty actuality (such a combination again brings Dean to
mind), and both are structured through a particular kind of
montage—internal in the case of the split-captioned photos of *Day
for Night*, immersive in the case of the installation space of *Sandra
of the Tuliphouse*. Such montage is the formal analogue of the
parallactic model of history that Koester advances in all of his
work—a folding of different temporalities within the space of each
piece. "You can really grasp time as a material through this simple
act of comparison," Koester writes; or as the German polymath
Alexander Kluge once put it, "nothing is more instructive than a
confusion of time frames."[39]

In his works focused on adventurers, Koester uses different time frames to highlight particular historical ruses. In *From the Travel of Jonathan Harker* (2003) he retraced the journey of the English protagonist of *Dracula* (1897) through the Borgo Pass, only to find not the fantastic Transylvania of lore but a tawdry reality of suburban tracts, illegal logging, and a tourist hotel called Castle Dracula. A similar sort of confrontation between real spaces and fictional subjects is produced in *The New Land(s) and the Tale of Captain Mission* (2004), in which Koester combined photographs of an actual site—Flevoland in the Netherlands—with evocations of a character from the William S. Burroughs novel *Cities of the Red Night.* Koester has taken up historical explorers too, such as the Swedish scientist Nils A. E. Nordenskiöld, the first European to venture deep into the Greenland ice cap. Nothing is more redolent of Northern Romanticism than a fascination with explorations gone awry (witness *The Sea of Ice* [1823–24] by Caspar David Friedrich with its wrecked ship), and in a piece titled *Message from Andrée* (2005) Koester reflects on the doomed polar expedition of the Swedish balloonist S. A. Andrée and his young associates Knut Fraenkel and Nils Strindberg. "On July 11th 1897," Koester tells us, "Andrée, Fraenkel, and Strindberg took off from Danes Island, Spitsbergen, with the intention of circumnavigating the North Pole in a balloon."[40] Yet the balloon soon crashed, and the explorers vanished on a deserted island surrounded by pack ice. Thirty-three years later a box of exposed negatives was found; some contained images, but most were "almost abstract, filled with black stains, scratches, and streaks of light." Out of this "visual noise" Koester produced a short 16mm film, "pointing to the twilight zone of what can be told and what cannot be told, document and mistake." As Koester reinscribes it, then, "the message from Andrée" is fundamentally ambiguous: an archival photo of the balloon just underway suggests the late-nineteenth-century dream of the glorious expedition—that the world can be readily mastered à la Jules Verne—while the film, like a message in a bottle worn away by exposure, points to an implacability in natural accidents as well as an indecipherability in historical events.

In two other photo sequences from the early to middle 2000s, one concerning a notorious figure of the occult, the other a celebrated

Joachim Koester, *Morning of the Magicians (Room of Nightmares #1)*, 2005.
C-print. 18½ x 23½ inches.

philosopher of the Enlightenment, Koester again produces broken
allegories about the significance of historical traces in the midst of
modern transformations. In *Morning of the Magicians* (2005) he
documented his search for the residence of the occultist Aleister
Crowley (1875–1947) and his followers outside the Sicilian town of
Cefalù. Closed by order of Mussolini in 1923, "The Abbey of
Thelema" was abandoned for more than thirty years, only to be
rediscovered by the filmmaker Kenneth Anger; supported by the
sexologist Alfred Kinsey, Anger uncovered the original murals
painted by the Crowley group, which point to tantric practices,
sexual rites, and drug use. These "pieces of leftover narratives and
ideas from the individuals that once passed through this place"
provided Koester with rich material, but it also presented him with a
narrative "knot," an obscurity that he conveys with photos both of
the interior marked by graffiti and of the exterior overgrown with
brush (it proved difficult even to find the house). The occult is thus

the subject here in a few senses of the word. First, the actual practices of the Crowley group were occult (the murals suggest that they ranged from the magical through the ribald to the hokey). Second, the occult interests Koester as an instance of a clandestine activity (such as that of the Crowley group) within official culture. And, third, there is the occlusion of historical events by way of the modernity that has encroached on the site (once a fishing village, Cefalù has become a "booming beachside town").

This multiple occlusion is also the subject of the photo sequence *The Kant Walks* (2003). Kant lived in Königsberg, and at the end of his life the philosopher of reason suffered from hallucinations; subsequently his hometown was also wracked by irrationalities: brutalized by the Nazis in the Kristallnacht of 1938 and bombed to rubble by the Royal Air Force in 1945, it was annexed by the Soviet Union and renamed Kaliningrad (in honor of the longtime Stalin associate Mikhail Kalinin). In his photo sequence Koester evokes these intertwined histories through a tracing of the daily walks taken by Kant, yet here again the path was not easy to discover. "One has to place two maps on top of each other, that of Königsberg and that of Kaliningrad, to find the locations today," Koester informs us, and then his own route was further disrupted by unexploded bombs, postwar constructions (some now in ruins), and official amnesia. *The Kant Walks* suggests a *terrain vague* of different spaces in temporal collision. Especially telling in this respect is one image of a Soviet cultural center constructed in the early 1970s on the site of an old castle. The castle tunnels made the new building unstable, so it was simply left, unoccupied, to deteriorate. "Detours, dead ends, overgrown streets, a small castle lost in an industrial quarter, evoked history as a chaos," Koester writes, "a dormant presence far more potential than tidy linear narratives used to explain past events."[41]

Even as modernity erases traces of history, it also produces "points of suspension" that expose its uneven development or, rather, its uneven devolution into so many ruins. Such are the "blind spots" that intrigue Koester. An oxymoron of sorts, the term suggests sites that, normally overlooked, might still provide insights (the *Oxford English Dictionary* tell us that a blind is not only an "obstruction to sight or light" but also a "screen for hunters"). For Koester these

Joachim Koester, *The Kant Walks*, 2003 (detail). C-print. 18½ x 23½ inches.

spots are unsettled, an unusual mix of the banal and the uncanny, symptomatic of an everyday kind of historical unconscious. Benjamin once remarked that Eugène Atget photographed his deserted Paris streets as if they were crime scenes, and Koester has a forensic gaze too, though the crimes in his unpopulated images are the familiar ones of capitalist junkspace, state suppression, and general oblivion. He uses the special nature of the photograph to seize "the 'index' of things" both as they emerge in time and as they fall back into it. Such is his double interest in "how history materializes" and how it decays into enigmatic precipitates.[42]

In *The Kant Walks* Koester evokes the Situationist practice of "psychogeography," a straying through a space guided by chance and desire rather than by rule and reason; but his more important reference is the multidimensional traveling of Robert Smithson (a key figure, as we have seen, for several archival artists). In certain respects Koester journeys to Kaliningrad as Smithson ventured to

Passaic, New Jersey—in search of inadvertent monuments in which "history or time [becomes] material."[43] In another project, *histories* (2005), Koester seeks out this temporal marking through a precise replication of the sites photographed by Smithson and other artists some five decades ago.[44] As Koester comments of the histories evoked in his piece, "There are at least two. That of conceptual photography, and that of the place and events depicted." The viewer is left not only to track but also to collate the various changes through the evidence provided.

The allegorical attention to "the index of things" in Koester again recalls Benjamin as well as Sebald, but, like Dean, Koester is relatively free of both the redemptive hope of the former and the melancholic resignation of the latter. In this regard, he is closer in spirit to Alexander Kluge in *The Devil's Blind Spot*.[45] Kluge also walks the blurred border between fact and fiction, and he too is drawn to blind spots in which the turns that history has taken, and might still take, are sometimes revealed to us.[46] For Kluge, these moments appear when the devil is napping, which leaves the door open, if not to the Messiah (as Benjamin hoped), at least to the possibility of change. This is how Koester intends his work to serve as well—as "a scene for potential narratives to unfold."[47] Yet, in Koester as in Kluge, the blind spots remain the devil's, and so whatever change might befall us is not necessarily for the better.

Like Dean and Koester, Sam Durant employs a variety of means— drawings, photographs, Xerox collages, sculptures, installations, sound, and video—but where Dean and Koester are precise about their mediums, Durant exploits the chaotic space between his forms. Moreover, where Dean and Koester are meticulous in their collection of sources, Durant is eclectic in his sampling of materials, ranging as he does from mid-century design through 1960s political activism and rock-and-roll history to do-it-yourself culture today.[48]

Durant stages his archive as a spatial unconscious where repressed histories return disruptively even as different practices mix entropically.[49] He is drawn to two moments within postwar American culture in particular: late modernist design of the 1940s and 1950s, such as that of Charles and Ray Eames, and early postmodernist art

of the 1960s and 1970s, such as that of Robert Smithson (who appears here yet again). Today the first moment appears distant, already the object of various recyclings, and Durant offers a critical perspective on both the original and its repetitions. The second moment is on the threshold of history, and includes "discourses that have just ceased to be ours," as Michel Foucault once wrote; as such it might point to "gaps" in contemporary thought, gaps that might in turn be converted into beginnings.[50] "So often I am attracted to things conceived in the decade of my own birth," Dean (born in 1965) has commented, and the same holds for Durant and others of this generation too.[51] Yet his archival materials seem more unstable than those of his peers, subject to collapse as much as to recovery.

Based in Los Angeles, Durant evokes his first moment through signature designs associated with Southern California, acting out an aggressive response to the repressive formalism he finds there.[52] A onetime carpenter, Durant stages a class struggle between the refinements of late modernist architecture (at a time when it had become both corporate and suburban) and the resentments of the working class (whose exclusion from this period style was all but assumed). Thus he has produced color photographs that show prized pieces of the time, such as the Eames shell chair, upset on the floor, "primed for humiliation."[53] He has also shown sculptures and collages that abuse effigies of the Case Study Houses designed by Richard Neutra, Pierre Koening, Craig Ellwood, and others from 1945 to 1966. In the sculptures rough models of the houses, made of foamcore, cardboard, plywood, and plexiglass, are burned, gouged, and graffitied; in a further class outrage some are also wired with miniature televisions tuned to trashy soap operas and talk shows.[54] His collages picture nasty eruptions of class spite too: in one image two beer-guzzlers appear in a classic Julius Shulman photograph of the Koenig House in a way that ruins its dream of transcendental good taste; in another image a trashy party girl is exposed in a way that undoes any pretense of a refined world beyond sex.[55] In further pieces Durant juxtaposes miniature toilets and plumbing diagrams with Eames chairs, IKEA shelves, and Minimalist boxes: again, in near literal fashion he plumbs "good design" and reconnects its clean avatars with unruly bodies, as though to unplug its cultural blockages. In effect, Durant

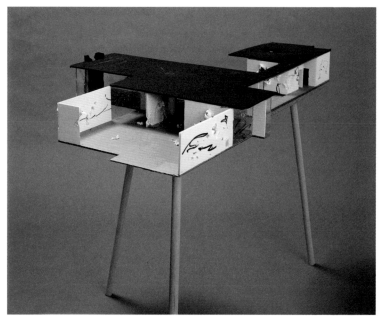

Sam Durant, *Abandoned House #4*, 1995. Foamcore, plexiglass, wood, metal. 24½ x 41 x 4½ inches. Durant images © Sam Durant. Courtesy of the artist and Paula Cooper Gallery. Photo Brian Forrest.

stages fantasies of revenge against pristine machines-for-living, both old and new.[56]

His second archival moment, more expansive than his first, encompasses advanced art, rock culture, and civil rights struggles of the late 1960s and early 1970s, the signs of which Durant often combines. In this archival probe, Smithson is a privileged cipher; like Dean and Koester, Durant regards him as both an early exemplar of the artist as archivist and a key term in this period archive. In one work, *Landscape Art (Emory Douglas)* (2002), Durant combines a reference to a photo sequence by Smithson of upside-down trees with an allusion to Emory Douglas, a graphic designer who served as minister of culture of the Black Panthers. In other pieces Durant cites *Partially Buried Woodshed*, produced by Smithson at Kent State in January 1970; here a model of a radical artwork mixes with a memory of an oppressive police force—the killing of the four students by National

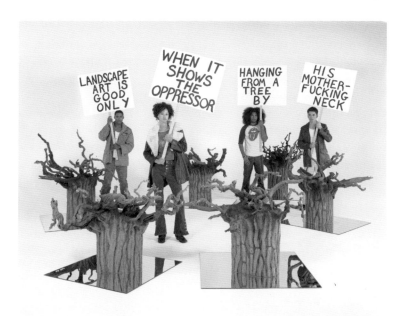

Sam Durant, *Landscape Art (Emory Douglas)*, 2002. C-print. 50 x 60 inches.
Photo Josh White.

Guardsmen on the same campus just a few months after *Woodshed* was installed. Allusions to utopian and dystopian events in rock culture also collide as recordings from Woodstock and Altamont play through speakers buried in dirt mounds.[57] These divergent signs erupt in this archival space, yet they are also confused there: opposed positions blur in an experimental devolution of vanguard art, countercultural music, and state power. In this way Durant not only sketches a cultural-political archive of the civil rights and Vietnam War era but also points to its entropic slide into media mélange.

Durant comes to entropy via Smithson, who offered this familiar exposé of its principles in his 1967 text "A Tour of the Monuments of Passaic, New Jersey":

Picture in your mind's eye [a] sand box [divided] in half with black sand on one side and white sand on the other. We take a child and have him run hundreds of times clockwise in the box

until the sand gets mixed and begins to turn grey; after that we have him run anti-clockwise, but the result will not be a restoration of the original division but a greater degree of greyness and an increase of entropy.[58]

Among other roles, entropy served Smithson as a final rebuttal both to formalist distinctions in art and to metaphysical oppositions in philosophy. For his part Durant extends its erosive action to the historical field of cultural practices that includes Smithson. What the sandbox was for Smithson, *Partially Buried Woodshed* becomes for Durant: it not only thematizes entropy but also instantiates it, and does so both in a micrological sense—partially buried in 1970, the woodshed was partially burned in 1975, and totally removed in 1984—and in a macrological sense—the woodshed becomes an allegorical archive of recent art and politics as "partially buried." "I read it as a grave site," Durant says of *Partially Buried Woodshed*. Yet if it is a grave for him, it is a fertile one for his work.[59]

Sam Durant, *Quaternary Field/Associative Diagram*, 1998. Graphite on paper. 22 x 29½ inches.

Often Durant "sets up a false dialectic [that] doesn't work or [that] negates itself."[60] In one piece he revises the structuralist map of "sculpture in the expanded field" proposed by Rosalind Krauss over three decades ago, in which he substitutes, for her disciplinary categories like "landscape" and "architecture," pop-cultural markers like "song lyric" and "pop star."[61] The parody comes with a point, which is the gradual collapse of the structured space of postmodernist art (his diagram might be called "installation in the imploded field" or "artistic practice in the age of cultural studies"). Perhaps Durant implies that the dialectic at large—not merely in advanced art but in all of cultural history—has faltered since that early moment of postmodernism, and that we are mired in a stalled relativism today. Perhaps he relishes this predicament. Yet this is not the only implication of his archival art: his "bad combinations" also serve "to offer space for associative interpretation," and they suggest that, even in an apparent condition of entropic decay, new connections can be made.[62]

The will "to connect what cannot be connected": this phrase from Hirschhorn suits the others in archival art discussed here as well. Importantly, however, this is not an imperative to totalize; rather, it is simply a wish to relate—to probe a misplaced past, to collate some of its traces, to ascertain what remains for the present. Again, this wish (which is active in my text too) varies in subject and strategy: Hirschhorn and Durant stress crossings of avant-garde and kitsch, while Dean and Koester gravitate to figures who fall outside these realms; the connections in Hirschhorn and Durant are often forced, in Dean and Koester often fragile, and so on. Nevertheless, the will to connect is enough to distinguish this archival impulse from "the allegorical impulse" that Craig Owens attributed, over three decades ago, to postmodernist art (he had in mind the use of appropriated images from Rauschenberg to Sherrie Levine).[63] In his account the allegorical is a fragmentary mode, one pitted against the symbolic, which aims for integration (this is a traditional opposition); in this light, aesthetic autonomy as proclaimed by Kant is on the side of the symbolic, as is "modernist painting" as understood by Clement Greenberg. The dispute with symbolic totalities of this sort is not as important to archival artists, for whom the fragmentary is a given

state of affairs. By the same token the archival impulse is also not "anomic" in the sense of the *Atlas* of Gerhard Richter as read by Benjamin Buchloh.[64] In his account, this vast compendium of source images, which Richter has often tapped for his paintings, defies all rule and logic ("anomic" derives from the Greek *anomia*, "without law"). This, too, is not the fight of archival artists: as with the fragmentary, the anomic is assumed as a condition, one to work through where possible. To this end they sometimes propose new orders of affective association, however partial and provisional, even as they also register the difficulty, at times the absurdity, of doing so. This is why archival art can appear tendentious, even preposterous.[65] In fact, its will to connect can betray a hint of paranoia, for what is paranoia if not a practice of forced connections, of my own private archive, of my own notes from the underground, put on display?[66] On the one hand, these private archives question public ones: they can be seen as perverse schemes that disturb (if only slightly) the symbolic order at large. On the other hand, they also point to a possible crisis in this order or, again, to an important change in its workings. For Freud the paranoiac projects his meanings onto the world precisely because it appears ominously drained of all significance (systematic philosophers, he implied, are closet paranoiacs). Might archival art emerge out of a similar sense of a failure in cultural memory, of a default in productive traditions? For why else connect things if they did not appear disconnected in the first place?[67]

Perhaps the paranoid dimension of archival art is the other side of its utopian ambition—its desire to turn belatedness into becomingness, to recoup failed visions in art, literature, philosophy, and life into possible scenarios for alternative kinds of social relations, to transform the no place of an archive into the new place of a utopia. This partial recovery of a utopian demand is unexpected; not so long ago this was the most despised aspect of the modern(ist) project, condemned as totalitarian gulag on the Right and capitalist *tabula rasa* on the Left.[68] The move in archival art to turn "excavation sites" into "construction sites" is welcome in another way too: it suggests a shift away from a melancholic culture that views the historical as little more than the traumatic.[69]

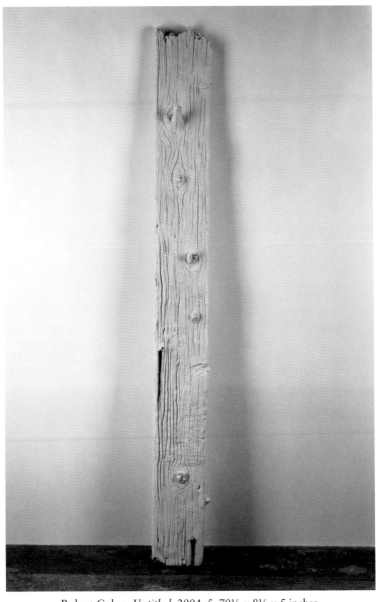

Robert Gober, *Untitled*, 2004–5. 70½ x 8¼ x 5 inches.

MIMETIC

First you see a knotty plank of faux wood in unpainted plaster leaning vertically against a wall, then two garbage cans, also in unpainted plaster, one set within the other. The cans are covered by a plywood sheet, on top of which lie the folded shirt of a priest and a newspaper clipping (it shows a female delegate to the 2004 Republican Convention mocking the Democratic candidate John Kerry). This makeshift pulpit, which mingles the religious and the political, opens onto two rows of three dirty-white slabs; though made of bronze, they look like chunks of old Styrofoam that have washed ashore. Like a plinth, each slab supports an object that appears found but is handcrafted. First, to the left, is a plank of faux wood in bronze that is malformed, at once molten and petrified, and, to the right, is a bag of diapers, made of plaster and sealed in faux packaging. Then comes a milk crate with three more diaper bags in plaster and one plank in bronze; and, finally, there are two glass bowls filled with large pieces of fruit that look plastic but are beeswax.

The presentation of these items is at once forensic, like evidence laid out in a police morgue, and ritualistic, for we walk down the rows of objects, hushed, as we might down the aisles of a chapel. And in fact on the far wall hangs a crucified Christ in concrete made to

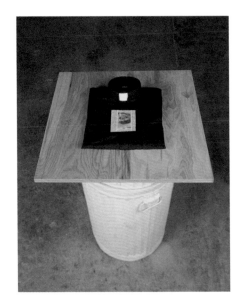

Robert Gober, *Untitled* (detail), 2004–5. 32½ x 24 x 24 inches.

Robert Gober, *Untitled* (detail), 2004–5. 20½ x 46½ x 25¼ inches.

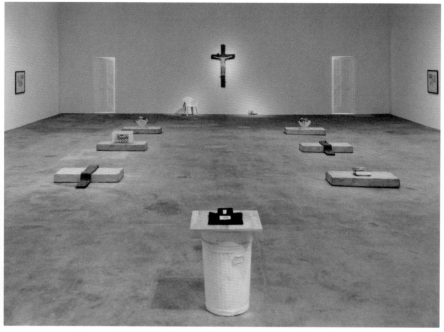

Robert Gober, installation of 16 works, all mixed media, at Matthew Marks Gallery, New York, 2005. Gober images © Robert Gober. Courtesy of the artist and Matthew Marks Gallery.

recall a churchyard ornament (an artificial robin is attached to the bronze cross). Decapitated as if vandalized, this Jesus is flanked, in the customary positions of the two Marys, by spare tokens of working-class America: a white chair that looks plastic but is porcelain (a yellow latex glove hangs from one arm) and a carton of yellow bug-lights in blown glass. Like stigmata turned into spouts, the nipples of the beheaded Christ gush steady streams of water into a round hole cut roughly into the floor. To the sides of this brutal crucifix are two doors wedged open a crack to show spaces bright with light. Peeking in, you see white bathtubs with flowing taps occupied, to the left, by two male legs and, to the right, by two female legs; on the floor to the right are two sections of the *New York Times* detailing the Starr Report on the sexual escapades of President Bill Clinton.

Robert Gober, *Untitled* (detail), 2004–5. 96 x 140 x 62 inches.

At this point, puzzled, you turn and notice, in the opposite corners of the space, two torsos in beeswax that mirror one another, each with one male breast and one female breast. Both bisexed torsos sprout from the crotch one male leg dressed with sock and shoe and three branches in faux wood (bark also appears on the legs). At this point, too, you see four framed pictures hanging on each side wall, all made up of individual spreads from the first section of the *New York Times* of September 12, 2001 (on the west wall the pages are literally reversed, as if seen in a mirror). Over the reports and photos of the al-Qaeda attacks of the previous day are drawn images, in pastel and graphite, of commingled body parts; it is not quite clear whether they

Robert Gober, *Untitled* (detail), 2003–5. 24¼ x 40 x 34 inches.

are male, female, or both. These nude bodies are locked in different embraces that seem erotic but, in the context of 9/11, might be deathly as well, as if in postures of mournful passion or passionate mourning. The pictures seem to be keys to the piece, yet they are as enigmatic as any other element.

Robert Gober, the creator of this untitled work from 2005, once described his installations as "natural history dioramas about contemporary human beings," and, like many dioramas, they mix the real with the illusionistic in ways that both fascinate and disorient; in effect they are broken allegories that at once elicit and resist interpretation.[1] Here it is the 9/11 aftermath that we revisit as if in a

Robert Gober, *Untitled* (detail), 2004–5. 22 x 26½ inches.

waking dream, and as in a dream nearly all the objects exist in an ontological no man's land, in this case somewhere between refuse, relic, and replica. That nothing is quite as it appears only adds to our anxious curiosity; the material uncertainty of the things injects a metaphysical unease into the scene.

If only for reassurance, we might call up art-historical connections. Specific models like *Etant donnés* (1946–66), the peep-show diorama of painstaking facsimiles crafted by Marcel Duchamp, come to mind, as do general precedents like the pictorial paradoxes contrived by René Magritte. More distantly, we might think of various representations of the Crucifixion and other episodes from the New Testament (in a 1997 installation Gober featured a full-dress

Virgin with a pipe cut through her middle), as well as particular paintings by Caravaggio (his *Bacchus* is evoked by the bowls of fruit), Géricault (his studies of severed body parts), and others.[2] Yet these associations get us only so far, and, as usual with Gober, they are overshadowed by allusions to topical events that are as epochal as 9/11 and as everyday as a bath. In this way, different registers of allegorical reading are set up, from the sacred to the profane, but these levels are broken. At every turn, the real disturbs the symbolic (as the tacky chair and lights disturbs the crucifix), even as the symbolic haunts the real (as the amorous bodies haunt the newspaper reports of 9/11).[3] A similar confusion troubles the oppositions in play between male and female, human and inhuman, public and private, and sacred and profane. Almost in a caricature of Lacanian psycho-analysis, the two bathrooms, emblematic markers of gender difference, seem to govern all the other oppositions, yet each binary is rendered ambiguous: male and female, human and inhuman, are combined in the odd torsos; public and private come into contact in the *Times* pages and through the bathroom doors; and sacred and profane collide in the crucifix scene. In this confusion a subtle ambivalence is created in every object, image, and space.

Gober adapts the intrinsic ambiguity of the still life. Usually an offering of food that is also a withholding of the same (for the food is never real), a still life is a gift that does not give, a *nature* that is *morte*, a *vanitas* whose beauty stings with a reminder of death.[4] Here, the fruit is artificial, the diapers are stiff (they recall the rat poison and cat litter in other Gober installations), the Styrofoam is unrecyclable, the wood is petrified, and the births are freakish; in fact Gober shows the entire world sea-changed into the strange, altered for the worse. The molten material, mortuary slabs, and commingled limbs evoke a historical hell that combines the post-attack space of the World Trade Center with the bombsites of Iraq: it is at once hallowed ground and hideous morgue, reliquary and wasteland. Implied here too is a polit-ical continuum in which the trauma of the 9/11 attacks was turned into a trope by the Bush administration into the triumphalism of "the war on terror," replete with the blackmail of the 2004 election whereby to oppose Bush was to appease the terrorists, to abandon the soldiers, and so on. And Gober implicates us in this debacle: again,

private and public spheres touch (the bathers next to the crucifix), even interpenetrate (the bodies drawn on top of the newspapers), and we readers of the *Times* appear passive compared to the implicit crusaders of the headless Christ (the beheaded figure also evokes the pitiless aspect of the Iraqi insurgency). The installation feels like the End of Days from the point of view of those of us left behind.

"History is bunk," Henry Ford once remarked, and over a half-century ago the Pop artist Eduardo Paolozzi took this claim seriously. He contrived collages out of *Time* magazine covers and called them "Bunk," as if to say that, if history is bunk, then bunk might provide material for its critique. Gober updates this move with the cultural kitsch of post-9/11 America, which he treats as a political program imposed on us. Yet he does not merely mock it; for all the ambiguity of his installation, it projects none of the sophisticated superiority found in camp, and little of the secret support advanced in parody. Although kitsch trades in false sentiment, it can possess a damaged authenticity of its own, and Gober is sensitive to the pathos in the expressions of loss after 9/11 (the fruit bowls on the mortuary slabs call up the flowers, candles, and other mementoes left from Trinity Church to Union Square in Manhattan). Here, then, he adapts his aesthetic of mourning vis-à-vis the AIDS epidemic (his forlorn legs and torsos were first resonant in that context) to the terrible aftermath of the Twin Towers attacks; and in his commingling of bodies he suggests a persistence of love among the ruins. At the same time Gober is aware of the manipulation at work in 9/11 kitsch and alert to the blackmail that acted through its tokens: the ribbons that exhorted us to remember the troops (the yellow accents in the installation, such as the bug lights, key this association), the decals of the towers draped with stars and stripes, indeed the little flags that appeared everywhere from antennas to lapels, the shirts and statuettes dedicated to New York City firemen and police, and so on. These last figures became heroes in the way that workers or soldiers are in any number of regimes, but rather than the common production of a society they emblematized a Christian story of sacrifice and wrath—of a violation taken to underwrite a far greater violence. Yet, again, Gober does not treat this American kitsch ironically; he evokes the pathos even as he questions the politics.

In 1933, as the Nazis came to power, the Austrian novelist Hermann Broch referred kitsch to an emergent bourgeoisie caught between contradictory values, an asceticism of work on the one hand and an exaltation of feeling on the other. As a compromise-formation, this early kind of kitsch tended toward a blend of prudery and prurience, with sentiment at once chastened and heightened (a representative instance is the painting of Arnold Böcklin). Broch was categorical about the disastrous effects of this kitsch: he called it "the evil in the value-system of art."[5] Clement Greenberg agreed. In another momentous year, 1939, he underscored its capitalist dimension. "A product of the industrial revolution," his kitsch was an ersatz version of "genuine culture," which the bourgeoisie, now dominant, sold to a peasantry-turned-proletariat, which had lost its own folk traditions on coming to the city. Soon mass-produced, kitsch became "the first universal culture ever beheld" and, as such, supported "the illusion that the masses actually rule."[6] It was this illusion that made kitsch (with variations for political ideology and national tradition) integral to the regimes of Hitler, Mussolini, Stalin, and others.

Greenberg also indicated how kitsch dictates its consumption through predigested forms and programmed effects. This notion of "fictional feelings," which almost anyone can access but no one quite possess, led Theodor Adorno, in *Aesthetic Theory* (1970), to define kitsch as a parody of catharsis.[7] It also allowed Milan Kundera, in *The Unbearable Lightness of Being* (1984), to argue that kitsch is instrumental to our "categorical agreement with being," that is, to our assent to the proposition "that human existence is good" despite all that is "unacceptable" in it, the reality of shit and death above all, which it is "the true function of kitsch . . . to curtain off." In this expanded definition kitsch engineers a "dictatorship of the heart" through "basic images" of "the brotherhood of man," a feeling of fellowship that, for Kundera, is little more than narcissism writ large: "Kitsch causes two tears to flow in quick succession. The first tear says: How nice to see children running on the grass! The second tear says: How nice to be moved, together with all mankind, by children running on the grass! It is the second tear that makes kitsch kitsch." It also what makes kitsch, in societies ruled by a single party,

"totalitarian," and "in the realm of totalitarian kitsch, all answers are given in advance and preclude any questions."[8]

Could it be that, after the collapse of the Soviet bloc, this dictatorial dimension surfaced in American culture? Certainly in the wake of 9/11 a new order of totalitarian kitsch came to pervade this society.[9] Among the signs were these: the trumping of basic civil rights by particular moral values; the brandishing of the Ten Commandments at courthouses; the obligation of national politicians to make a show of faith; the appropriation of "life" against those who support reproductive choice; and, of course, the clash of fundamentalisms. It is this last connection that Gober captures in the brilliant touch of his acephalic Jesus, for condensed here is not only a reminder of the beheaded hostages in Iraq but also a figure of America in the guise of Christ the sacrificial victim turned righteous aggressor, the one who kills in order to redeem.[10]

You enter a space given over to a noisy tangle of video screens, cables, and wires; here and there homemade mechanisms, mostly in the low-tech form of small surveillance cameras, relay the bizarre actions of toy figures on nearby monitors. This infernal world—its title, you discover, is *The Palace at 4 A.M.*—is entered through a passage surrounded by a giant beaver-shot. You next encounter a blowup of the trashed residence of Saddam Hussein after the Iraq invasion; the palace in question seems to be his. Yet you also confront a large picture of George W. Bush with the word "war" scrawled across his forehead in blood red, so the location might be his White House as well. In time you understand the palace in question to be a psychological bunker that Saddam and Bush shared for a time, making the rest of us share it with them. In this respect the palace is your home too—in the middle of the night, say, when the war on terror troubled your sleep. And in fact the oscillation between engulfment and recoil produced by *The Palace at 4 A.M.* is not unlike that of a nightmare.

In this carnivalesque space you pass by discrete stations. In one called "One Hour Photo," tacky postcards of the World Trade Center revolve on a vertical conveyor-belt, at the bottom of which a small video camera is placed. As each card approaches the camera and then trips over it, the monitor shows a wobbly zoom in on the

Jon Kessler, *The Palace at 4 A.M.*, 2005. Mixed media installation at PS 1
with cameras, monitors, lights, and mirrors. Kessler images © Jon Kessler.
Courtesy of the artist and Salon 94.

Twin Towers; it is as though an outrageous videogame had projected
you into the doomed planes of 9/11. This perverse point of view, in
which you are asked to identify with a weapon, became familiar
during the first Gulf War with cameras embedded in smart bombs.
"One Hour Photo" thus conjures up the perspective of both terrorists
and victims on the 9/11 jets; in effect you are offered a reimagining of
this trauma. But it is one that is compulsively repeated, not worked
through, a conundrum literalized by the mechanical loop. And you
recognize the toxic character of all such spectacular events—how
they are at once traumatically real, utterly mediated, and endlessly
replayed.

Another station in *The Palace at 4 A.M.* is called "Modern Vision,"
which lines you up, via video, with a mock smart bomb that targets
the Museum of Modern Art. Its predecessor (not included in *The
Palace at 4 A.M*) is titled "Heaven's Gate." Here, again via a video,
you fly through a model city into a model apartment, where the
camera zooms in on a computer screen. On this screen you first see

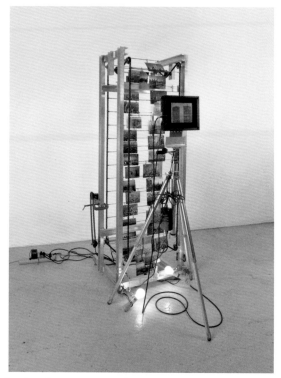

Jon Kessler, *One Hour Photo*, 2004. 74 x 39 x 26 inches.

the buttocks of a doll, and then pass through this unexpected aperture, only to emerge, on the other side, into a gallery space. Once again representation is imagined as a carnal act, in this case an anal rebirth: in opposition to pervasive myths about the transcendence of art and the immateriality of information, you are asked to consider the physical bases and the corporeal effects of art and information alike.[11] You are also led to reflect on a general condition of obscenity in contemporary news and entertainment alike, in which representations, bodies, and machines often converge violently.[12]

Jon Kessler, the architect of *The Palace at 4 A.M.* (2005), takes bites out of the spectacle-machine of the American Empire under George W. Bush, chews them over, and spits them out again. Combining news events, military reports, touristic postcards,

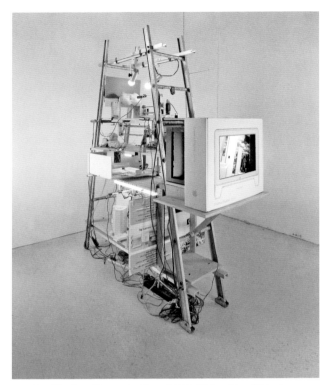

Jon Kessler, *Heaven's Gate*, 2004. 123 x 91 x 80 inches.

seductive ads, and franchised toys, his delirious little dramas decon-
struct some of the political fixations and cultural obsessions of the
period. Kessler also works by blunt appropriation and perverse
refunctioning in his titles. Consider "Global Village Idiot," an avatar
of a ragged old man who appears in *The Palace at 4 A.M.* and other
Kessler productions. The name plays on Marshall McLuhan, who, in
such texts as *War and Peace in the Global Village* (1968), suggested
that the instantaneous reach of electronic communications had, for
the first time in history, made for an informed audience around the
world. In his revision Kessler intimates that in our global village
today, one of endless infotainment controlled by a handful of govern-
ments and corporations, we are trained to be village idiots—cultural
know-nothings and political incompetents. The implication—that

technological progress and social regression are more complements than opposites—is one key to the critical charge of his art, and it flies out in many directions at once. For not only is Bush the idiot here, but so too are Saddam and Osama bin Laden, and neither the artist nor his viewers are excused: "global village idiocy" is an equal-opportunity condition.[13]

Since his mechanisms are even more viciously circular than the media around us, Kessler exacerbates the greater spectacle. At the same time he also interrupts this spectacle, since he introduces compulsive breaks into its flow. All of his setups are rough, and as we

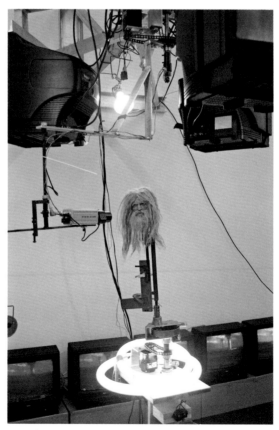

Jon Kessler, *Party Crasher*, 2004 (detail). 112 x 84 x 55 inches

watch the low-tech images we see their madcap production; it is a production so close to destruction that the two cannot be easily distinguished. So, too, just as his mechanisms are not stable, our position is not secure: sometimes we are seen as we see, caught on the monitors as we scan them, and no two viewers witness the same scene. Machine and image attempt "to complete each other," Kessler comments, but this is impossible, and so "a puncture" is produced between representation and referent; it is this puncture that allows us to see through the setups and, in principle, to see though others in the world. Through his little counter-spectacles, then, Kessler suggests that the greater spectacle of American power is in trouble, that its wizards cannot maintain its theater of illusions forever, and that wondrous new technologies are always haunted by awful new disasters.

Like Gober, Kessler calls up different precedents, such as Jean Tinguely and his auto-destructive contraptions, Robert Rauschenberg and his rambunctious combinations of machines and media, and Claes Oldenburg and his regressive theater of homemade products and signs. Kessler also updates the Surrealist juxtaposition of found images and objects, and sometimes here too this results in a "convulsive beauty" in which desire and death are revealed as bound up with one another. More specifically, Kessler alludes to Alberto Giacometti, who in his own *Palace at 4 A.M.* (1932), with its spectral figures caged in a skeletal house, conjures up an obscure drama of Oedipal subject-formation. In his *Palace*, however, with its action figures caught up in spectacular disasters, Kessler reflects on how we are formed as subjects today, that is, how we are inscribed in new regimes of global entertainment and imperial politics in ways that radically reformulate the old familial dramas and psychological interiorities.

In this respect, Kessler is driven by a critical paranoia (another Surrealist theme), as are some of the figures he calls to mind here— theorists like Paul Virilio, filmmakers like David Cronenberg, and authors like Thomas Pynchon, J. G. Ballard, and Philip K. Dick. As we saw in Chapter 2, Freud defined the paranoiac as a subject who is desperate to connect the facts, often through conspiracy theories, precisely because they appear so disconnected in the first place: for the paranoiac, the very survival of the world seems to depend on the

coherence that he can project onto it by the sheer force of his inter-pretative will. In a further study, the Freud associate Victor Tausk focused on paranoiacs whose conspiracy theories took the form of control by "influencing machines." Clearly, Kessler plays with the tension between connection and disconnection, and he constructs his own influencing machines in doing so. However, he refuses to be at their mercy; indeed, his machines are do-it-yourself models of how to jam, at least momentarily, the image-flow of machines of power.

These two installations by Robert Gober and Jon Kessler produce different moods: the Gober is cool and enigmatic, as befits his setting (a chapel crossed with a morgue in the aftermath of 9/11), while the Kessler is heated and explicit, as suits his scene (a videogame parlor crossed with a presidential bunker during the war on terror). But the two artists exploit a similar strategy, which is a mimesis of the given—of political kitsch in the former case, of political infotainment in the latter. And this mimesis is heightened, even exacerbated, to the point of mimicry—"mimesis" connotes this kind of mocking through miming as well—which Gober effects through painstaking facsimiles and Kessler through jerry-rigged assemblages. In each instance the idea of the *Gesamtkunstwerk* or total work of art is turned from its initial ideal, a utopian reintegration of the human senses, to a contem-porary actuality, a dystopian confusion of spectacle and death.

Let me offer a third instance of mimetic exacerbation, one that exceeds a single installation. In her performance of the madness of everyday existence under advanced capitalism, Isa Genzken not only presents a broad historical sweep—from postwar reconstruction to the war on terror—but also articulates a grimly dialectical view of that history.

Genzken took postwar American abstraction as her point of depar-ture: her long and sleek *Ellipsoids* (1976–82) and *Hyperbolos* (1979–83), made of lacquered wood, possess an engineered precision that outper-forms any Minimalist object. Later she engaged German precedents too: her nonobjective paintings titled *Basic Research* (1988–91) and *MLR* (the acronym of "More Light Research," 1992) are in direct dialogue with the oddly null abstractions of Gerhard Richter as well as the faux-kitsch patterns of Sigmar Polke; and in the gimcrack models of her *Fuck the Bauhaus (New Buildings for New York)* (2000) and *New Buildings*

Isa Genzken, *Fuck the Bauhaus* #4, 2000. Mixed media. 88¼ x 30¾ x
24 inches. Genzken images © Isa Genzken. Courtesy of the artist and
Galerie Buchholz.

for Berlin (2001–4), she refers, often brutally, to such modernist design-
ers as Herbert Bayer and Mies van der Rohe.

Genzken is as involved with modern media, technology, and
commodity culture as she is with modernist art and architecture.
With *World Receiver* (1982) she presented a multiband radio as an
immaculate readymade in a way that attests to her affinities with Pop
art (Richard Hamilton in particular). However, by the time Genzken
came to her caustic proposals of the 2000s—for mock memorials to
the afflicted powers that brought us the wars in Afghanistan and Iraq
(*Empire/Vampire, Who Kills Death* [2002–3]) as well as for mock
institutions to be sited at Ground Zero in New York (e.g., *Osama*

Isa Genzken, *Osama Fashion Store (Ground Zero)*, 2008. Plastic, fabric,
spray paint, acrylic, paper, fiberboard, casters. 45 x 32 x 32 inches.

Fashion Store [2008])—she had soured on our contemporary version
of modernity almost completely. Indeed, hers is a dialectic that almost
revels in the dystopian underside of utopian dreams, whether
proposed in prewar modernism or in postwar consumerism. Yet, as
with Gober and Kessler, it is a dialectic that glimpses a weird vitality
in the midst of these ruins, that reveals not only the failure of utopia
(which is easy enough to do today) but also the energy in disaster.

 In the world according to Genzken, this dialectic has penetrated
into the very nature of things. Only two years separate her high-tech
radio from her plaster sculpture *Pile of Rubbish* (1984), which is
almost formless, and in her hands substances like concrete and epoxy

Isa Genzken, *Honeycomb*, 1989. Concrete, steel. 81x 26 x 30¾ inches.

appear both perfect and corrupt. As Genzken stacked concrete blocks roughly or bore through them excessively in the 1980s, this essential material of twentieth-century architecture returned to us as failed, scarcely distinct from rubble, as though any reconstruction—whether after the catastrophe of World War II, the fall of the Berlin Wall, or the collapse of the Twin Towers—could only end up as another form of destruction. Despite titles that allude to rooms, pavilions, and galleries, her structures in concrete and epoxy are either too closed or too open to offer any shelter; in this way Genzken reveals structure to be no less degraded than material. In another instance, even as her *New Buildings for Berlin* allude to the visionary skyscrapers that

Isa Genzken, *Bismarckstrasse*, 1994. Epoxy resin, steel. Each part 137¾ x 37¾ x 33¾ inches.

Mies proposed for the German capital after World War I, they also underscore how distant the modernist vision of glass architecture now appears. These colored planes, some in glass, others in silicone, prop each other up in a way that has no tectonic integrity whatsoever: like the modernist value of truth to materials, the modernist faith in rationality of structure dies a definitive death here.

In related works Genzken highlights how reflective glitz has triumphed over modernist transparency in contemporary urbanism; her *Social Facades* (2002), made of strips of reflective metal, mosaic foil, and plastic, are also a riposte to the floating world of mirrored architecture in recent decades. At the same time such pieces express a delight in immersive effects, a delight that extends to the gritty ambience of Berlin

Isa Genzken, *New Buildings for Berlin* (detail), 2004. Epoxy resin, glass,
wood. 86½ x 23½ x 17¾ inches.

club interiors and graffitied city walls evoked in other projects. Genzken
has also produced columns in metal, wood, and mirror named after her
friends; there is one called *Isa* too, so she seems to identify with these
tacky surfaces as well. Obviously, these models are not proper studies
for actual buildings; even less are they models in the sense of ideal struc-
tures—just the opposite in fact. And yet only a true believer could still
be disappointed enough by the shortcomings of the Bauhaus to tell it to
fuck off, and, though her absurdist proposals for Ground Zero are
scathing send-ups of urbanist business as usual, they remain committed
to the enterprise of metropolitan life.[14]

This grim dialectic also governs her view of technology and
media, as Genzken moves from her early enthusiasm for radios and

Isa Genzken, *Social Facade*, 2002. Metal, wood, mirror foil, holograph foil, tape. 23¾ x 31½ inches.

stereos to later work such as *Da Vinci* (2003), which consists of four pairs of airliner windows, the last one splattered with paint in a way that suggests an exploded body: here the dream of flying machines sketched by Leonardo collapses into the nightmare of weaponized jets on 9/11. The same ambivalence is active in her relation to the modernist idea of art as experiment. Her *Basic Research* paintings, in which Genzken squeegeed oil paint across canvas placed flat on her studio floor, evoke demonstrations of indexical mark-making from Surrealist *frottage* to process art; and her *MLR* paintings, in which she stenciled images of designer lamps and other abstract forms with spray paint or lacquer on canvas or fiberboard, allude to the experiments with light by László Moholy-Nagy and his Bauhaus colleagues. Yet her versions of these practices

Isa Genzken, *MLR*, 1992. Spray paint on canvas. 48 x 31¼ inches.

are intentionally flat, almost rote, without the access to the uncon-
scious sought by the Surrealists or the faith in technology sustained
by the Bauhauslers; in short, Genzken parodies the idea of art as
experiment even as she performs it. Nevertheless, in yet another
dialectical twist, her use of materials and techniques is innovative in
its very oddity.

Modernist art and architecture are not the only ruins in Genzken;
the contemporary capitalist subject is also in deep trouble. Her own

Isa Genzken, *My Brain*, 1984. Plaster, metal, paint. 9½ x 8 x 7 inches.

image appears often in her art and its literature, sometimes via photographs by her friend Wolfgang Tillmans, and, though Genzken once worked as a fashion model, this staging is the opposite of vain; instead she documents how time not only ages the body but often ravages the soul. *Self-Portrait* (1983), now destroyed, was a misshapen head in clay that imagined the artist as an Elephant Woman, and *My Brain* (1984) is another near-*informe* mound of plaster with a wispy wire stuck on its top like a dead antenna. *X-Rays* (1989–91), in which Genzken exposed her own skull as she laughed and drank wine, fall into this same line of black humor;

Isa Genzken, *X-Ray*, 1991. Gelatin silver print. 39½ x 31½ inches.

here again, she inverts the techno-optimism of an artist like Moholy even as she also invokes any number of German death-heads from Dürer to Dada and beyond. These stark images were soon followed by *Bonnet I (Woman)* and *Bonnet II (Man)* (1994), produced the year of her divorce from Richter (they were married in 1982). Made of fabric hardened with epoxy, these lurid helmets, which appear almost viscous, are stuck, like chopped-off heads, atop steel poles, and they rotate slowly toward and away from each other: a portrait of man and wife as coupled Medusas whose gazes bring mutual petrification.

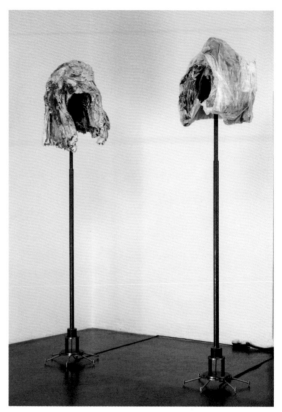

Isa Genzken, *Bonnet I (Woman)* and *Bonnett II (Man)*, 1994. Epoxy resin, fabric, steel, motors. 104¾ and 107 inches high.

The pièce de résistance in this portraiture of the ruined self is *Spielautomat* (1999–2000), an actual slot machine covered with photographs of Genzken, friends, strangers, and celebrities mixed with urban scenes of streets and facades. Ever since Walter Benjamin speculated on the herky-jerky behavior of Baudelaire in mid-nineteenth-century Paris, we have understood the modern subject to be one that must parry the shocks of the metropolitan world in order to survive, but the trope of the self as a slot machine, in which all play appears automated (including aesthetic *Spiel*) and all chance seems scripted (beyond any "canning" imagined by Duchamp), is

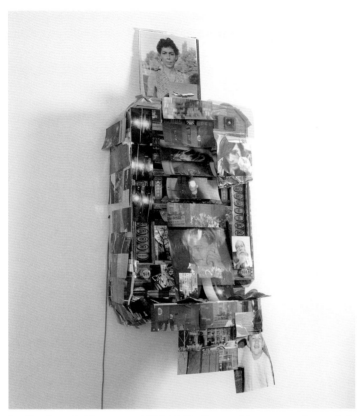

Isa Genzken, *Spielautomat*, 1999–2000. Slot machine, paper, photos, foil, tape. 63 x 25½ x 19¾ inches.

hard to accept, even as today we must also come to terms with our status as digital "dividuals" subject to algorithmic determination, whose data the National Security Administration can access in ways that we never can.[15] In her array of snapshots Genzken places another old friend, the artist Lawrence Weiner, next to the celebrity Leonardo DiCaprio as though they were separated at birth: effaced here is any boundary between private and public or inside and outside, the very distinction once thought to be the precondition of a secure self. According to Freud, the ego is a body image in the first instance, a schema that Lacan developed in architectural terms in

his famous "Mirror Stage" essay (where he refers to the "I" as "a fortress or a stadium"); with Genzken, however, this ego architecture is broken down.[16] Yet once more she provides a dialectical fillip, for in the end her work valorizes a fragmented ego over a fortified one, which often turns aggressive in its very armoring (in *Écrits* Lacan paired his "Mirror Stage" paper with one titled "Aggressivity in Psychoanalysis"). In this way Genzken suggests a critique of the subject that differs from "the death of author" performed by poststructuralist theorists and postmodernist artists alike, even as it is akin to the dismantling of the self staged by her contemporaries Martin Kippenberger and Mike Kelley.

By the time of her *Fuck the Bauhaus* models, in which commodity junkspace overwhelms all design schemes, Genzken comes to rely on the readymade, so Duchamp appears to be her primary resource; yet, especially in her work of the last decade or so, the commodity and the readymade are ruined as well.[17] The *Merz* collages of Kurt Schwitters come next to mind, and with its associations of commerce (the term

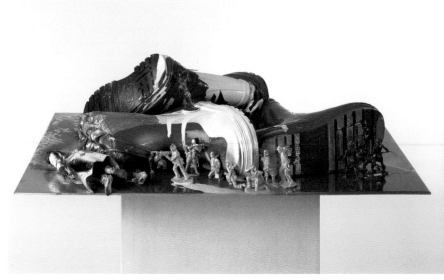

Isa Genzken, *Empire/Vampire, Who Kills Death*, 2002–3 (detail).
Mixed media. 62 x 23½ x 19 inches.

derived from the word *Commerzial*), pain (*Schmerz*), and shit (*merde*), the neologism *Merz* does suit the later Genzken well; postwar bricoleurs of urban trash, both American and German, such as Rauschenberg, Ed Kienholz, and Dieter Roth, are also recalled. In the end, however, the artistic lineage that Genzken reanimates is that of Berlin and Zürich Dada. If these Dadaists exaggerated the subjective effects of both military collapse and political crisis, both mechanization and commodification, Genzken pushes the distracted-compulsive behavior of the contemporary city-dweller of consumerist empire to the edge of breakdown. "The Dadaist suffers . . . from the dissonances [of his age] to the point of self-disintegration," Hugo Ball wrote in *Flight Out of Time*, his great diary of Zürich Dada, and Genzken enacts this sacrificial kind of artistic passion too.[18] In this way her work stands as an effective diagnosis of our times, the beer belly of post-1989 Germany and post-9/11 America cut and probed with a distinctive kitchen knife of her own.

A hundred years ago, in the midst of World War I, the Zürich Dadaists developed the strategy of mimetic exacerbation at issue here: they took the corrupt language of the European powers around them and played it back as a caustic nonsense. "The ideals of culture and of art as a program for a variety show—that is our kind of *Candide* against the times," Ball wrote in March 1916 about the raucous events staged at the Cabaret Voltaire, the main venue of Zürich Dada, and in June of that year he went on to describe this Dada not only as a "requiem mass," a term that suits the Gober chapel morgue, but also as a "buffoonery," a term that fits the Kessler palace ruin. "What we call Dada," Ball asserted then, "is a farce of nothingness in which all higher questions are involved; a gladiator's gesture, a play with shabby leftovers, the death warrant of posturing morality and abundance." This account can be transposed, almost word for word, to Genzken, who often combines both requiem and buffoonery as well.

A key persona of Dada was the mime, and a key strategy of this mime, especially in Berlin and Zürich, was mimetic adaptation to the traumatic conditions around him, whereby the Dadaist assumed these conditions—in particular the armoring of the military body, the

fragmenting of the industrial worker, and the commodifying of the capitalist subject—and inflated them through hyperbole or "hypertrophy" (a term sometimes used by Cologne Dadaist Max Ernst, it means the enlargement of an organ due to excessive nutrition).[19] Such hypertrophic buffoonery is a critical mode of parody that Dada made its own; this is the "farce of nothingness," the "play with shabby leftovers," that Ball had in mind. And yet, even though his world is a chaos of fragments, the Dadaist still aims for a grasp on the whole; "he is still so convinced of the unity of all beings, of the totality of all things," Ball argued, "that he suffers from the dissonances to the point of self-disintegration."[20] This tension between fragment and totality was a crucial one for Zürich Dada, but amidst "the dissonances" it was very difficult to maintain, and for figures like Ball "self-disintegration" had its own paradoxical attractions. So it does again for recent practitioners of mimetic exacerbation; this is the risk of an excessive identification with the corrupt conditions of a symbolic order. Nevertheless, if maintained as a strategy, with a degree of distance created not through withdrawal but through excess, mimetic exacerbation can also expose this order as failed, or at least as fragile. Such was the politics of Dada then, and such is the politics of its legatees today.

Often in *Flight Out of Time* Ball alludes to a tactic of "exaggeration," which he describes not as nihilistic but as immunological: if the Dadaist "suffers from the dissonances to the point of self-disintegration," he does so in order to "fight against the agony and the death throes of this age."[21] His model is not the absolute anarchist but "the perfect psychologist [who] has the power to shock or soothe with one and the same topic"; as "the organ of the outlandish," the Dadaist also "threatens and soothes at the same time," Ball adds. "The threat produces a defense."[22] Here his immunological language takes an apotropaic turn, and his diary becomes peppered with Medusan metaphors. In March 1916, after Richard Huelsenbeck first drummed out his primitivistic poems, Ball writes, "The Gorgon's head of a boundless terror smiles out of the fantastic destruction."[23] However, to call mimetic adaptation immunological or apotropaic is not to say that it is sublimatory: Medusa's gaze is not transformed into Athena's shield; the Dadaist answers "fear, terror, and agony" with more of

the same. For Ball this heady mix is best captured in the unruly masks made by Marcel Janco for the Cabaret soirees; here "the horror of our time, the paralyzing background of events, is made visible."[24] In effect, this is the Dadaist as shaman, a figure with forerunners of its own. Dada is "a synthesis of the romantic, dandyistic, and demonic theories of the nineteenth century," Ball argued. "The great isolated minds of the last epoch have a tendency to persecution, epilepsy, and paralysis. They are obsessed, rejected, and maniacal, all for the sake of their work. They turn to the public as if it should interest itself in their sickness; they give it the material for assessing their condition."[25] Ball saw Nietzsche, the subject of his 1910 dissertation at the University of Munich, as the great precedent of this mimetic performance. For Benjamin the exemplar was Baudelaire, who had the "physiognomy of a mime" and possessed an "empathy with inorganic things."[26] His colleague Adorno turned this particular intuition into a general thesis: "Art is modern art through mimesis of the hardened and alienated," he wrote in *Aesthetic Theory* (1970). "Baudelaire neither railed against nor portrayed reification; he protested against it in the experience of its archetypes."[27] Both Adorno and Benjamin also read this "dandyistic and demonic" genealogy through the optic of Dada (Benjamin came to know Ball in Bern in early 1919). For example, in *Philosophy of Modern Music* (1948) Adorno remarked of Stravinsky: "Musical infantilism belongs to a movement which designed schizophrenic models everywhere as a mimetic defense against the insanity of war; around 1918, Stravinsky was attacked as a Dadaist."[28] And in a scattered note on "Negative Expressionism," Benjamin had this to say about the Russian Eccentrics, a troupe of avant-garde actors who liked to mimic circus performers: "Clown and natural peoples—sublation of inner impulses and of the body center . . . Dislocation of shame. Expression of true feeling: of despair, displacement. Consequent discovery of deep expressive capacity: the man remains seated as the chair on which he sits is pulled out from under him . . . Connection to Picabia."[29] The final aside ties these performers directly to Dada.

For Benjamin the ultimate purpose of mimetic adaptation was to remain seated after the chair is pulled out, "to survive civilization if need be."[30] Such was the ultimate goal of the Dada mime as well, and

finally it is why Dadaists like Ball and Ernst practiced the buffoonery of "the bashed ego."[31] More desperate than the cynical reason of Duchamp and his descendants, the bashed ego of Ball and his followers resists in the "form of unresisting accommodation."[32] For many critics this is the political limitation of this Dadaist genealogy: it advances a critique that flaunts its own futility, a defense that knows the damage is already done. After Ball designated the Dadaist "as the organ of the outlandish," he added: "But since it turns out to be harmless, the spectator begins to laugh at himself about his fear." Yet this catharsis is not a purging; it is a sickening, and it only compounds the hopelessness; paradoxically, however, it is this very hopelessness that gives the bashed ego its critical edge, its unaccommodated negativity. "The farce of these times, reflected in our nerves," Ball wrote in February 1917, "has reached a degree of infantilism and godlessness that cannot be expressed in words."[33]

This is Dada in extremis. "Everyone has become mediumistic," Ball added in April of that year, "from fear, from terror, from agony, or because there are no laws anymore—who knows?"[34] What if the principal predicament were not an oppressive presence of law but, as Ball suggests here, an apparent absence of the same, that is, a state of emergency or even of exception? (I mean the term in the technical sense devised during this period by the controversial German legal theorist Carl Schmitt, with whom Ball was in close dialogue in his post-Dada years as he revised his diary for publication.)[35] One can obey the law, as most of us do, or one can violate it, as some avant-gardes purported to do, but what does one do if "there are no laws anymore"? This is the dilemma that Dada faced: how to create, how to exist, in a state of emergency in which the rule of law is suspended, as it was in many European nations during and after World War I, and as it was, for all intents and purposes, in the United States after 9/11?

Typically we understand the historical avant-garde to be driven by two motives only: the transgression of a given order or the legislation of a new one. Yet if "there are no laws anymore"—and, again, this condition was and is far more common than we acknowledge—how is the avant-garde to be defined? Not heroic, this avant-garde will not pretend that it can break absolutely with the old order or found a

new one; rather, it will seek to trace fractures that already exist within the given order, to pressure them further, to activate them somehow. Neither *avant* nor rear, this *garde* will assume a position of immanent critique, and often it will adopt a posture of mimetic exacerbation in doing so. If any avant-garde is relevant to our time, it is this one.[36]

Over the past two decades, during another period of intermittent emergency, mimetic exacerbation became a pervasive strategy in art, as is evident in the work of a wide range of practitioners, including Jeremy Deller, Cyprien Gaillard, Rachel Harrison, Thomas Hirschhorn, Cameron Jamie, Mike Kelley, Paul McCarthy, Jason Rhoades, Ryan Trecartin, Kara Walker, Mark Wallinger, and many more.[37] Most of these artists incline to sculptural and spatial modes, which they often reformat according to the newfangled technologies of advertising, media, and Internet display. For most, too, there is scant public sphere outside this "capitalist garbage bucket" and scarce object-relations beyond its junkspace, and so they work with the materials of consumption and infotainment given to them.[38] As the modernist types of the sculptural object—above all, the ready-made and the assemblage—were conceived for a different stage of capitalist development, they often appear in this contemporary work not merely as outmoded but almost as pathetic, either hypertrophied or ruined or both (evident with Genzken, this is emphatic with Rachel Harrison).

Mimetic exacerbation is not without its problems. It can be mistaken as an affirmation, even a celebration, of the capitalist garbage bucket; in fact "celebration" is the position advanced by Jeff Koons, with whom the negativity of Duchampian Dada, already dampened with Pop, is all but extinguished. ("I have always tried to create work which does not alienate any part of my audience," Koons avers.)[39] Conversely, the mimesis of the hardened might compound the alienation that it means to volatilize, with the difference between acting-out and acting-on thereby lost; this danger, already potential with Pop, became actual with an artist like Takashi Murakami. So, too, mimetic exacerbation might simply collapse into capitalist nihilism. Deep in the Depression of the 1930s, with an eye to the embittered realisms of the previous decade, Benjamin remarked: "The

incorporation of a nihilism into its hegemonic apparatus was reserved for the bourgeoisie of the twentieth century."[40] Sometimes indulged by Pop, this nihilism is updated by artists like Damien Hirst and Maurizio Cattelan, for whom the point is less "to survive civilization" than to exult in its degradation. And yet, despite these dangers and others noted above (a wallowing in morbid symptoms, a strange attraction to self-destruction, and so on), there remains a critical force in this "organ of the outlandish."

Thomas Hirschhorn with *Emergency Library* (detail), 2003. One of 37 enlarged
book covers (originally designed by John Heartfield). Hirschhorn images ©
Thomas Hirschhorn. Courtesy of the artist and Barbara Gladstone Gallery.

PRECARIOUS

Thomas Hirschhorn builds not from the good old days but from the bad new ones, as Brecht urged us all to do.[1] This is so because Hirschhorn aims to confront the present, which, in his idiom, is also to "agree" with it. This is hardly to say that he approves of it; he agrees with the present only in the sense that he finds most of his strategies and situations in "the capitalist garbage bucket" that is our shared world.[2] This way of working follows an important line on the Left that insists on the resources, cultural as well as political, that lie dormant in the "general intellect" of everyday people, people that, to different degrees, face a state of emergency today.[3] Here I want to indicate some of the concepts Hirschhorn has developed to address this condition, concepts that have application well beyond his practice: the precarious, the *bête*, expenditure, and emergency.

Although Hirschhorn has long used the term *précaire*, the full significance of the precarious was not always apparent to him. Initially the term denoted the insecure status and limited duration of his pieces, some of which, such as *Abandoned Works* and *Someone Takes Care of My Work* (both 1992), consisting simply of scrap wood, cardboard, and the like, were left on the street to be picked up by others.

Thomas Hirschhorn, *Someone Takes Care of My Work*, 1992. Mixed media.

For a while, Hirschhorn merely distinguished the precarious from the ephemeral, which, as an attribute of materials alone, did not interest him so much.[4] (In any case, his is not a critique of the artwork as a fixed thing or even as a commodity; moreover, as we will see, he insists on such values as aesthetic autonomy and artistic universality, which he defines in his own ways.) Soon, though, the precarious came to figure less as a characteristic of his art than as a predicament of the people Hirschhorn wanted to address with it, with ramifications that are both ethical and political.

The French word *précaire* indicates a socioeconomic insecurity that is not as evident in the English term *precarious*; indeed, *précarité* is used to describe the condition of a vast number of laborers in neoliberal capitalism for whom employment (let alone health care, insurance, or pension) is anything but guaranteed. This "precariat" is seen as a product of the post-Fordist economy, though, historically, precarity might be more the rule and the Fordist promise of relative job security and union protection more the exception.[5] It is a tricky category. What might be lost in a discursive shift from

Thomas Hirschhorn, *Musée Précaire Albinet*, 2004. Mixed media. Courtesy
of Les Laboratoires d'Aubervilliers.

proletariat to *precariat*? Might the term normalize a specific condi-
tion, a "society of risk," that is subject to critical challenge and
political change?[6] Can the precariat be freed from its victim status
and developed as a social movement? At least one thing is certain: it
is not a unified class. As the theorist Gerald Raunig notes, there are
"smooth forms of precarization" for "digital bohemians" and
"*intellos précaires*" on the one hand, and "rigidly repressive forms
of labor discipline" for migrants and *sans papiers* on the other.[7] This
point is pertinent, for Hirschhorn has sited some of his signal projects
along the interface between such communities. This is true not only
of his *Musée Précaire Albinet* (2004), located in the Aubervilliers
banlieue northeast of Paris, but also, as we saw in Chapter 2, of his
four "monuments," the makeshift structures he dedicated to the
philosophers most dear to him—the Spinoza monument (1999) in
the red-light district of Amsterdam, the Deleuze (2000) in a mostly
North African quarter of Avignon, the Bataille (2002) in a largely
Turkish neighborhood in Kassel, and the Gramsci (2013) in a

Thomas Hirschhorn, *Gramsci Monument*, 2013. Mixed media. 10 x 18 inches.
Courtesy of Dia Art Foundation.

primarily African-American and Latino complex in the Bronx. "Is there a way to cross from our stable, secure and safe space," Hirschhorn asks, "in order to join the space of the precarious? Is it possible, by voluntarily crossing the border of this protected space, to establish new values, real values, the values of the precarious—uncertainty, instability, and self-authorization?"[8]

What does a practice of "the precarious as a real form" entail? "The truth can only be touched in art with headlessness," Hirschhorn asserts, in "hazardous, contradictory, and hidden encounters."[9] This suggests a first principle of his practice, a sharing in the actual conditions lived by a precariat in a particular situation, and to this end Hirschhorn often takes up the position of a quasi-squatter in the communities in which he works. "In order to reach this moment I have to be present and I have to be awake," he continues. "I have to *stand up*, I have to face the world, the reality, the time and I have to risk myself. That is the beauty in precariousness."[10] Alert to the

Deleuzean caveat about "the indignity of speaking for others," Hirschhorn does not stand in place of the precariat; rather, he insists, "I want to engage [in] dialogue with the other without neutralizing him."[11] In fact, Hirschhorn does not always seek solidarity with this precariat, for such solidarity might only come of a forced union of very different parties. Unlike some artists involved in "relational aesthetics," who often imagine a benign community, he acknowledges that his activity might result in antagonism as well as in fellowship, and to mitigate this effect he sticks to a principle of "Presence and Production," which names his commitment to be present on the site where he produces his work. In this way Hirschhorn updates the argument in "Author as Producer" (1934), in which Walter Benjamin finds the political use-value of an artwork less in its attitude to social causes than in its position within a mode of production.

The *Oxford English Dictionary* informs us that *precarious* derives "from the Latin *precarius*, obtained by entreaty, depending on the favor of another, hence uncertain, precarious, from *precem*, prayer." This definition underscores that this state of insecurity is a constructed one, engineered by a regime of power that the precariat depends on for favor and that it can only petition for help. This means that to act out the precarious, as Hirschhorn often does, is not only to evoke the perilous aspect of this condition, but also to intimate how and why its privations are produced, and so to implicate the authority that imposes this "revocable tolerance."[12] The note of entreaty lodged in the word is strong in many Hirschhorn projects, where it often carries the force of accusation as well.

Here the political dimension of the precarious shades into the ethical. "To give a form to the precarious," Hirschhorn comments, is to attest to "the fragility of life," awareness of which "compels me to be awakened, to be present, to be attentive, to be open; it compels me to be active."[13] In "Precarious Life" (2004), her brief essay on Emmanuel Levinas, Judith Butler writes in a similar vein: "In some way we come to exist in the moment of being addressed, and something about our existence proves precarious when that address fails." Here Butler explores the notion of "the face," which Levinas posed as the very image of "the extreme precariousness of the other." "To respond to

the face, to understand its meaning," Butler argues, "means to be awake to what is precarious in another life or, rather, the precariousness of life itself."[14] Hirschhorn attempts "to respond to the face," to meet its gaze, in his work.

In a 2003 conversation with Hirschhorn, Benjamin Buchloh begins with "a typical art historian's question": "Who was more important for you, Andy Warhol or Joseph Beuys?" Refusing this either-or, Hirschhorn suggests that he has drawn on them equally.[15] "Every man is an artist," Beuys liked to say, and just as Hirschhorn affirms this vision of commonality, he does the same with the version offered by Warhol, whose painting *129 Die* (1962) struck Hirschhorn strongly when he first saw it in 1978 (he was twenty-one at the time): "I felt included, immediately, included in the work of the artist, included in art."[16] More recently, the importance of "a nonexclusive public" was underscored for Hirschhorn by Jacques Rancière, whose *The Ignorant Schoolmaster* (1991) proclaims "the equal intelligence of human beings."[17] One might sum up these commitments with an anecdote about Brecht, who is reported to have kept a little wood donkey next to his typewriter with a sign around its neck that read "Even I must understand it."

Hirschhorn anticipated some aspects of the precarious in a book of crude collages titled *Les plaintifs, les bêtes, les politiques* (1995). These works were "directly inspired by the placards I saw in the street and in the metro," he tells us, "cardboard signs made by people in existential need, signs that appear in a form that is economic, effective, beautiful . . . They are beautiful because they combine the language of engagement with that of sincerity. The result is pure."[18] His own collages query a world that can abide, with apparent indifference, the most blatant contradictions. One work shows a photograph of a youth wearing a peace symbol while cradling a rifle; in the margin Hirschhorn has scrawled arrows to both objects, exclaiming in capital letters, "I really don't understand!" Another collage reproduces a Soviet poster, designed by the Constructivist Gustav Klucis, of a colossal Stalin looming over an industrial plant, beside which Hirschhorn has scratched in pen: "Help me!! I find this poster beautiful, but I know what Stalin did. What to do?"

Thomas Hirschhorn, *Les plaintifs, les bêtes, les politiques* (detail), 1995.
Artist book. Courtesy of Centre Genevois de Gravure Contemporaine.

As noted above, "the plaintive" is one register of the precarious,
but just as often Hirschhorn speaks in the voice of the *bête*—*bête* as
in silly, even stupid. "Help me [understand]!" is a recurrent cry of
Les plaintifs, les bêtes, les politiques, and the sentiment is not fake:
the collages, Hirschhorn reports, "were born of an existential need
on my part too. I need to comprehend."[19] Some of his favorite terms
might clarify what is involved here. One placard quotes the writer
Robert Walser (to whom Hirschhorn dedicated one of his kiosks):
"When the weak take themselves for the strong." This is not a
Christian prophecy of "The meek shall inherit the earth," much less
a Nietzschean critique of such morality. Rather, in this "'weak' posi-
tion" Hirschhorn finds "an explosive force, a kind of resistance"; it is
from beneath, he reminds us, that subversion comes.[20] If the weak is
one aspect of the *bête,* another is "the headless," a notion that
Hirschhorn adapts from Bataille, who investigated the figure of the

acéphale in the mid-1930s. Often Hirschhorn aims for work that "escapes control, even the control of the one who made it," for he finds a "resistant character" in this headlessness too, which he describes as a position "completely submerged but still unresigned, unreconciled, and (of course) uncynical."[21]

The headless in turn calls up a third avatar of the *bête* in Hirschhorn: the fan. "The fan can seem *kopflos* [headless]," he writes, "but at the same time he can resist because he's committed . . . It's a commitment that doesn't require justification."[22] In various pieces Hirschhorn has adopted not only the tokens of a fan (such as team pennants and scarves) but also the devotion (he is a supporter of Bataille, he says, just as he is a supporter of his Paris Saint-Germain football club). In effect, Hirschhorn seeks to redirect the passionate investment of the fan in a *détournement* of cultural value, as in his altars dedicated to lost and marginal artists and writers: Why not Otto Freundlich and Ingeborg Bachmann as an object of devotion, he asks, rather than Michael Jackson and Princess Diana? As noted in Chapter 2, this is a utopian gesture, but it holds a critical charge, one not unlike the old Marxist insistence, associated with Ernst Bloch, that the Left must not concede the force of popular passions to the Right, even (or especially) when those passions are archaic or atavistic (like "Blood and Soil" in the Nazi period of Bloch, or "God and Guns" in our own Tea Party present). If we live in a culture of affect today, Hirschhorn implies, then we must use its means too.[23]

For Hirschhorn the *bête* is also a mode of seeing and reading. One way not to look away, he suggests, is to "look dumb," that is, to allow that we are often "dumbstruck" by the outrageous events of the world, such as the mass murder of innocent citizens during the Iraq War, gruesome images of which Hirschhorn presents in his *Ur-Collages* (2008). In this respect, looking dumb is a form of witnessing that has both ethical and political force (Hirschhorn speaks of his collages as "evidence").[24] Also implied here is a further aspect of the *bête*, which I will call, after Eric Santner, "the creaturely." For Santner the creaturely is provoked by "exposure to a traumatic dimension of political power"; at such moments a creaturely cringe is "called into being, *ex-cited*, by exposure to the

Thomas Hirschhorn, *Ur-Collage (A4)*, 2008. Collage.

peculiar 'creativity' associated with this threshold of law and nonlaw." The creaturely can be obscene (think of Caliban in *The Tempest*), yet it can also point to cracks in the symbolic order at large, "fissures or caesuras in the space of meaning," which might become places of purchase where power can be resisted or at least withstood and perhaps reimagined.[25] From *Les plaintifs, les bêtes, les politiques* to *Ur-Collages*, Hirschhorn often looks for such creaturely openings. (As suggested in Chapter 3, the same is true of one line of the historical avant-garde that is often overlooked.)

Finally, the *bête* is also the simple, which Hirschhorn values; "simplicity is a founding," he says in a characteristic turn of phrase, at once odd and apt, that suggests how the simple is both a found thing and a foundational support for him. This aspect of the *bête* returns us not only to the common world of everyday words and images differently tapped by Brecht, Beuys, and Warhol, but also to the resources, creative as well as critical, to be discovered in "the general intellect" of everyday people.[26] Gramsci (to whom, again, Hirschhorn dedicated his fourth monument) once defined "common sense" as "the folklore of philosophy," that is, as a reserve not only of superstition to be exposed but also of truth to be deployed.[27] Sartre wrote about "the commonplace" in a similar way: "This fine word

has several meanings," the philosopher remarked; "it refers, doubt-less, to the most hackneyed of thoughts, but these thoughts had become the meeting-place of the community. Everyone finds himself in them and finds the others too. The commonplace is everyone's and it belongs to me; it belongs in me to everyone and it is the presence of everyone in me."[28] It is in the interest of this "commonism" (as Warhol once called Pop), not out of cynicism, that Warhol turned to Campbell's soup and Coca-Cola as subject matter (the Queen drinks the same Coke, he liked to say, as the bum on the street). It is in this interest, too, that Hirschhorn turns to everyday materials like card-board and duct tape and common techniques like downloaded photos and rough-and-ready collages. It is part of his search for a non-exclusive public, a public that persists after the demise of the bourgeois public sphere.

"Energy yes, quality no," Hirschhorn proclaims. It is a motto that speaks to his desire to recharge art, especially public art, and his altars, kiosks, monuments, and festivals do stage a passionate kind of public pedagogy. For Hirschhorn as for Bataille, any economy is plagued not only by scarcity but also by surplus. "Energy," Bataille writes in *La part maudite* (1949), a key text for Hirschhorn, "must necessarily be lost without profit; it must be spent, willingly or not, gloriously or catastrophically"; it is "the accursed share" that must be expended.[29] Hirschhorn agrees: "I think more is always more. And less is always less," he asserts in an early polemic against the modernist motto of Mies van der Rohe ("less is more"). "More is more, as an arithmetical fact, and as a political fact. More is a major-ity. Power is power. Violence is violence. I want to express that idea in my work as well."[30]

The Bataillean notion of expenditure (*dépense*) has guided Hirschhorn in several ways. In the first instance, there is the extrava-gance of his displays, which perform a headless mimesis of the deranged excesses of advanced capitalism, of the overproduction and overconsumption all around us.[31] As we saw in Chapter 3, this strat-egy of mimetic exacerbation runs back, through Claes Oldenburg and other Pop artists to Hugo Ball and other Dadaists. With Hirschhorn it is especially paradoxical: at the simplest level, even as

his standard materials "make you think of poverty," they are also deployed in the most abundant ways.[32] In this manner, as Buchloh has argued, Hirschhorn questions a capitalist order that sacrifices use value at the altar of sign-exchange value. At the same time, Hirschhorn insists enigmatically of his art, "It's about absolute value."[33] This formulation suggests that he aims not only to subject capitalist exchange to critique but also to propose a different exchange altogether, along the lines of the "general economy" of nonproductive expenditure advocated by Bataille.[34] "This motive is very important in my work," Hirschhorn says of the Bataillean account of the potlatch in *La part maudite*. "I want to make a lot, give a lot . . . I want to do that in order to challenge the other people, the viewers, to get equally involved, so that they also have to give."[35]

Bataille based his version of the potlatch on the theory of the gift presented by Marcel Mauss a century ago. A socialist, Mauss defined the gift, implicitly, as the obverse of the commodity. Like the commodity for Marx, the gift for Mauss produces a partial confusion of things and persons, "things which are to some extent parts of persons, and persons and groups that behave in some measure as if they were things." Yet, unlike commodity exchange, gift exchange sets up a "pattern of symmetrical and reciprocal rights," a charged ambivalence between people that binds them together, not an abstract equivalence between products that separates people. "To refuse to give, or to fail to invite, is—like refusing to accept—the equivalent of a declaration of war," Mauss writes; "it is a refusal of friendship and intercourse."[36] Hirschhorn seeks to reanimate subject–object relations along the lines of gift exchange. In fact, he once described a proposal for giant roadside books as "an obscene gift"; it is a rubric that could be used for much of his art.

"Giving, affirming, is about demanding something of the public," Hirschhorn writes of the big book project.[37] "Rather than triggering the participation of the audience," he says of another work, "I want to implicate them . . . This is the exchange I propose."[38] "I am the one, as artist, who has to give first," Hirschhorn comments about a third piece. "Participation can only be a lucky outcome, because I, the artist, have to do the work for the implication of the other."[39] Rather than hope for participation, then, Hirschhorn prepares it by

presence and production and then prompts it through implication. Like all acts of generosity, his projects are charged with ambivalence, mixing as he does "the neighbor" and "the stranger"; yet this mixing is undertaken precisely so that a different kind of microsociety might crystallize, if only temporarily.[40] In the potlatch, prestige accrues to whomever can expend the most, and artists like Beuys and Warhol did acquire symbolic power with their own kinds of potlatch, Beuys with his cult of students and Warhol with his factory of followers. This is less the case with Hirschhorn, who seeks that oxymoronic thing, an egalitarian potlatch ("1 Man = 1 Man" is another of his mottos).[41]

Call it symbolic order or social contract, it is always more tenuous than we believe. Certainly our current version was precarious long before September 11, 2001; already in the 1980s Ronald Reagan and Margaret Thatcher led the neoliberal charge with the battle cry "There is no such thing as society." Yet after 9/11 this precarious condition was both deepened in the Anglo-American world and extended far beyond it. Any list of salient events would include the deception of the Iraq War, the debacle of the occupation of Iraq, Abu Ghraib, Guantánamo Bay, the rendition to torture camps, Hurricane Katrina, the scapegoating of immigrants, the health-care crisis, the financial house of cards, the assault on British society in the name of "Big Society," the attack on American government by those most eager to take it over—and these are mostly restricted to the United States and the United Kingdom. For all the discussion of "failed states" elsewhere, our own came to operate, routinely and destructively, as rogues, and in this capacity they have come to threaten us all.

It is little wonder, then, that the concept of the state of exception, developed by Carl Schmitt in the early 1920s, has returned with such force. For Schmitt, who became a Nazi jurist, the state of exception to the law that founds the law is not a primordial act lost in the mists of time; it recurs whenever a government not simply suspends its judicial code (that is a state of emergency) but actually nullifies it.[42] In fact, as foreseen by Benjamin in "Theses on the Philosophy of History" (1940), his final text before his suicide while in flight from

Nazi Europe, this state threatens to be "not the exception but the rule."[43] More recently, Giorgio Agamben has turned this foreboding into a principle: "The Jews were exterminated not in a mad and giant holocaust," he argues, "but exactly as Hitler has announced, 'as lice,' which is to say, as bare life." Agamben extends this principle to a judgment on contemporary modernity at large: bare life now approaches normative status, he avers, and the camp is the "new biopolitical *nomos* [law] of the planet."[44]

In a well-known formulation, Agamben defines "bare life" as "the life of *homo sacer* (sacred man), who *may be killed and yet not sacrificed*."[45] This man is sacred in the antithetical sense of the word that is mostly lost to us today, that is, he is accursed, at the mercy of all. Indeed, in the Roman social order *homo sacer* was the lowest of the low, yet as such he was also the complement of the highest of the high: "The sovereign is the one with respect to whom all men are potentially *homines sacri*," Agamben writes, "and *homo sacer* is the one with respect to whom all men act as sovereigns."[46] This doubling of bare life and sovereign power intrigues Agamben, just as the doubling of "the beast and the sovereign" intrigued Jacques Derrida in his final seminars.[47] The two terms in both pairs are antipodal: the one base, the other supreme, the one beneath the law, the other above it. Yet the two are also alike in this exceptional exteriority, and often represented as such, in the guise of each other: the prince as wolf, the beast as king (imaged most famously in the Leviathan of Hobbes). For Derrida as for Agamben, these pairs pose a riddle that points to how power is founded in a primordial yoking of violence and law, that is, in the sheer violence of self-authorization.

Faced with a situation in which precarious life seems the norm for those below, and emergency authority the norm for those above, Hirschhorn performs this doubling in his work. On the one hand, he approaches the precarious; on the other, he acts out a state of emergency (in which role he assumes such guises as "lone fighter," "'warrior' with dreams," and so on).[48] And, more and more, precarity and emergency come together in his discourse: "Precariousness is the dynamic, the emergency, the necessity of this work . . ."[49] In 2003, when Hirschhorn assembled thirty-seven books, greatly enlarged, for his *Emergency Library* (2003), it was not for

desert-island reading but as an arsenal of "absolute demands" for here-and-now.[50]

When Hirschhorn cries "Help me!" he speaks to emergency, but he does the same thing when he avows "I love you!" "I selected figures about whom I could really say, 'I love you,'" Hirschhorn says of the dedicatees of his altars, "about whom I really meant it; it was a real commitment."[51] This expression of love is not only about a libidinal investment in obscure artists and authors; it is also a performative contract, made both in and against emergency, with the commitment of a fan "that doesn't require justification." It is an attempt to rescue the likes of Otto Freundlich and Ingeborg Bachmann from oblivion, and to entreat their ghosts to take up arms with him in the present. "The past can be seized only as an image which flashes up at the instant when it can be recognized," Benjamin wrote in his

Thomas Hirschhorn, *Where do I stand? What do I want?*, 2007. Photocopy.

"Theses on the Philosophy of History," "and is never seen again."[52] It is in this urgent "time of the now" that Hirschhorn aims to act.[53]

In such a time, "commitment" and "autonomy" are not in contradiction (as they are often said to be in aesthetic discourse in general), for the autonomy that interests Hirschhorn is not the "self-sufficiency" of art but "the autonomy of courage, the autonomy of assertion, the autonomy to *authorize myself*."[54] Over a century ago Gauguin asked, "Where do we come from? What are we? Where are we going?" In his map of his practice Hirschhorn asks, "Where do I stand? What do I want?"[55] These are questions he means us to ask too.

FIVE

POST-CRITICAL?

Critical theory took a beating during the culture wars of the 1980s and the 1990s, and the situation in the 2000s was only worse. After 9/11 the demand for affirmation was very strong in the United States (for a time it was said, without irony, that irony had to be avoided), and still today there is little space for critique even in such preserves as the university and the museum.[1] Bullied by conservative commentators, many academics no longer stress the importance of critical thinking for an engaged citizenry, and, dependent on corporate sponsors, many curators no longer promote the critical debate once deemed essential to the public reception of difficult art.[2] Moreover, the relative irrelevance of criticism is evident enough in an art world where value is determined by market position above all; today "criticality" is frequently dismissed as rigid, rote, passé, or all of the above. "Theory" fares even worse (if that is possible), serving mostly as idiot reification and scare word. Sometimes this general condition is called "post-critical," and often it is welcomed as a release from constraints that are variously seen as conceptual, historical, and political. Yet the result is less a robust pluralism than a debilitating relativism.[3]

How did we arrive at a point where critique is dismissed? Over the last few decades, most of the charges, at least from the Left, have

concerned the positioning of the critic. First, there was a rejection of judgment, especially of the moral right that seems to be arrogated in any act of critical evaluation. Then, too, there was a refusal of authority, particularly of the political privilege that allows the critic to speak abstractly on behalf of others. Finally, there was a skepticism about distance, about the very possibility of separation from the culture that the critic purports to examine. "Criticism is a matter of correct distancing," Walter Benjamin wrote almost ninety years ago. "It was at home in a world where perspectives and prospects counted and where it was still possible to adopt a standpoint. Now things press too urgently on human society."[4] How much more urgent is that pressing in our age of instantaneous media?

However, not all critique depends on correct distancing. Estrangement à la Brecht is hardly correct in this sense, and there are interventionist models in which critique is explicitly positioned as immanent—through such techniques as mimetic exacerbation, as we saw in Chapter 3, or symbolic *détournement*, as practiced in Situationism, or deconstruction, which finds its critical terms in the very discourse under analysis.[5] As for the charges involving judgment and authority, they boil down to two in the end: that critique is not reflexive enough about its own claims to truth, and that it is often driven by a will to power. Two concerns underlie these objections in turn: that the critic as ideological patron might displace the social group that he means to represent (a caution first raised by Benjamin in "Author as Producer" [1934] and later revised by Michel Foucault, Gayatri Spivak, and others), and that critical theory might be granted a scientific truth (such as Louis Althusser claimed for the Marx of *Capital*) that it cannot attain. Such objections are often valid, yet they are hardly reason enough to throw the baby out with the bathwater.

More recent accusations concerning the primary critiques advanced by poststructuralist theory have operated through guilt by association. Rather than overly confident in its truth claims, the critique of representation was seen to erode our trust in truth as such, and so to promote a moral indifference and a political nihilism. The critique of the subject was also charged with unintended consequences, as its demonstration of the constructed nature of the

subject was said to abet a consumerist relation to identity, which was taken to be little more than a performance of commodified signs. For many skeptics, these two effects came to count as postmodernism pure and simple, which was to be deplored, if not condemned, as a result. Yet the charge of consumerism was often a Leftist caricature that reduced postmodernism to the rote expression of neoliberal capitalism: as neoliberalism deregulated the economy, this argument ran, so postmodernism derealized the culture.[6] And the accusation of nihilism was less pertinent to postmodernism than to the Rightist abuse of some of its received ideas, as when Republicans took up the notion of "the social construction" of science to dispute the fact of global warming.[7]

More pointed objections have come from two philosophers, Bruno Latour and Jacques Rancière, who were trained in the critique that they now question. According to Latour, whose principal field is science studies, the critic assumes a position of enlightened knowledge that allows the critic to demystify the fetishistic belief of others more naïve than he is, that is, to demonstrate how the belief of these others is "a projection of their wishes onto a material entity that does nothing at all by itself."[8] For Latour, the fatal mistake of this critic is not to turn his antifetishistic gaze on his own belief, in particular his own conviction in the powers of demystification (which Latour thus counts as a fetish in its own right), a mistake that renders the critic the most naïve one of all. "This is why," Latour concludes (implicating us all), "you can be at once and without even sensing any contradiction (1) an antifetishist for everything you don't believe in— for the most part religion, popular culture, art, politics, and so on; (2) an unrepentant positivist for all the sciences you believe in—sociology, economics, conspiracy theory, genetics, evolutionary psychology, semiotics, just pick your preferred field of study; and (3) a perfectly healthy sturdy realist for what you really cherish—and of course it might be criticism itself, but also painting, bird-watching, Shakespeare, baboons, proteins, and so on."[9]

For Rancière, whose subjects range from workers movements of the early nineteenth century to contemporary art, critique is also compromised by its arrogant posture of demystification. "In its most general expression," he writes in *Aesthetics and Its Discontents*,

"critical art is a type of art that sets out to build awareness of the mechanisms of domination to turn the spectator into a conscious agent of world transformation."[10] Rancière has several objections to this presumption (which he caricatures here for his own purposes). First, not only is "awareness" not transformative per se, but "the exploited rarely require an explanation of the laws of exploitation." So, too, critical art depends on its own projection of a passive audience that it then claims to activate (this is his primary complaint in *The Emancipated Spectator*).[11] Finally, critical art "asks viewers to discover the signs of capital behind everyday objects and behaviors," yet in doing so it only confirms the "transformation of things into signs" that capitalism performs anyway.[12] Thus, like the critic for Latour, the critical artist for Rancière is trapped in a vicious circle. "If there is a circulation that should be stopped at this point," he remarks, "it's this circulation of stereotypes that critique stereotypes, giant stuffed animals that denounce infantilization, media images that denounce the media, spectacular installations that denounce the spectacle, etc. There is a whole series of forms of critical or activist art that are caught up in this police logic of the equivalence of the power of the market and the power of its denunciation."[13]

Latour and Rancière make important points, but might these two meta-critics be caught up in circular thinking of their own? For his part, Latour updates the inaugural move of critique in Marx and Freud, who were the first to argue that "we have never been modern" in a way that might be ventriloquized as follows: "You moderns think you are enlightened, but in fact you are as fetishistic as any primitives—fetishists not only of the shiny new commodity whose production you fail to understand, but also of any trivial object that you desire inappropriately. In each case you project a value, a power, or a life onto things that they do not intrinsically possess." To this critical turning-of-the-tables performed by Marx and Freud, Latour adds his own reversal: "You antifetishistic critics are fetishists too— fetishists not only of your disciplinary protocols but also of your critical debunkings." To this extent, then, Latour remains within the rhetorical coils of the very critique of fetishism he wishes to cut.[14] And no more than Rancière does he acknowledge that his challenge to this "hermeneutics of suspicion" is a familiar one: undertaken long

ago within critical theory, this questioning was fundamental to its own shift from a search for occluded interests and hidden meanings (the Marxian and Freudian versions of such interpretation, respectively) to a consideration of the structural conditions of possibility of a given discourse (an analysis associated with Foucault) and the superficial significance of signs in a given text (a reading associated with Roland Barthes).

Rancière falls into his own trap in a similar way. He condemns critique for its projection of a passive spectator in need of activation (this is his version of the naïve believer in need of demystification in Latour), yet Rancière assumes such passivity, too, when he calls for an activation that goes beyond "awareness" (again, "the exploited rarely require an explanation").[15] "Aesthetic acts," he argues in *The Politics of Aesthetics*, are "configurations of experience that create new modes of sense perception and induce novel forms of political subjectivity."[16] This is a noble formulation, but it grants an agency to art that it does not at present possess. That art can intervene effectively in this manner is far from clear today; certainly it is no match for image industries and information agencies, both corporate and governmental, that monitor and regulate the sensible with enormous power. At least for the time being, any new "distribution of the sensible" through contemporary art borders on wishful thinking; it might even be a form of faith that calls for demystifiction.

All that said, one understands the fatigue with critique, even the aversion to it, that many express today, for it can feel oppressive in its correctness when not defeatist in its negativity.[17] Against this image of the destructive critic, Latour offers his own benevolent figure:

> The critic is not the one who debunks, but the one who assembles. The critic is not the one who lifts the rugs from under the feet of the naïve believers, but the one who offers the participants arenas in which to gather. The critic is not the one who alternates haphazardly between antifetishism and positivism like the drunk iconoclast drawn by Goya, but the one for whom, if something is constructed, then it means it is fragile and thus in need of great care and caution.[18]

Who could not warm to such an empathetic critic? Yet this ethics of "care and caution" introduces a problem of its own, which is in fact the old problem of fetishism, for here again the constructed thing is treated as a quasi-subject ("in need of great care").[19]

This tendency is also strong in recent schools of thought, sometimes indebted to Latour, such as thing theory and affect discourse, which attempt to move beyond the "iconoclasm" of critical theory as well.[20] Indeed, the proposal to endow some constructed things with some human attributes is programmatic in "the vital materialism" advanced by the political philosopher Jane Bennett.[21] These discourses are important, but it is not clear how relevant they are to contemporary art, since for the most part they emerge from disciplines (e.g., science studies, political theory, anthropology) at a remove from artistic practice.[22] Perhaps more salient are recent texts in art history that show a similar tendency to project the human onto the non-human, texts that ascribe "power" to images, "wants" to pictures, and so on.[23] Yet here again there is a remove to consider, for these texts have developed mostly in medieval and early modern areas that are also distant from contemporary art. Moreover, these fields treat societies whose subject–object relations differed radically from our own, where it was customary to endow certain things with human properties and even divine powers.[24]

However, some art today does imagine the artwork in terms of subjecthood. In recent sculpture, for example, the fetish and the part object have returned as common models for practice, and they explicitly present the artwork as though it were animated by its own desires.[25] The rub here is twofold. First, when the fetish and the part object were introduced into modernist art by Constantin Brancusi, Alberto Giacometti in his Surrealist period, and Marcel Duchamp in his late work, they challenged the normative notion of a Kantian disinterestedness in aesthetic experience. Almost no one holds to that position any longer, certainly not in relation to contemporary art, where, again, the fetish and the part object are anything but exceptional.[26] Second, in capitalist modernity, subject–object relations are overridden by the commodity form, which tends to refashion the image-object as an agent-person in its own terms. Any attempt to animate the artwork in another way must confront the sheer force of

that pervasive spell. (Rancière is quite right that denunciation alone is insufficient.)

Certainly I do not deny the many effects that myriad objects and images have on us; we simply need to be clear about the location of these effects. One agrees absolutely with Latour, Bennett, and others that, now more than ever, no clear line exists between the human and the nonhuman, the cultural and the natural, the constructed and the given, and that we need a language, an ethics, and a politics to address this complex condition. Nevertheless, the apparent liveliness in things should not be confused with the actual liveliness of people, thoroughly imbricated though the two often are in the present, and it would be perverse to conflate the humanization of the world that the young Marx imagined with the denaturing of the environment, the algorithmization of Internet operations, the roboticization of our smart prostheses (from phones to drones), and so on.[27] Hence, again, the continued importance of antifetishistic critique, which is here motivated primarily by a resistance to any operation whereby human constructs (God, the Internet, an artwork) are projected above us and granted an agency of their own, from which position and with which power they are more likely to overbear us than to enlighten us (let alone to delight us).[28]

Again, fetishization involves two operations above all, a misplacing of value or agency, as underscored by Marx in his account of commodity fetishism, and a blocking of perception or knowledge, as emphasized by Freud in his account of sexual fetishism. Both unfold as near-instantaneous relays of recognition and disavowal: "I know exploited laborers produced this commodity, but nevertheless it appears immaculate to me"; "I know my mother lacks a penis, but nevertheless I deny this traumatic absence." Cynical reason, the dismissive knowingness that often obstructs our productive engagement in worldly affairs, also has this structure of "I know but nevertheless." For example: "I know the ideology of 'no taxes' is a boon to the rich and a bust for me, but nevertheless I subscribe to it."[29] As such, cynical reason calls for antifetishistic critique as well.

Of course, such critique is never enough: one must intervene in the given, turn it somehow, and take it somewhere else. But this somewhere else is opened up through critique; without critique alternatives

do not become readily manifest, let alone strongly motivated. Critique will not get far along this path, however, if it remains locked into oppositions that no longer apply, especially oppositions to the fictive and the aesthetic. Here defetishization should not be conflated with demystification, which does target the fictive.[30] Defetishization is not necessarily skeptical of the fictive in this way.[31] The relation of critique to the aesthetic is more complicated. A generation ago some critics (I was one) viewed the aesthetic suspiciously as a realm of resolution, not only in the terms proposed by Kant—as a space where judgments of fact might be reconciled with judgments of value—but also in the manner questioned by poststructuralist theory—as a space where subjectivity might be experienced as more integrated and society as more unified than they in fact are. At this time, too, the dominant account of modernist art, advanced by Clement Greenberg with reference to Kant, also posited the aesthetic as a space of absolutes "beyond ideological violence and confusion."[32] It was in defiance of these two positions that both critical theory and critical art turned "anti-aesthetic." Yet this polemic was situational, and its time is past. Today we are more alert to the dialectical connections between the aesthetic and the anti-aesthetic in twentieth-century art.[33] At the same time we are also more attuned to the critical dimension in aesthetic experience and vice versa, that is, more attuned to the capacity of the aesthetic to resist ideology (e.g., of the sensuous particularity of the artwork not to be utterly subsumed in the ceaseless flow of images and information) as well as to the capacity of criticism to be artful in its own ways (e.g., to be open to alternative modes of engagement that do not oppose aesthetic experience and critical reflection).[34]

Why take up the bedraggled banner of critique now? The reason is simple (and it returns us to the concerns with which I began): criticism is essential to the public sphere, at least as this notion was articulated by Jürgen Habermas in 1962 and developed thereafter.[35] In some ways criticism *is* this sphere in operation. Consider the development of art criticism alone. When the figure of the critic emerged in the Paris Salons of the early eighteenth century, he not only assumed "the point of view of a public visitor," but also created, in

writing about the art on view, a representation of the public—a representation that helped different groups become self-aware as a public.[36] Of course, this sphere was always more hypothetical than actual, and it was problematic in any case: its franchise was largely restricted to the bourgeois class; it was further constrained by gender and race; and when the bourgeoisie was threatened politically, it was quick to sacrifice its social ideals (such as public debate) to its economic interests, as Marx pointed out as early as 1852 in *The Eighteenth Brumaire of Louis Bonaparte*. Its subsequent vicissitudes are also familiar: as capitalism became consumerist in orientation, the public sphere was effectively overwhelmed by the publicity of mass media, not to mention the management of political opinion. As the sociologist Talcott Parsons argued long ago, social integration is not required if system integration is achieved, and with routine surveillance and big data that goal seems all but met.[37]

The dissolution of the public sphere in its original definition is also evident. Much participatory art of the last generation has aimed to compensate for this loss, foregrounding discursivity and sociability above all else. As Pierre Huyghe commented in 2002, "Discussion has become an important moment in the constitution of a project," and in the same year Rirkrit Tiravanija defined his art explicitly as "a place of socialization."[38] The ethical and everyday are also pronounced in such work: art is "a way to explore other possibilities of exchange," Huyghe remarks; it is a model of "living well," Tiravanija adds.[39] Yet one senses that these qualities are highlighted largely because they appear faint elsewhere: it is as though the very idea of community has taken on a utopian tinge.[40] Even Nicolas Bourriaud, the principal advocate of relational aesthetics, has acknowledged the compensatory nature of this participatory impulse: "Through little services rendered," he writes, "the artists fill in the cracks in the social bond." Indeed, Bourriaud seems most accurate when he is most grim: "The society of spectacle is thus followed by the society of extras, where everyone finds the illusion of an interactive democracy in more or less truncated channels of communication."[41]

Today the social bond is as pressured as the public sphere is atrophied, and criteria more robust than discursivity and sociability are required in response. Perhaps the hapless condition of the public

sphere makes the concept on which it depends, citizenship, radical once again (certainly Hannah Arendt has returned as an essential resource). In any case, citizenship is also under enormous strain, and this is so on every front. What counts as citizenship in a world driven by corporate institutions and political agents that have moved beyond the international to the postnational? What does citizenship signify when putative democracies like the United States and the United Kingdom can "discredit" or disqualify it, that is, when it is redefined as "a privilege, not a right"? And what does citizenship mean in the face of the routine mistreatment of vast numbers of undocumented immigrants, occupied peoples, and stateless refugees? Certainly we need new accounts of citizenship, ones that aim to take the full measure of neoliberalism, perhaps along the lines of the citizen of Europe proposed by Habermas or, even more broadly, of the citizen of the Anthropocene suggested by Latour.[42] Perhaps, too, artists and critics can assist, even lead, in this imagining (a little wishful thinking of my own), and in this respect the global range of the contemporary art world might well be a virtue. Certainly they have done so in the past (interventions by Hans Haacke and Allan Sekula, among others, come to mind), and in the near present (one thinks of examples by Yto Barrada, Claire Fontaine, Sharon Hayes, Thomas Hirschhorn, Emily Jacir, Isaac Julien, Hito Steyerl, and again many others). One thing is clear: a post-critical posture is of no use in this project.

Marina Abramović, *Seven Easy Pieces* (detail), 2005, at the Guggenheim Museum; reenactment of *How to Explain Pictures to a Dead Hare*, by Joseph Beuys, 1965. Photo Attilio Maranzano. Courtesy of the Marina Abramović Archives.

IN PRAISE OF ACTUALITY

1. Over the last decade, art museums have restaged many performances and dances, mostly from the 1960s and 1970s. (The 2010 retrospective of Marina Abramović at the Museum of Modern Art is a good example of the first tendency; Judson Dance Theater figures prominently in the second.)[1] Not quite live, not quite dead, these reenactments have introduced a zombie time into these institutions.[2] Sometimes this hybrid temporality, neither present nor past, takes on a gray tonality, not unlike that of the old photographs on which the reenactments are often based, and like these photos the events seem both real and unreal, documentary and fictive. Sometimes, too, the spaces that are proposed to present this undead art are imagined as gray: along with the white cube for painting and sculpture and the black box for projected-image art, "gray boxes" are envisioned to maintain such work in this state of suspended animation.[3]

2. The institutionalization of performance is also evident in the creation of new curatorships and biennials. This can be seen negatively as the recuperation of alternative practices or positively as the recovery of lost events; like independent film, experimental performance and dance have come to the art museum both for

Trisha Brown Dance Company, *Roof Piece Re-Layed* (detail), 2011, at the Museum of Modern Art. Photo © Yi-Chun Wu / The Museum of Modern Art.

audience exposure and out of economic necessity. Yet this does not explain the sudden embrace of live events in institutions otherwise dedicated to inanimate art.[4] During the recent boom in new museums, Rem Koolhaas remarked that, since there is not enough past to go around, its tokens can only rise in value. Today, it seems, there is not enough present to go around: for reasons that are obvious in a hyper-mediated age, it is in great demand too, as is anything that feels like presence.[5] Here the zombie time of reenacted performances complicates matters, for, again, they do not seem quite actual. In a review of *Seven Easy Pieces* (2005), in which Abramović reinterpreted historical performances by Bruce Nauman, Vito Acconci, Valie Export, Gina Pane, and Joseph Beuys (as well as two of her own) at the Guggenheim Museum, Johanna Burton described this condition as one of "sophisticated holograms, both

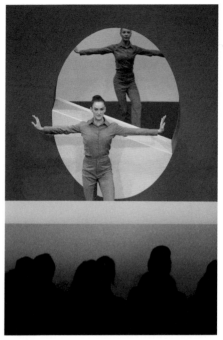

Elad Lassry, *Untitled (Presence)* (detail), 2012, at The Kitchen. © Elad Lassry.
Photo courtesy of the artist, 303 Gallery, and David Kordansky Gallery.

present and past, fact and fiction."[6] What is staged is less a histor-
ical performance than an image of that performance; the
performance appears as a simulation, one destined to produce
more images for circulation in the media (perhaps it is partly
designed to do so). Some artists are aware of this condition, and
have taken it up as a subject, as Elad Lassry did in his *Untitled
(Presence)* staged at The Kitchen in 2012, which underscored the
imagistic dimension of performance.[7]

3. Scholars of performance often resort to the linguistic category of
the performative to underscore what performance might do as
distinct from what it might mean. Yet in the context of the reenact-
ments at issue here, the term no longer signifies as it did in the

speech-act theory where it originated: this performative does not actualize (as a performative utterance is said to do, as in "I pronounce you husband and wife") so much as it virtualizes. It seems to offer the presence we desire, but it is a spectral presence, one that famishes, with the result that as viewers we come to feel a little spectral as well. In the 1960s the audience was almost as constitutive of the performance as the performer was (this was taken to be one of its signal differences from theater); however, in reenactments we are positioned as incidental witnesses to an event that could as readily occur without us.[8] In fact, some reenactments appear to be more interested in the camera than in the audience; new performances often come image-ready as well. As a result, we do not seem to exist in the same space-time as the event.

4. Some institutions have also restaged historical exhibitions, and tellingly one focus has fallen on shows of art that foreground presence and process, such as *Primary Structures* (1966) and *Live in Your*

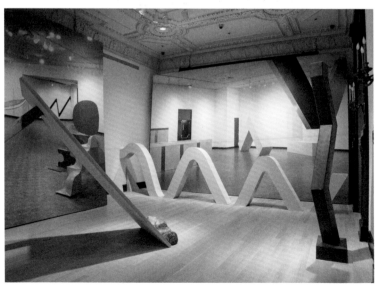

Installation view of *Other Primary Structures* at the Jewish Museum, 2014.
Photo David Heald.

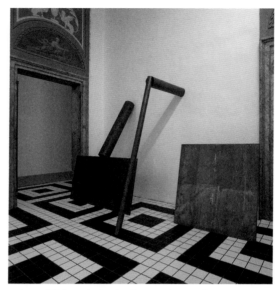

Installation view of *When Attitudes Become Form: Bern 1969/Venice 2013* at
the Prada Foundation, Venice, 2013.

Head: *When Attitudes Become Form* (1969), which were among the
inaugural presentations of Minimalism and Postminimalism, respec-
tively.[9] A perfect reconstruction is impossible, but no such thing is
attempted here: often the original works are represented by enlarged
photos on the wall or forensic outlines on the floor. This treatment
cannot help but derealize the art, and the derealization works on the
viewer as well. Once again we are in a gray zone, and this zone is
hardly the owlish twilight of historical understanding made famous
by Hegel; it might actually get in the way of this coming to terms with
the past. A good counter to these recreations is the reenactment prac-
tice of such artists as Jeremy Deller, Sharon Hayes, Kirsten Forkert,
and Mark Tribe, who also treat political events. "I've always
described it as digging up a corpse and giving it a proper post-
mortem," Deller remarked of *The Battle of Orgreave* (2001), his
filmed restaging of a confrontation between police and miners in
South Yorkshire in 1984, a key moment in Thatcherite neoliberalism.

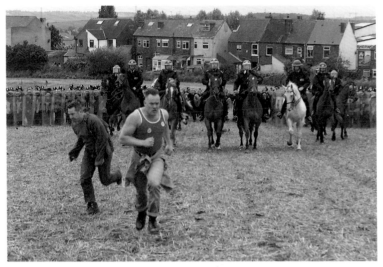

Jeremy Deller, *The Battle of Orgreave* (detail), 2001. © Jeremy Deller.
Courtesy of the artist. Photo Martin Jenkinson.

For Deller, historical reenactment does not lay the past to rest but
puts it into play again; it is a kind of preposterous history—"prepos-
terous" because it conjures both a before (pre) and an after (post) in
a way that aims to open up possibilities for the now.[10]

5. Given these problems, why has the performative returned as an
almost automatic good? One reason, along with its promise of pres-
ence, is that it seems to open up the work to its audience, to expose
its making once and for all. Such transparency was a goal of various
avant-gardes, both prewar and postwar, and nowhere more so than
in process art in the 1960s. (A famous instance is *Verb List*
[1967–8], in which Richard Serra announced his intention "to roll, to
crease, to fold . . ." his given substances of rubber and lead.) Like
performance, process is back with us too; yet, now as then, this
making manifest of materials and actions in the work can render its
purpose more opaque to the viewer, not more transparent, which is
to say that, rather than motivate the work, this giving over to mate-
rials and actions can make it appear arbitrary (why is one substance

selected and not another? why is it treated in this way and not another? and so on). Process can also open up the work to the point of its dispersal, with the result that, if anybody experiences any one thing, nobody experiences the same one thing. Without the possibility of concentrated experience or shared debate, our viewing is likely to be casual and quick, without much aesthetic resonance or discursive consequence. As with performance à la Abramović, process is also easily theatricalized—a common critique of relevant pieces by Matthew Barney, Urs Fischer, and others.

6. So why is the performative so readily embraced? Another reason is that, like process, it is said to activate the viewer, especially so when the two are combined, that is, when a process—an action or a gesture—is performed. The assumption is that to leave a work undone is to prompt the viewer to complete it, and yet this attitude can easily become an excuse not to execute fully. A work that appears unfinished hardly ensures that the viewer will be engaged; indifference is as likely a result, perhaps a more likely one. In any case, such informality tends to discourage sustained attention, both aesthetic and critical: we are likely to pass over the work quickly because its maker seems to have done the same prior to us, or because superficial effect seems to be what was intended in the first place. Two further assumptions are no less dubious. The first is that the viewer is somehow passive to begin with, which need not be the case at all, and the second is that a finished work in the traditional sense cannot activate the viewer as effectively, which is also false. For purposes of activation and attention give me a Piet Mondrian over a George Maciunas any day.[11]

7. Might it be that the critique of authorship as authority has done its job, even done it too well? When Duchamp insisted on the share of the beholder in "the creative act" and Umberto Eco argued for the radicality of "the open work" in their influential essays of 1957–8, and when Foucault questioned "the author function" and Barthes celebrated "the death of the author" in their landmark texts of 1967–8, they did so to challenge the dominance of two positions above all— the formalist idea of the artwork understood as a closed system of significance (this was the central principle of the New Criticism of the

time) and the popular idea of the artist seen as the fount of all mean-
ing (a residue of Romanticism that is lodged deep in most of us).
Those ideas are hardly dominant today; on the contrary, notions of
the "indeterminacy" of the work, as advocated by John Cage in the
late 1950s and early 1960s, and strategies for the participation of the
viewer, as pioneered by such movements as Neo-Concretism and
Fluxus in the same period, are privileged in art practice and art
history alike. Disdained not long ago, they are now prized.[12] That is
a good thing, but it is less so if we become oblivious to what moti-
vated the indeterminate and the participatory in the first instance, or
indeed blind to how these qualities might be valued in art today
precisely because they are devalued elsewhere in society (the indeter-
minate reduced by big data, for example, and the participatory
diminished in democracies overtaken by oligarchies).

8. Participatory art in the past is called up by participatory work in
recent years, including relational aesthetics, which is another legatee
of the Duchampian-Cagean tradition of creative indeterminacy. In
1998 Nicolas Bourriaud defined relational art as "an ensemble of
units to be reactivated by the beholder-manipulator."[13] "The ques-
tion is less 'what?' than 'to whom?,'" Pierre Huyghe added in 2002.
"It becomes a question of address."[14] Yet when is this activation too
great a burden to place on the viewer, and when is this address too
invasive a test for the audience? Ironically, as with process art again,
there is a risk of illegibility here: often the death of the author has
meant not the birth of the reader, as Barthes imagined, so much as
the befuddlement of the viewer. This might serve only to reposition
the artist as both origin and end of the work—the very default that
was to be undone in the first place.[15]

9. Activation of the viewer has become an end, not a means, and not
enough attention is given to the quality of subjectivity and sociality
thus effected. Today museums cannot seem to leave us alone; they
prompt and program us as many of us do our children. As in the
culture at large, communication and connectivity are promoted,
almost enforced, for their own sake. This activation helps to validate
the museum, to overseers and onlookers alike, as relevant, vital, or

simply busy, yet, more than the viewer, it is the museum that the museum seeks to activate. However, this only confirms the negative image that some of its detractors have long had of it: that aesthetic contemplation is boring and historical understanding elitist, that the museum is a mausoleum.[16] Just as the viewer must be deemed passive in order to be activated, so artwork and art museum alike must be deemed lifeless so that they can be reanimated. Central to modern discourse on the art museum, this ideology is basic to art history "as a humanistic discipline," the mission of which, Erwin Panofsky wrote seventy-five years ago, is to "enliven what otherwise would remain dead."[17] Here the proper retort in our time comes from medieval art historian Amy Knight Powell: "Neither institution nor individual can restore life to an object that never had it. The promiscuity of the work of art—its return, reiteration, and perpetuation beyond its original moment—is the surest sign it never lived."[18]

10. Another serious question arises about modes of art that promote participation and process above all else. Sometimes a politics is

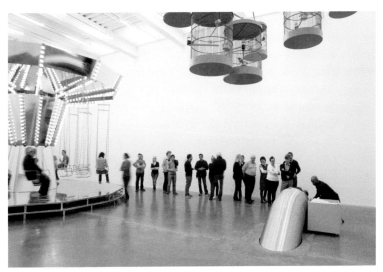

Carsten Höller, *Experience* (detail), at the New Museum, 2011–12. © Carsten Höller. Courtesy of the artist and the New Museum. Photo Benoit Pailley.

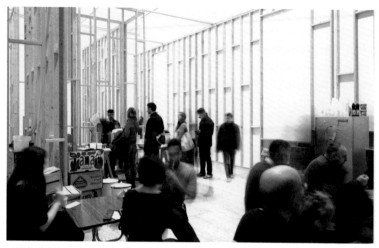

Rirkrit Tiravanija, *untitled 1992/1995 (free/still)*, 1992/1995/2007/2011. ©
The Museum of Modern Art. Courtesy of the artist and Gavin Brown's
Enterprise. Photo Jonathan Muzikar.

ascribed to such practices on the basis of a shaky analogy between an
open artwork and an inclusive society, as though a desultory arrange-
ment of material might evoke a democratic community of people, a
nonhierarchical installation predict an egalitarian society, or a
deskilled artwork prefigure an anybody-can-be-an-artist world. Not
only a complication of authorship, collaboration becomes an antici-
pation of collectivity, and thus again an almost automatic good. Yet
even as a strong advocate of this line of thinking as Hans Ulrich
Obrist has voiced a reservation here. "Collaboration is the answer,"
he has remarked. "But what is the question?"[19] This is to suggest that
collaboration threatens to become autonomous as well as automatic;
collaboration, like activation, is encouraged for its own sake. At the
very least, collaboration, especially in the guise of curatorial practice
taken up as artistic practice and vice versa, can become an alibi for
informal work of the sort questioned here. It can also be a way to
sneak in labor that is both unacknowledged and unpaid.[20]

11. I argued above that, when process opens up the work of art radi-
cally, it sometimes runs the risk of formlessness. For Bataille "the

formless" was an operation pledged to undo any form that had become fixed, in particular fixed as meaning (which he tended to regard as ipso facto idealist).[21] If detached from its transgression of the formal, the *informe* can become a meaning, even a value, in its own right, which Bataille would have rejected outright. The same is true of "the anti-aesthetic"; if removed from its agon with the aesthetic, it can become a protocol, even a principle, of its own.[22] Such might be the risk, too, of painting that is asked to visualize the image flows of mass media that far exceed it, and of sculpture that is expected to be anti-formal as a matter of course.[23] Like similar positions before them, both the case for "transitive" painting and the argument for "unmonumental" sculpture are pledged against the idea of aesthetic autonomy as well as against the reality of commodification. Yet such painting can be autonomous in its own way, and such sculpture might reiterate the junkspace around us more than critique it.

12. In the heyday of relational aesthetics, Rirkrit Tiravanija questioned "the need to fix a moment where everything is complete."[24] This provisionality, which extends to traditional mediums like painting, was once thought to shield the artwork from commodity status, on the one hand, and from the artist as brand, on the other, yet it did neither very effectively.[25] What it sometimes did do was to obscure one service that art can still render, which is to take a stand, and to do so in a manner that brings together the aesthetic, the cognitive, and the critical in a precise constellation. That this notion seems almost quaint or overly ambitious or both suggests how difficult it has become to imagine a mode of appearance and a register of time that do not conform to the image flows and information networks that run around and through us. Rather than adapt to this oddly static fluidity, however, one might strive, on the one hand, to exacerbate it critically and, on the other, to resist it formally.

13. I attempted to make the case for mimetic critique in Chapter 3; the argument for formal resistance is more familiar. "The true and most important function of the avant-garde," Clement Greenberg wrote in "Avant-Garde and Kitsch" (1939) during a period of enormous turmoil,

was "to find a path along which it would be possible to keep culture *moving* in the midst of ideological confusion and violence."[26] In his view the proper path was to push the given mediums of art to "the expression of an absolute in which all relativities and contradictions would be either resolved or beside the point," a path that was largely abandoned long ago.[27] However, in a revision of Greenberg in the early 1980s, another time of turmoil (the early years of neoliberalism), T. J. Clark argued that such "self-definition" was inseparable from "practices of negation" produced precisely out of "relativities and contradictions," with negation understood as "an attempt to *capture* the lack of consistent and repeatable meanings in the culture—to capture the lack and make it over into form."[28] Formlessness today is not what it was in the period addressed by Greenberg, or even at the moment in which Clark wrote; to an extent formlessness has taken on the appearance of digital fluidity, which is even more difficult to grasp. And yet, apart from sheer difficulty, is there any reason why this project, a making over of formlessness into form, should be abandoned?

14. Is there any reason why the corollary of this approach cannot be pursued as well—that is, an attempt to exacerbate "relativities and contradictions" critically in ways that evoke, as directly as possible, both the "confusion" of ruling elites and the "violence" of global capital, both the political insecurity and the economic precarity of the neoliberal order? As we saw in Chapter 3, such mimesis need not be desultory; rather, artistic instability redoubles social instability in this practice as it foregrounds its own schismatic condition, its own lack of shared meanings. Perhaps paradoxically, the formless can thus take on a form, that of the precarious, a form that might convert this debilitating affliction into a powerful appeal.[29] Above, I questioned the ready analogy between an open artwork and an egalitarian society, and here I seem to draw a similar parallel between a formless artwork and a precarious society, yet what is proposed in this case is not an affinity or a reflection but a critique.

15. Formal resistance and mimetic exacerbation: however redolent of Adorno and Benjamin they might sound, I hold out for these approaches over two others currently on offer. The first approach,

which can be called neo-Gramscian, advocates "social practice art," a rubric that uses "practice" to yoke "social" and "art" together but, in this very attempt, also suggests how far apart the two often are.[30] Moreover, rather than connect the two terms, rubrics like "social practice art" might release a given artist from the criterion of either social effectivity or artistic invention; or the one criterion might become the alibi for the other, with any pressure from the social side dismissed as "sociological" and any pressure from the artistic side as "aestheticist." In either case the anticipated resolution of "social" and "art" breaks down almost before it is posed.

16. The second approach, which can be called neo-Situationist, urges artists to take up images that agglomerate in image flows and information networks in ways that give them enhanced publicity and power—publicity and power that might be redirected if these images are reformatted effectively by artists. In this "epistemology of the search," as David Joselit calls it, such flows and networks might also be diagrammed in such a manner that "meaningful patterns" become apparent.[31] This visualization is very important, but such pattern recognition might be either too much or too little to expect of the viewer: too much in the sense that these flows and networks exceed the capacity of individuals to map them, and too little in the sense that contemporary art-viewing is often mere pattern-seeking as it is.[32] Moreover, a specific painting or sculpture can hardly function as a "cynosure" that focuses the relay between artwork and network when that same artwork is already deemed merely contemplative or totally reified or both.[33] Why not bolster, rather than collapse, the gap that still exists between artwork and network, in the mode of formal resistance, or, alternatively, when that gap appears to be closed, why not attempt to make those "petrified social conditions" dance again, in the mode of mimetic exacerbation?

17. I started with questions about the ambiguous presence of some performative art and proceeded to a caution about the desultory aspect of some participatory art. I did not pursue this line in the hope of either an unmediated relation to the real or a perfectly resolved work of art. Rather, what I value is a sense of actuality, in the strong

sense of the term: artworks that are able to constellate not only different registers of experience (aesthetic, cognitive, and critical) but also different orders of temporality. This constellation is opposed to the virtual confusion of spaces and the zombie confusion of times with which I began. Yet neither does this actuality simply mean presence (I have also questioned the desire for presence, or rather the manipulation of that desire), much less presentism (though a purchase on the present is one effect of the artistic constellation I have in mind). Any artwork holds together various times of production and reception, not only as we confront it in the present of our own experience, but also as other moments are inscribed in the work as it passes through history.[34] Yet a superior work helps us to actualize those diverse temporalities. This actuality is not as dramatic as the "dialectical image" of Benjamin; it is closer in spirit to the Baudelairean definition of painting as "mnemotechny of the beautiful"—as long as that memory-technique is understood to be sensitive to the other of the beautiful too, which we once called the sublime and now often see as the traumatic.[35] At the same time, such actuality cannot be fixed on a traumatic view of the past; that is, even as it calls up past art, it must also open onto future work.

NOTES

In Search of Terms

1 For another version of this argument, see my "Tales of Twentieth-Century Art," in Elizabeth Cropper, ed., *Dialogues in Art History, from Mesopotamian to Modern: Readings for a New Century* (Washington, DC: National Gallery of Art, 2009).

2 For the pitfalls of the application of "paradigms" to recent art, see Caroline Jones, "The Modernist Paradigm: The Artworld and Thomas Kuhn," *Critical Inquiry* 26 (Spring 2000): 488–528.

3 There is some internal debate concerning these terms, as we will see: the abject questions some aspects of postmodernism (e.g., it rejects the mobility of the signifier), the archival questions some aspects of abjection (e.g., it rejects the real in favor of the referential), and so on.

4 Leo Steinberg, "Jasper Johns: The First Seven Years of His Art," in *Other Criteria: Confrontations with Twentieth-Century Art* (New York: Oxford University Press, 1972), 23.

5 Although much of this book is based on essays published over the last two decades, they are revised and related to each other here. It is bad enough that a critic must be educated in public;

there is no need to go through it twice. That said, I have resisted the temptation to update them substantially; I have also not engaged subsequent texts that take up, critically or not, my own. An initial version of Chapter 1 was published as "Obscene, Abject, Traumatic" in *October* 78 (Fall 1996); it also appeared as part of the title essay of my *The Return of the Real* (Cambridge, MA: MIT Press, 1996). I have made the unusual decision to include it here because it is the first in the sequence of terms that is the subject of this book. Chapter 2 was first published in different form as "An Archival Impulse" in *October* 110 (Fall 2004). Chapter 4 appeared, also in different form, as "Toward a Grammar of Emergency" in Thomas Bizzarri, ed., *Thomas Hirschhorn: Establishing a Critical Corpus* (Zürich: JRP/Ringier, 2011). A preliminary version of Chapter 5 appeared with the same title in *October* 139 (Winter 2012).

6 Chapters 2, 3, and 4 lead with the art, which tests the theoretical models that follow. Chapter 1 is more theoretically driven, perhaps a sign of its comparatively early date.

7 See Hal Foster, ed., "Questionnaire on 'The Contemporary,'" *October* 130 (Fall 2009): 3–124.

1: Abject

1 Jacques Lacan, *The Four Fundamental Concepts of Psychoanalysis*, trans. Alan Sheridan (New York: W. W. Norton, 1978), 72, 75, 77, 95.

2 Ibid., 96. Curiously, the Sheridan translation adds a "not" ("But I am not in the picture") where the original reads "Mais moi, je suis dans le tableau" (*Seminar XI* [Paris: Editions du Seuil, 1973], 89). This addition has abetted the mistaking of the place of the subject mentioned in the next note. Lacan is clear enough on this point: "the first [triangular system] is that which, in the geometral field, puts in our place the subject of representation, and the second is that which turns *me* into a picture" (105).

3 Ibid., 89. Some readers place the subject in the position of the screen, perhaps on the basis of this statement: "And if I am anything in the picture, it is always in the form of the screen,

which I earlier called the stain, the spot" (97). The subject is a screen in the sense that, looked at from all sides, (s)he blocks the light of the world, casts a shadow, is a "stain" (paradoxically, it is this screening that permits the subject to see at all). But this is different from the image screen, and to place the subject only there is to contradict the superimposition of the two cones wherein the subject is both viewer and picture. The subject is an agent of the image screen, not one with it.

4 Ibid., 103.

5 Norman Bryson has argued that, however threatened by the gaze, the subject of the gaze is also confirmed by its very alterity; see his "The Gaze in the Expanded Field," in Hal Foster, ed., *Vision and Visuality* (Seattle: Bay Press, 1988). As Bryson notes, other models of visuality—spectacle, the male gaze, surveillance—are also tinged with paranoia. What produces this paranoia, and what might it serve—that is, besides this ambiguous (in)security of the subject? On the atavism of the nexus of gaze, prey, and paranoia, also consider this remark of Philip K. Dick: "Paranoia, in some respects, I think, is a modern-day development of an ancient, archaic sense that animals still have— quarry-type animals—that they're being watched . . . I say paranoia is an atavistic sense. It's a lingering sense, that we had long ago, when we were—our ancestors were—very vulnerable to predators, and this sense tells them they're being watched. And they're being watched probably by something that's going to get them . . ." (extract from a 1974 interview used as an epigraph to *The Collected Stories of Philip K. Dick*, vol. 2 [New York: Carol Publishing, 1990]).

Lacan relates this maleficent gaze to the evil eye, which he sees as an agent of disease and death, with the power to blind and to castrate: "It is a question of dispossessing the evil eye of the gaze, in order to ward it off. The evil eye is the *fascinum* [spell], it is that which has the effect of arresting movement and, literally, of killing life . . . It is precisely one of the dimensions in which the power of the gaze is exercised directly" (*Four Fundamental Concepts*, 118). For Lacan the evil eye is universal, and no beneficent eye exists as its complement, not even in the Bible. Yet

much Christian art is focused on the gaze of the Madonna on the Child and of the Child on us. Typically, Lacan concentrates instead on the exemplum of envy in Saint Augustine, who tells of his murderous feelings of exclusion at the sight of his little brother at the maternal breast: "Such is true envy—the envy that makes the subject pale before the image of a completeness closed upon itself, before the idea that the *petit a*, the separated *a* from which he is hanging, may be for another the possession that gives satisfaction" (116). Here Lacan can be contrasted with Walter Benjamin, who imagines the gaze as auratic and replete, from within the dyad of mother and child, rather than as anxious and invidious, from the position of the excluded third. Indeed, in Benjamin one discovers the beneficent eye that Lacan denies, a magical gaze that begins to undo castration and to reverse fetishism, a redemptive aura based on the memory of the primal relationship with the maternal gaze and body. For more on this distinction, see my *Compulsive Beauty* (Cambridge, MA: MIT Press, 1993), 193–205.

6 Rosalind Krauss conceives this desublimation as an attack on the sublimated verticality of the traditional image in *Cindy Sherman* (New York: Rizzoli, 1993). She also discusses the work in relation to the Lacanian diagram of visuality, albeit in a different way, as does Kaja Silverman in *Thresholds of the Visible* (New York: Routledge, 1996).

7 See Julia Kristeva, *Powers of Horror*, trans. Leon S. Roudiez (New York: Columbia University Press, 1982).

8 See Georges Bataille, *Visions of Excess*, trans. Allan Stoekl (Minneapolis: University of Minnesota Press, 1985), 31. Regarding the differences between these concepts see "Conversation on the *Informe* and the Abject," *October* 67 (Winter 1994), and Rosalind Krauss and Yves-Alain Bois, *Formless: A User's Guide* (Cambridge, MA: Zone Books, 1997).

9 I admit that this is a false etymology: "obscene" derives from the Latin *obscaenus*, or "ill-omened." The attack on the image screen has assumed other guises in other periods. See, for instance, Louis Marin on the alleged ambition of Caravaggio "to

destroy painting" in *To Destroy Painting* (Chicago: University of Chicago Press, 1995). In the twentieth century this ambition was active in Dada and décollage (where spectacle was targeted), among other practices. Such antivisuality might also be related to the paranoia of the gaze noted above.

10 Kristeva, *Powers of Horror*, 2.

11 One such conundrum is the relation here between subject and society, the psychological and the anthropological. With her recourse to the work of Mary Douglas (especially *Purity and Danger*), Kristeva tends to conflate the two, with the result that a disturbance of the one is automatically a disturbance of the other. Kristeva also tends to primordialize disgust; to map abjection onto homophobia may be to primordialize homophobia in turn. There are many readings of the Kristevan abject; for a critical one see Judith Butler, *Gender Trouble* (New York: Routledge, 1990) and *Bodies That Matter* (New York: Routledge, 1993).

12 This question points to a parallel one: can there be an obscene representation that is not pornographic? The difference between the two might be thought along these lines: the obscene is a representation without a scene to stage the object, with the result that the object appears too close to the viewer, whereas the pornographic is a representation that distances the object, with the result that the viewer is safeguarded as a voyeur.

13 Georges Bataille, *Erotism: Death and Sensuality* (1957), trans. Mary Dalwood (San Francisco: City Lights Books, 1986), 63. There is a third option: that the abject is double and that its transgressive value is a function of this ambiguity. (Bataille, no less than Freud, was drawn to such nondialectical doublings.)

14 Kristeva, *Powers of Horror*, 18.

15 Yet when is this order not in crisis? The notion of hegemony suggests that it is always under threat. In this regard, the very notion of the symbolic order might project more solidity than the social possesses.

16 This is my understanding of Dada, at least in some of its manifestations, which I take up in Chapter 3. Radical art and theory have often celebrated failed figures, especially deviant masculinities, as transgressive of the symbolic order, but this avant-gardist

logic also assumes (affirms?) a stable order against which these figures are posed. In *My Own Private Germany: Daniel Paul Schreber's Secret History of Modernity* (Princeton, NJ: Princeton University Press, 1996), Eric Santner offers a brilliant rethinking of this logic: he relocates transgression within the symbolic order, at a point of internal crisis, which he defines as "symbolic authority in a state of emergency" (32).

17 The obscene might have this effect of inadvertent support as well. Indeed, the obscene might be the ultimate apotropaic shield against the real, partaking of it in order to protect against it.

18 "Everything tends to make us believe," Breton wrote in the *Second Manifesto of Surrealism* (1930), "that there exists a certain point of the mind at which life and death, the real and the imagined, past and future, the communicable and the incommunicable, high and low, cease to be perceived as contradictions. Now, search as one may one will never find any other motivating force in the activities of the surrealists than the hope of finding and fixing this point" (*Manifestoes of Surrealism*, trans. Richard Seaver and Helen R. Lane [Ann Arbor: University of Michigan Press, 1972], 123–4). Signal works of modernism emerge at this point between sublimation and desublimation; there are examples in Picasso, Jackson Pollock, Cy Twombly, Eva Hesse, and many others. Perhaps these artists are so privileged because we need the tension between the two to be treated somehow, both aroused and assuaged—in a word, managed.

19 See Breton, *Manifestoes of Surrealism*, 180–87. At one point Breton charges Bataille with "psychasthenia" (see note 32).

20 See Bataille, *Visions of Excess*, 39–40. For more on this opposition, see *Compulsive Beauty*, 110–14.

21 Bataille, "L'esprit moderne et le jeu des transpositions," *Documents* 8 (1930). The best discussion of Bataille on this score remains Denis Hollier, *Against Architecture* (Cambridge, MA: MIT Press, 1989), especially 98–115. Elsewhere Hollier has specified the fixed aspect of the abject according to Bataille: "It is the *subject* that is abject. That is where his attack on metaphoricity comes in. If you die, you die; you can't have a substitute. What can't be substituted is what binds subject and abject

together. It can't simply be a substance. It has to be a substance that addresses a subject, that puts it at risk, in a position from which it cannot move away" ("Conversation on the *Informe* and the Abject").

22 This relationship is similar to that of sovereign and *homo sacer* as developed by Giorgio Agamben in his writings of the 1990s.

23 For an incisive reading of this discontented modernism, see Rosalind Krauss, *The Optical Unconscious* (Cambridge, MA: MIT Press, 1992); and for a comprehensive history of this anti-ocular tradition, see Martin Jay, *Downcast Eyes: The Denigration of Vision in Twentieth-Century French Thought* (Berkeley: University of California Press, 1993).

24 Sigmund Freud, "On Transformations of Instinct as Exemplified in Anal Erotism," in *On Sexuality*, ed. Angela Richards (London: Penguin, 1977), 301. On the primitivism of this avant-gardist defiance, see my "Primitive Scenes," *Prosthetic Gods* (Cambridge, MA: MIT Press, 2004). Mediations of anal eroticism, as in the Black Paintings of Robert Rauschenberg or the early graffiti paintings of Cy Twombly, are usually more subversive than declarations of anal defiance.

25 Here and elsewhere Kelley pushed infantilist defiance toward adolescent dysfunction: "An adolescent is a dysfunctional adult, and art is a dysfunctional reality, as far as I am concerned" (quoted in Elisabeth Sussman, ed., *Catholic Tastes* [New York: Whitney Museum of American Art, 1994], 51).

26 Janine Chasseguet-Smirgel, *Creativity and Perversion* (New York: W. W. Norton, 1984), 3.

27 Mike Kelley, quoted in Sussman, *Catholic Tastes*, 86.

28 Freud, "On Transformations of Instinct," 298. Kelley plays on both psychoanalytic and anthropological intuitions about the interconnection of all these terms—feces, money, gifts, babies, penises . . .

29 Karl Marx, *The Eighteenth Brumaire of Louis Bonaparte*, in *Surveys from Exile*, ed. David Fernbach (New York: Vintage Books, 1974), 197.

30 Bataille, *Visions of Excess*, 15.

31 This was the case with the culture of slackers and losers, of

grunge rock and Generation X. What was the music of Nirvana about if not the Nirvana principle, a lullaby droned to the dreamy beat of the death drive? See my "Cult of Despair," *New York Times*, December 30, 1994.

32 Roger Caillois, "Mimicry and Legendary Psychasthenia" (c. 1937), *October* 31 (Winter 1984). Denis Hollier glosses "psychasthenia" as follows: "a drop in the level of psychic energy, a kind of subjective detumescence, a loss of ego substance, a depressive exhaustion close to what a monk called *acedia*" ("Mimesis and Castration in 1937" [*October* 31], 11).

33 Caillois, "Mimicry and Legendary Psychasthenia," 30.

34 This was first broached by Jameson in "Postmodernism and Consumer Society," in Hal Foster, ed., *The Anti-Aesthetic: Essays on Postmodern Culture* (Seattle: Bay Press, 1983). This ecstatic version cannot be dissociated from the apparent economic boom of the early 1980s, nor the melancholic version (noted below) from the actual bust of the late 1980s and early 1990s.

35 This oscillation suggested the dynamic of psychic shock parried by protective shield that Freud developed in his discussion of the death drive and that Benjamin elaborated in his discussion of Baudelairean modernism—but now placed well beyond the pleasure principle. See Freud, *Beyond the Pleasure Principle*, trans. James Strachey (New York: W. W. Norton, 1961 [1920]), and Benjamin, "On Some Motifs in Baudelaire," in *Illuminations*, trans. Harry Zohn (New York: Schocken Books, 1977 [1939]). The bipolarity of the ecstatic and the abject provides one affinity, sometimes remarked in cultural criticism, between the Baroque and the postmodern. Both are drawn toward an ecstatic shattering that is also a traumatic breaking.

36 Kelley quoted in Sussman, *Catholic Tastes*, 86.

37 "Self-divestiture in these artists," Leo Bersani and Ulysse Dutoit write of Samuel Beckett, Mark Rothko, and Alain Resnais in *Arts of Impoverishment* (Cambridge, MA: Harvard University Press, 1993), "is also a renunciation of cultural authority." Yet then they ask: "Might there, however, be a 'power' in such impotence?" (8–9). If so, it is a power they seem to advocate rather than to question.

2: Archival

1 Douglas Gordon in Hans Ulrich Obrist, *Interviews, Volume 1* (Milan: Charta, 2003), 322.

2 Philippe Parreno in Obrist, *Interviews, Volume 1*, 701. Also see Tom McDonough, "No Ghost," *October* 110 (Fall 2004).

3 See Nicolas Bourriaud, *Postproduction: Culture as Screenplay: How Art Reprograms the World*, trans. Jeanine Herman (New York: Lukas & Sternberg, 2002).

4 To take two prominent examples of the time: The 2002 documenta, directed by Okwui Enwezor, was conceived in terms of "platforms" of discussion, staged around the world (the exhibition in Kassel was only the final such platform), and the 2003 Venice Biennale, directed by Francesco Bonami, featured such sections as "Utopia Station." "Interactivity" is an aim of "relational aesthetics" as propounded by Bourriaud in his 1998 text of that title. For a critique of these trends, see Claire Bishop, "Antagonism and Relational Aesthetics," *October* 110 (Fall 2004).

5 Lev Manovich discusses the tension between database and narrative in *The Language of New Media* (Cambridge, MA: MIT Press, 2001), 233–6.

6 Liam Gillick describes his work as "scenario-based"; positioned in "the gap between presentation and narration," it might also be called archival. See Liam Gillick, *The Woodway* (London: Whitechapel Gallery, 2002).

7 Jacques Derrida uses the first pair of terms to describe the opposed drives he sees at work in the concept of the archive; see *Archive Fever: A Freudian Impression*, trans. Eric Prenowitz (Chicago: University of Chicago Press, 1996). Jeff Wall uses the second pair to describe the opposed imperatives he sees at work in the history of the avant-garde; see Thierry de Duve et al., *Jeff Wall* (London: Phaidon Press, 1996). How does the archival impulse relate to "archive fever"? Perhaps, like the Library of Alexandria, any archive is founded on disaster (or its threat), pledged against a ruin it cannot forestall. For Derrida archive fever is even more profound, bound up with repetition-compulsion and the death drive.

8 See my "Artist as Ethnographer" in *The Return of the Real* (Cambridge, MA: MIT Press, 1996).

9 Dean discusses "collection" in *Tacita Dean* (Barcelona: Museu d'Art Contemporani, 2001); Koester mentions "comparison" in "Lazy Clairvoyants and Future Audiences: Joachim Koester in Conversation with Anders Kreuger," *Newspaper Jan Mot* 43/44 (August 2005); and "bad combination" is the title of a 1995 work by Durant. The classic text on "the rhizome" is Gilles Deleuze and Felix Guattari, *A Thousand Plateaus*, trans. Brian Massumi (Minneapolis: University of Minnesota Press, 1987). There they underscore its "principles of connection and heterogeneity": "Any point of a rhizome can be connected to any other, and must be. This is very different from the tree or root, which plots a point, fixes an order" (7).

10 Thomas Hirschhorn, "Interview with Okwui Enwezor," in James Rondeau and Suzanne Ghez, eds, *Jumbo Spoons and Big Cake* (Chicago: Art Institute of Chicago, 2000), 32. This statement by Gabriel Orozco is also apposite: "I take the word 'studio' literally, not as a space of production but as a time of knowledge" (Obrist, *Interviews, Volume 1*, 646). Again, many other artists could be considered here, and the archival is only one aspect of the work I do discuss.

11 "I can say that I love them and their work unconditionally," Hirschhorn says of his commemorated figures (*Jumbo Spoons and Big Cake*, 30). I return to Hirschhorn in Chapter 4.

12 Hirschhorn in Obrist, *Interviews, Volume 1*, 396–9. This impulse is in tension with the destructive energy Derrida sees in the archive (see note 7).

13 Hirschhorn in *Jumbo Spoons and Big Cake*, 31.

14 Ibid., 30.

15 Benjamin Buchloh, "Cargo and Cult: The Displays of Thomas Hirschhorn," *Artforum* (November 2001): 114.

16 Hirschhorn in *Jumbo Spoons and Big Cake*, 32, and in Obrist, 399. His chosen writers—the Swiss Walser, the French Bove, the Austrian Bachmann, and the American Carver—also vary widely, yet each succumbed to a premature death or (in the case of Walser) madness: here again are incomplete projects, unfulfilled beginnings.

17 Perhaps of all precedents *The Cathedral of Erotic Misery* of Schwitters is the most telling, for it too was a kind of archive of public debris and private fetishes (one that blurred this very distinction).

18 Buchloh alludes to "a new type of cultural value" in "Cult and Cargo," 110.

19 This is how Jürgen Habermas glosses the story in "Modernity— An Incomplete Project," in Hal Foster, ed., *The Anti-Aesthetic* (Seattle: Bay Press, 1983), 13.

20 Thus Hirschhorn is a contemporary practitioner of the Dadaist strategy of mimetic exacerbation I take up in Chapter 3.

21 *Der kapitalistische Abfallkübel* (2000) is the title of a work that consists of a huge wastebasket stuffed with glossy magazines; *Kübel* is also the word for the toilet in a prison cell. In a world of financial flux and information flow, reification is hardly opposed to liquefaction, a paradoxical condition that Hirschhorn evokes in many of his manic displays. On junkspace, see Rem Koolhaas and Hal Foster, *Junkspace with Running Room* (London: Notting Hill Editions, 2013).

22 Buchloh, "Cargo and Cult," 109. On the dialectic of "reification and utopia in mass culture," see the classic text of that title by Fredric Jameson in *Social Text* 1 (Winter 1979); for his more recent reflections on the subject see "Politics of Utopia," *New Left Review* 2: 25 (January/February 2004): 35–54. In a well-known statement, Theodor Adorno once remarked of modernism and mass culture: "Both bear the stigmata of capitalism, both contain elements of change . . . Both are town halves of an integral freedom, to which however they do not add up. It would be romantic to sacrifice one to the other . . ." (Letter of 18 March 1936 to Walter Benjamin in *Aesthetics and Politics* [London: New Left Books, 1977], 123). Hirschhorn offers one version of what these maimed halves look like today.

23 See Ernst Bloch, *Heritage of Our Times* (1962), trans. Neville and Stephen Plaice (Berkeley: University of California Press, 1991).

24 Tacita Dean in *Tacita Dean*, 12.

25 Ibid., 39.

26 Ibid., 50.

27 Ibid., 52. Her archives recall those probed by Michel Foucault under the rubric "The Life of Infamous Men" (1977), a collection of "archives of confinement, police, petitions to the king and *lettres de cachet*" concerning anonymous subjects who became (in)famous due to "an encounter with power" c. 1660–1760. See Meaghan Morris and Paul Patton, eds, *Michel Foucault: Power, Truth, Strategy* (Sydney: Feral Publications, 1979), 76–91.

28 Dean in *Tacita Dean*, 54.

29 Renée Green has also produced a video on *Partially Buried Woodshed*; see "Partially Buried," *October* 80 (Spring 1997). Like some of the figures commemorated by Hirschhorn, Smithson represents another unfulfilled beginning for these artists. "His work allows me a conceptual space where I can often reside," Dean comments. "It's like an incredible excitement and attraction across time; a personal repartee with another's thinking and energy communicated through their work" (*Tacita Dean*, 61). She has also cited other artists from this same archive, among them Marcel Broodthaers, Bas Jan Ader, and Mario Merz.

30 Dean in *Tacita Dean*, 54.

31 Perhaps they are arks in analogy with *The Russian Ark* (2002) of filmmaker Andrei Sokurov, yet Dean does not totalize her histories as Sokurov does his—on the contrary. In a suggestive text, Michael Newman discusses her work as an archive of senses as well as mediums; see his "Medium and Event in the Work of Tacita Dean," *Tacita Dean* (London: Tate Britain, 2001). Also helpful are the texts included in *Tacita Dean: Seven Books* (Paris: Musée d'art moderne de la ville de Paris, 2003). The notion of "failed futuristic visions" points to a principle of dis/connection in Hirschhorn too: "I opened possible doorways between them," he remarks of the disparate figures honored in *Jumbo Spoons and Big Cake*. "The links are the failures, the failures of utopias . . . [A] utopia never works. It is not supposed to. When it works, it is a utopia no longer" (*Jumbo Spoons and Big Cake*, 35).

32 See Walter Benjamin, "Theses on the Philosophy of History" (1940) and "Surrealism: The Last Snapshot of the European

Intelligentsia" (1928), in Hannah Arendt, ed., *Illuminations* (New York: Schocken Books, 1969); and Peter Demetz, ed., *Reflections* (New York: Harcourt Brace Jovanovich, 1978). "Balzac was the first to speak of the ruins of the bourgeoisie," Benjamin wrote in "Paris, Capital of the Nineteenth Century" (Exposé of 1935). "But only Surrealism exposed them to view. The development of the forces of production reduced the wish symbols of the previous century to rubble even before the monuments representing them had crumbled" (*Reflections*, 161). The "wish symbols" in question were the capitalist wonders of the nineteenth-century bourgeoisie at the height of its confidence, such as "the arcades and interiors, the exhibitions and panoramas." These structures fascinated the Surrealists nearly a century later—when further capitalist development had turned them into "residues of a dream world" or, again, "rubble even before the monuments which represented them had crumbled." For the Surrealists to intervene in these outmoded spaces, according to Benjamin, was to tap "the revolutionary energies" trapped there. As noted above, the outmoded for archival artists today does not possess this same force; in fact some (like Durant) are conflicted about the pasts they unearth.

33 See Tacita Dean, "W. G. Sebald," *October* 106 (Fall 2003).

34 W. G. Sebald, *The Rings of Saturn*, trans. Michael Hulse (New York: New Directions, 1998), 237, 187, 234. Dean seems closest to the Sebald of this book.

35 W. G. Sebald, *The Emigrants*, trans. Michael Hulse (New York: New Directions, 1996), 1. On this point, see Mark M. Anderson, "The Edge of Darkness: On W. G. Sebald," *October* 106 (Fall 2003).

36 Dean in *Tacita Dean: Location* (Basel: Museum für Gegenwartskunst, 2000), 25. Also romantic is the implication of a partial doubling of her failed figures with the figure of the artist.

37 At the very least, her archival tales hold out the possibility of errance in an otherwise plotted world. Dean suggests one aspect of the temporality of her work in the subtitle of a 2001 aside concerning the old East Berlin Fernsehturm: "Backwards into the Future." This movement suggests "the crabwalk" performed by

Günter Grass in his 2002 novel of that title regarding the symptomatic persistence of the Nazi past: "Do I have to sneak up on time in a crabwalk, seeming to go backward but actually scuttling sideways, and thereby working my way forward fairly rapidly?" See Günter Grass, *Crabwalk*, trans. Krishna Winston (New York: Harcourt, 2003), 3.

38 "Ghost-hunting" is his term. See Joachim Koester, "Lazy Clairvoyants and Future Audiences," n.p.

39 Ibid.; Alexander Kluge, *The Devil's Blind Spot: Tales from the New Century*, trans. Martin Chalmers and Michael Hulse (New York: New Directions, 2004), 182. This internal montage is not a function of digital manipulation; hence the image retains its documentary effect (even as that effect might also be questioned). The result of the juxtaposition is a kind of "third meaning" that also interests contemporaries such as Huyghe.

40 Unless otherwise specified, all Koester texts can be found in Joachim Koester, *Messages from the Unseen* (Lund: Lund Konsthall, 2006).

41 Koester continues: "Nowhere in Europe are the traces after World War Two more visible than in Kaliningrad. Hauntings from a war that shaped lives and destinies for generations to come. Including my own—like many, affected by the 'third generation syndrome,' I have always felt as if I was pulled towards an empty space: 'that which has not been said.'"

42 There is a connection here to the often banal photographs that appear in Surrealist novels; see Denis Hollier, "Surrealist Precipitates, *October* 69 (Summer 1994). In novels like *Nadja* (1928), Hollier writes, "indexical signs leave doors ajar through which the *demain joueur*, the gambling tomorrow, does or does not make its entry" (126).

43 Koester, "Lazy Clairvoyants and Future Audiences," n.p. The Smithson text returns below.

44 Here we see what has befallen the Golden Coach Diner that Smithson saw in Passaic in 1967 (a Dunkin' Donuts replaces the mom-and-pop place); a Los Angeles apartment Ed Ruscha snapped in his 1965 photobook of the same (a "Now Leasing" banner replaces the snappy "Fountain Blu" sign on the facade);

a tract home under construction in Colorado Springs photographed by Robert Adams in 1969 (the low-end suburb has encroached); a giant coal-breaker photographed by the Bechers in Pennsylvania in 1975 (it is a relic now, with windows broken and birch trees in the train tracks); a curb in Jamaica, Queens, one of the pocket pieces of real estate documented by Gordon Matta-Clark in 1973 (except for new hedge, it looks suspiciously the same—can we trust all "documents" in site-specific art?); and a building on East 3rd Street in Manhattan once owned by Shapolsky et al., part of the 1971 critique of that tenement lord by Hans Haacke (the structure is the only one from the documented Shapolsky empire still standing).

45 *The Devil's Blind Spot* is a partial translation of *Die Lücke, die der Teufel lässt* (2003), which literally means "the gap left by the devil." At one point in *The Devil's Blind Spot* Kluge has this internal dialogue, which, with the necessary transpositions, might apply to Koester as well:

"—And what do you mean by this metaphor? Why are you, a Germanist, acting as an historian?

—It shows the parallelism of events. As one epoch overlaps with another.

—Imperceptibly?

—Well, none of the contemporary witnesses noticed it." (132)

46 In one sense archival art returns to the referent; in another sense it treats that referent as a blind spot. There is a rub here for this art. "If you go to a show now you will have to adjust to the work each time," Koester remarks in his conversation with Anders Kreuger. "You need to find the manual for the show, and sometimes it does need a manual, and I don't see anything bad about that." Archival art is all about epistemological curiosity. Here are fragments of a story, it says; here is what they might tell us about our (in)abilities to see, represent, narrate, understand. But often the effect is rather an epistemological dilemma. Do I (the viewer) want to enter this story and labor on its puzzle? Must I? "Nothing in the world," Koester acknowledges, "is more boring than participating in a game when you don't know the rules" ("Lazy Clairvoyants and Future Audiences").

47 Ibid.

48 See Michael Darling, "Sam Durant's Riddling Zones," in Michael Darling, ed., *Sam Durant* (Los Angeles: Museum of Contemporary Art, 2002), 11. Darling notes the adjacency of this universe to the subcultural worlds explored by Mike Kelley and John Miller.

49 Durant in Rita Gersting, "Interview with Sam Durant," in ibid., 62. As with the models of repression and entropy, Durant borders on parody here.

50 Michel Foucault, *The Archaeology of Knowledge*, trans. A. M. Sheridan Smith (New York: Harper, 1976), 130–31.

51 Dean in *October* 100 (Spring 2002): 26. On this return to the 1960s, see my "This Funeral Is for the Wrong Corpse," *Design and Crime (and Other Diatribes)* (London: Verso, 2002).

52 This attack on modernist architecture has precedents (e.g., Tristan Tzara and Salvador Dalí), and its political valence is often problematic; here Durant borders on parody.

53 Michael Darling in *Sam Durant*, 14.

54 Durant: "My models are poorly built, vandalized, and fucked up. This is meant as an allegory for the damage done to architecture simply by occupying it" (ibid., 57).

55 These collages recall the early photomontages by Martha Rosler titled *Bringing the War Home* (1967–72).

56 This is a troubling of both modernist design and Minimalist logic on the model of Smithson and Matta-Clark as well as feminist artists from Eva Hesse to Cornelia Parker. Such a move of counter-repression, which is programmatic in such titles as *What's Underneath Must Be Released and Examined To Be Understood* (1998), is also indebted to Kelley.

57 See James Meyer, "Impure Thoughts: The Art of Sam Durant," *Artforum* (April 2000). In related pieces Durant features the Rolling Stones, Neil Young, and Nirvana.

58 Robert Smithson, *The Writings of Robert Smithson*, ed. Nancy Holt (New York: New York University Press, 1979), 56–7.

59 Durant in *Sam Durant*, 58. Smithson also alludes to his sandbox as a grave.

60 Ibid.

61 See Rosalind Krauss, "Sculpture in the Expanded Field," *October* 8 (Spring 1979).

62 Durant in an unpublished statement of 1995 quoted in *Sam Durant*, 14.

63 See Craig Owens, "The Allegorical Impulse: Notes toward a Theory of Postmodernism," *October* 12 (Spring 1980): 67–86; and 13 (Summer 1980): 59–80.

64 See Benjamin H. D. Buchloh, "Gerhard Richter's Atlas: The Anomic Archive," *October* 88 (Spring 1999).

65 I mean "preposterous" in the sense of mixed temporalities too, of "the pre" or before conjoined with "the post" or after. See my "Preposterous Timing," *London Review of Books*, November 8, 2012, and the Coda.

66 There is an archival impulse in recent fiction as well; one thinks of Dave Eggers, Richard Powers, William Vollman, and David Foster Wallace, among others. Here too it sometimes takes on a manic quality.

67 This speculation invites two others. First, even as archival art cannot be separated from the recent "memory industry" (e.g., the profusion of memorials), it suggests that this industry is amnesiac in its own way (recall Sebald: "and the last remnants memory destroys"). Indirectly, then, this art calls out for a practice of counter-memory. Second, archival art might be bound up, ambiguously, even deconstructively, with an "archive reason" at large, that is, with a "society of control" in which our past actions are archived (e.g., medical records, border crossings, political involvements) so that our present activities can be surveilled and our future behaviors predicted. This networked world does appear both disconnected and connected in a way that archival art might be taken to mimic (e.g., Hirschhorn displays can resemble mock webs of information), which might also bear on its paranoia vis-à-vis an order that seems both chaotic and systemic. For different accounts of different stages of "archive reason," see Allan Sekula, "The Body as Archive," *October* 39 (Winter 1986), and Gilles Deleuze, "Postscript on the Societies of Control," *October* 59 (Winter 1992).

68 For a recent excoriation see T. J. Clark, "For a Left with No Future," *New Left Review* 2: 74 (March/April 2012): 53–75.

69 Hirschhorn in Obrist, *Interviews, Volume 1*, 394.

3: Mimetic

1 Robert Gober, "Interview with Richard Flood," in Richard Flood, ed., *Robert Gober: Sculpture + Drawing* (Minneapolis: Walker Art Center, 1999), 125. Also see my "A Missing Part" in *Prosthetic Gods* (Cambridge, MA: MIT Press, 2004). Gober began to plan this installation soon after 9/11 and completed most elements by the time of the 2004 presidential election; it appeared first at the Matthew Marks Gallery in spring 2005 and then, revised somewhat, at his retrospective at the Museum of Modern Art in fall 2014. For the American pavilion at the 2001 Venice Biennale, Gober also orchestrated an installation that mixed the sacred (rooms arrayed like chapels) and the profane (allusions to contemporary events, such as the sodomization of the Haitian immigrant Abner Louima with a toilet plunger by New York police in 1997). The faux Styrofoam plinths appeared here too (Gober found the original on the beach near his Long Island studio of the time).

2 For other such associations, see Brenda Richardson, *A Robert Gober Lexicon* (New York: Matthew Marks Gallery, 2005). Adrian Piper used the device of images drawn over *Times* pages in her series "Vanilla Nightmares" (1986), where black bodies haunt the white subjects projected by fashion advertisements.

3 As in the archival art discussed in Chapter 2, the allegorical here is less about transcendental meanings than about the breakdown of such significance; it is less biblical than Benjaminian. The insistence of the real also recalls the abject art in Chapter 1. The Starr Report predates 9/11, of course, but, coincidentally, it was released on September 11, 1998. Its presence in the installation does several things at once. It renders the rupture of 9/11 less punctual, which also reminds us that the Rightist turn in American politics was underway long before George W. Bush. The intermingling of private bodies and public politics in the

report is also another (very different) version of the intermingling evoked by Gober in his *Times* drawings. (Thanks to Hannah Yohalem for these points.)

4 On these aspects of still life, see Norman Bryson, *Looking at the Overlooked* (Cambridge, MA: Harvard University Press, 1990).

5 See Hermann Broch, "Evil in the Value-System of Art" (1933), in *Geist and Zeitgeist: The Spirit in an Unspiritual Age* (New York: Counterpoint, 2003).

6 Clement Greenberg, *Art and Culture* (Boston: Beacon Press, 1961), 9, 12.

7 Theodor Adorno, *Aesthetic Theory*, trans. Robert Hullot-Kentor (Minneapolis: University of Minnesota Press, 1997), 239.

8 Milan Kundera, *The Unbearable Lightness of Being*, trans. Michael Henry Heim (London: Faber and Faber, 1985), 247, 244, 247. In *The Art of the Novel* (1986) Kundera makes the narcissistic implication here explicit: "The kitsch-man's (*Kitschmensch*) need for kitsch: it is the need to gaze into the mirror of the beautifying lie and to be moved to tears of gratification at one's own reflection" (*The Art of the Novel*, trans. Linda Asher [New York: Harper & Row, 1988], 135).

9 For my account of this phenomenon, which I draw on here, see my "Bush Kitsch," *London Review of Books*, July 7, 2005.

10 Of course, for many Christians the radicality of Jesus was precisely his break with the ancient law of vengeance (*lex talionis*). On this point, see René Girard, *Violence and the Sacred*, trans. Patrick Gregory (Baltimore: Johns Hopkins University Press, 1977), and *Things Hidden since the Foundation of the World*, trans. Stephen Bann and Michael Metteer (Stanford, CA: Stanford University Press, 1987).

11 See David Joselit, "Information Man," *Artforum* (September 2004).

12 Here we are back to the abjection discussed in Chapter 1.

13 "Global Village Idiot" is also the title of a 2004 piece Kessler produced in the midst of the news of the Abu Ghraib torture.

14 Even in her acerbic mock models for Ground Zero structures, a glimmer of the modernist faith in social transformation through

new materials and ideal forms sometimes shines through, but this glint of utopia only makes the pieces all the more infernal.

15 See Walter Benjamin, "On Some Motifs in Baudelaire" (1939), in *Selected Writings, Volume 4, 1938–1940*, ed. Howard Eiland and Michael W. Jennings (Cambridge, MA: Harvard University Press, 2003), 313–55. Duchamp referred to his *3 Standard Stoppages* (1913–14) as "canned chance," and Gilles Deleuze wrote of "dividuals" in "Postscript on Societies of Control," *October* 59 (Winter 1992).

16 See Jacques Lacan, "The Mirror Stage" (1949), in *Écrits: A Selection*, trans. Alan Sheridan (New York: W. W. Norton, 1977), 5.

17 As with Rachel Harrison, a younger artist with whom Genzken is sometimes associated, this assault takes in not only other modes of modernist object-making (more on which below) but also the product lines of Jeff Koons, Takashi Murakami, and other corporate studios. On the notion of "junkspace," see Rem Koolhaas and Hal Foster, *Junkspace with Running Room* (London: Notting Hill Editions, 2013).

18 Hugo Ball, *Flight Out of Time: A Dada Diary* (1927), trans. Ann Raimes (New York: Viking Press, 1974), 66 (June 12, 1916).

19 For more on the Dadaist version of mimetic exacerbation, see my "Dada Mime," *October* 105 (Summer 2003), which I draw on here. Also see Brigid Doherty, "'See: *We Are All Neurasthenics!*' or, The Trauma of Dada Montage," *Critical Inquiry* (Autumn 1997), as well as Michael Taussig, "Homesickness & Dada," in *The Nervous System* (New York: Routledge, 1992).

20 Ball, *Flight Out of Time*, 66 (June 12, 1916).

21 Ibid.

22 Ibid., 37, 54 (October 26, 1915; March 2, 1916).

23 Ibid., 56 (March 11, 1916).

24 Ibid., 65 (May 24, 1916).

25 Ibid., 117, 40 (May 23, 1917; November 3, 1915).

26 Walter Benjamin, *Charles Baudelaire: A Lyric Poet in the Era of High Capitalism*, trans. Harry Zohn (London: New Left Books, 1973), 55.

27 Theodor W. Adorno, *Aesthetic Theory*, trans. Robert Hullot-Kentor (Minneapolis: University of Minnesota Press, 1997), 21.

Benjamin: "The unique importance of Baudelaire resides in his being the first and the most unflinching to have taken the measure of the self-estranged human being, in the double sense of acknowledging this being and fortifying it with armor against the reified world" (*The Arcades Project*, trans. Howard Eiland and Kevin McLaughlin [Cambridge, MA: Harvard University Press, 1999], 322).

28 Theodor W. Adorno, *Philosophy of Modern Music*, trans. Anne G. Mitchell and Wesley V. Blomster (New York: Seabury Press, 1980), 168.

29 Walter Benjamin, *Gesammelte Schriften* 6, ed. Rolf Tiedemann and Hermann Schweppenhäuser (Frankfurt: Suhrkamp Verlag, 1972–91), 132. For a suggestive account of this genealogy, which Benjamin extended to Charlie Chaplin and Mickey Mouse, see Esther Leslie, *Hollywood Flatlands: Animation, Critical Theory, and the Avant-Garde* (London: Verso, 2002).

30 In a 1931 fragment on Mickey Mouse, Benjamin writes: "In these films, mankind makes preparations to survive civilization" (*Selected Writings: Volume II, 1927–1934*, ed. Michael Jennings et al. [Cambridge, MA: Harvard University Press, 1999], 545). He uses similar lines in "Karl Kraus" (1931) and "Experience and Poverty" (1933).

31 I borrow the term "bashed ego" from Peter Sloterdijk in *Critique of Cynical Reason*, trans. Michael Eldred (Minneapolis: University of Minnesota Press, 1987), 391–409. For cynical reason in recent art, see my *The Return of the Real: The Avant-Garde at the End of the Century* (Cambridge, MA: MIT Press, 1996).

32 Sloterdijk, *Critique of Cynical Reason*, 441.

33 Ball, *Flight Out of Time*, 98 (February 10, 1917).

34 Ibid., 108 (April 20, 1917). As Ball suggests here, the very apprehension that "there are no laws anymore" might produce psychotic effects.

35 In 1924 Ball published what Schmitt considered the most incisive analysis of his work to date. See Hugo Ball, "Carl Schmitt's Political Theology," trans. Matthew Vollgraff, *October* 146 (Fall 2013); also see Trevor Stark: "*Complexio Oppositorum*:

Hugo Ball and Carl Schmitt" in the same issue. World War I was a laboratory of states of emergency and exception. I return to these states in Chapter 4.

36 I associate this avant-garde, which I will explore in subsequent work, with the old challenge of the young Marx to make "petrified social conditions . . . dance by singing them their own song" (Karl Marx, "A Contribution to the Critique of Hegel's Philosophy of Right, Introduction," in *Early Writings*, ed. T. B. Bottomore [New York: McGraw-Hill, 1964], 47; translation modified). In this light, contemporary art might trigger an art-historical revision—a partial shift in emphasis not only in the Dadaist lineage, away from Duchamp and toward Ball, but also in the Pop legacy, whereby we might attend to Andy Warhol a little less and to Claes Oldenburg a little more, especially his "rips out of reality" (as he called his early homemade objects). With the "fetishistic stuff" mimicked in his *Street* and *Store* presentations of 1960–61, Oldenburg acted out the regression enforced by postwar consumerism and, in doing so, protested against it. Like the Russian Eccentrics described by Benjamin, Oldenburg found a "deep expressive capacity" precisely in "displacement" and "dislocation." The same is true of current legatees of Ball and Oldenburg such as the artists discussed here.

37 Dubbed "hysterical realism" by the literary critic James Wood, mimetic exacerbation is also practiced by contemporary novelists, including Jonathan Safran Foer, George Saunders, Gary Shteyngart, Zadie Smith, David Foster Wallace, and others, who look back, in this regard, to William Gaddis and Thomas Pynchon.

38 I owe the locution in quotes to Thomas Hirschhorn (see Chapters 2 and 4).

39 Jeff Koons in Anthony D'Offay, ed., *The Jeff Koons Handbook* (London: Anthony D'Offay Gallery, 1992), 44. The artist Carol Bove astutely sees this "cooperation as a form of aggression" in *Artforum* (September 2014): 316. Also see my "At the Whitney," *London Review of Books*, July 31, 2014.

40 Benjamin, *Arcades Project*, 385.

4: Precarious

1 Bertolt Brecht as reported by Walter Benjamin in "Conversations with Brecht," in *Reflections*, trans. Edmund Jephcott (New York: Harcourt Brace Jovanovich, 1978), 219.

2 "To be in agreement [with the world] does not mean to approve," Hirschhorn writes. "To be in agreement means to look. To be in agreement means to not turn away. To be in agreement means to resist, to resist the facts" ("Ur-Collage" in *Ur-Collage* [Zürich: Galerie Susanna Kulli, 2008], 3). Nearly all of the texts cited in this chapter can be found in Lisa Lee and Hal Foster, eds, *Critical Laboratory: The Writings of Thomas Hirschhorn* (Cambridge, MA: MIT Press, 2013). For an excellent survey of the art prior to the last decade, which I do not undertake here, see Benjamin H. D. Buchloh, "Thomas Hirschhorn: Lay Out Sculpture and Display Diagrams," in Alison M. Gingeras et al., *Thomas Hirschhorn* (London: Phaidon, 2004).

3 Marx speaks of "the general intellect" in "Fragment on Machines," Notebook VII of the *Grundrisse*. The notion is developed by Paolo Virno in *A Grammar of the Multitude: For an Analysis of Contemporary Forms of Life*, trans. Isabella Bertoletti (Los Angeles: Semiotext(e), 2004), and Franco "Bifo" Berardi in *The Soul at Work: From Alienation to Autonomy*, trans. Francesca Cadel and Giuseppina Mecchia (Los Angeles: Semiotext(e), 2009), among others.

4 "My work isn't ephemeral, it's precarious," Hirschhorn says. "It's humans who decide and determine how long the work lasts. The term 'ephemeral' comes from nature, but nature doesn't make decisions" ("Alison M. Gingeras in Conversation with Thomas Hirschhorn," in Gingeras, *Thomas Hirschhorn*, 24). For an incisive account of the precarious in this sense, see Sebastian Egenhofer, "Precarity and Form," in *Ur-Collage*.

5 See Gerard Raunig, *A Thousand Machines: A Concise Philosophy of the Machine as Social Movement*, trans. Aileen Derieg (Los Angeles: Semiotext(e), 2010). On the precarious in relation to contemporary art, see Julieta Aranda, Brian Kuan Wood, and Anton Vidokle, eds, *Are You Working Too Much?*

Post-Fordism, Precarity, and the Labor of Art (Berlin: Sternberg Press, 2011), as well as my "Precarious," Artforum (December 2009): 207–9.

6 This critique is sometimes made of the two major theorists of such a society, the sociologists Anthony Giddens and Ulrich Beck.

7 Raunig, A Thousand Machines, 78.

8 Hirschhorn, email communication in response to my text "Precarious" (see note 5). The next phrase is also from this email.

9 Hirschhorn, "Restore Now" (2006). Unless otherwise credited, all cited Hirschhorn texts are courtesy of the artist.

10 Ibid. Hirschhorn could also be said to "squat" the work of the artists, writers, and philosophers chosen for his altars, kiosks, and monuments.

11 Hirschhorn, "About the Musée Précaire Albinet" (2004). Once charged by the art historian Thierry de Duve with such displacement, Hirschhorn responded, somewhat disingenuously, that his work develops autonomously (see "Letter to Thierry" [1994], in Thomas Hirschhorn, 120–21). This dispute about his "ethnographic authority" still divides much of his audience. On this question, see my "The Artist as Ethnographer," The Return of the Real (Cambridge, MA: MIT Press, 1996).

12 This is how his sometime collaborator, the French poet Manuel Joseph, defines précarité in his unpublished text, "L'infâme et la tolérance révocable: La précarité comme dispositif politique et esthétique." Joseph writes there: "Precariousness, by right, is put into practice by means of a provisional authorization, that is, by a 'revocable tolerance' accorded by the Letter of the Law—law as conceived, invented, written by man. It concerns a 'condition' whose duration is not guaranteed, except for the men who have drawn up, decreed, and imposed this contract."

13 Hirschhorn, "Théâtre précaire pour 'Ce qui vient'" (2009). Here he describes the force of the precarious as "fragile, cruel, savage but free."

14 Judith Butler, Precarious Life: The Powers of Mourning and Violence (London: Verso, 2004), 130, 134. Of victims of war in particular, Butler writes, "We have been turned away from the

face" (150). This is what Hirschhorn refuses to do in *Ur-Collages* concerning the Iraq War, which are often brutal juxtapositions of images of constructed models from glossy magazines and of destroyed bodies found on the Internet (the victims are often literally faceless).

15 Benjamin Buchloh, "An Interview with Thomas Hirschhorn," *October* 113 (Summer 2005): 77. Hirschhorn adds, "Warhol is for me by no means the apparent opposite of Beuys."

16 Hirschhorn, "Where do I stand? What do I want?," *Art Review* (June 2008), n.p.

17 Hirschhorn, "Ur-Collage"; Hirschhorn, "Where do I stand? What do I want?"

18 Hirschhorn, "Les plaintifs, les bêtes, les politiques" (1993).

19 Ibid.

20 Buchloh, "Interview with Thomas Hirschhorn," 98. Perhaps "the weak" in Hirschhorn is akin to "the minor" in Deleuze and Guattari; see their *Kafka: Toward a Minor Literature*, trans. Dana Polan (Minneapolis: University of Minnesota Press, 1986).

21 Hirschhorn, "Ur-Collage"; Hirschhorn, "Bijlmer-Spinoza Festival" (2009).

22 "Gingeras in Conversation with Hirschhorn," 35.

23 I mean *affect* not as it is often used—as a term for primal energies or "intensities" of the body—but to stand for those sentimental feelings and emotive opinions that inhabit us, even interpellate us, deeply even when they are not properly our own: affect as "an ideological media apparatus."

24 One might also see the collages as a *pense-bête* (a term used by Marcel Broodthaers) in the colloquial sense of a record of events or a reminder of tasks. Perhaps there is an echo here, too, of the Lévi-Straussian notion of a *pensée sauvage* that proceeds by means of bricolage (Hirschhorn describes his collages as "simple, primitive, prehistoric"). The bricoleur, Lévi-Strauss writes in a famous definition, "makes do with 'whatever is at hand,'" "a collection of oddments left over from human endeavors," which he treats not only as "intermediaries between images and concepts," but also as "operators" that "represent a set of actual and possible relations" (Claude

Lévi-Strauss, *The Savage Mind* [1962; Chicago: University of Chicago Press, 1966], 17, 19, 21, 18).

25 Eric L. Santner, *On Creaturely Life: Rilke/Benjamin/Sebald* (Chicago: University of Chicago Press, 2006), 15, xv. "Creaturely life is just life abandoned to the state of exception/emergency, that paradoxical domain in which law has been suspended in the name of preserving law" (22), more on which below.

26 Hirschhorn, "Where do I stand? What do I want?" This is where Hirschhorn rejects the cynical reason of some of his contemporaries discussed at the end of Chapter 3.

27 Antonio Gramsci, *Selections from the Prison Notebooks*, ed. and trans. Quintin Hoare and Geoffrey Nowell Smith (New York: International Publishers, 1971), 326.

28 Jean-Paul Sartre, introduction to Nathalie Sarraute, *Portrait d'un Inconnu* (1957), reprinted in *Portraits*, trans. Chris Turner (London: Seagull Books, 2009), 5–6. Sartre continues: "To appropriate [the commonplace] requires an act: an act by which I strip away my particularity in order to adhere to the general, to become generality. Not in any case *similar* to everyone, but, to be precise, the *incarnation* of everyone. By this eminently social adherence, I identify myself with *all* others in the indistinctness of the universal" (6).

29 Georges Bataille, *The Accursed Share: An Essay on General Economy*, trans. Robert Hurley (New York: Zone Books, 1988), 2.

30 Hirschhorn, "Less Is Less, More Is More" (1995), in *Thomas Hirschhorn*, 122.

31 See Chapter 3.

32 "Gingeras in Conversation with Hirschhorn," 15.

33 Ibid., 34.

34 Bataille, 25. "I chose this book," Hirschhorn remarked of *La part maudite* when he included it in his *Emergency Library* (2003), "because nothing has more value than that which has no value, and which cannot be translated on a scale of values."

35 Buchloh, "Interview with Thomas Hirschhorn," 93.

36 Marcel Mauss, *The Gift: Forms and Functions of Exchange in Archaic Societies*, trans. E. E. Evans-Pritchard (New York: W.W. Norton, 1967 [1925]), 11.

37 Hirschhorn, "The Road-Side Giant-Book Project" (2004).
38 "Gingeras in Conversation with Hirschhorn," 25–6.
39 Hirschhorn, "Foucault Squatter" (2008).
40 Hirschhorn: "I want to create the relation with the other only if this other is not specifically connected to art. This is and has always been my guideline: to create—through art—a form which implicates the other, the unexpected, the uninterested, the neighbor, the unknown, the stranger" ("Six Concerns about Bijlmer" [2009]).
41 That said, Hirschhorn does extract value from his community projects, value that is then realized in other works.
42 See Carl Schmitt, *Political Theology: Four Chapters on the Concept of Sovereignty*, trans. George Schwab (Cambridge, MA: MIT Press, 1985), 53.
43 Walter Benjamin, "Theses on the Philosophy of History," in *Illuminations*, trans. Harry Zohn (New York: Schocken Books, 1969), 257.
44 Giorgio Agamben, "What Is a Camp?," in *Means without End*, trans. Vincenzo Binetti and Cesare Casarino (Minneapolis: University of Minnesota Press, 2000), 45.
45 Agamben, *Homo Sacer: Sovereign Power and Bare Life*, trans. Daniel Heller-Roazen (Stanford, CA: Stanford University Press, 1998), 8 (italics in original).
46 Ibid., 84.
47 See Jacques Derrida, *The Beast & the Sovereign*, vols. 1 and 2, trans. Geoffrey Bennington (Chicago: University of Chicago Press, 2009 and 2011).
48 Hirschhorn, "Bataille Monument" (2002); Hirschhorn, "Utopia, Utopia=One World, One Army, One Dress" (2005). Also see "Foucault Squatter" (2008): "The esthetic of the squat does not interest me for its style; I am interested in the aesthetic of the squat because it conveys emergency, spontaneity and encounter. The squat is the precarious form of a precious moment."
49 Hirschhorn, "Restore Now" (2006).
50 Hirschhorn, "Emergency Library," in *Thomas Hirschhorn*, 113.
51 Buchloh, "Interview with Thomas Hirschhorn," 82.
52 Benjamin, "Theses," 257.

53 Ibid., 263.
54 Hirschhorn, "Where do I stand? What do I want?" "It put me in an emergency situation," Hirschhorn said of his Bataille Monument (other projects have done the same). "At that moment I was confronted with the fundamental question that was posed: What do I want? . . . I had to act and use a certain degree of authority and also force . . ."
55 Ibid. Here Hirschhorn quotes Alexander Kluge: "In danger and emergency, to choose the middle way leads to certain death."

5: Post-Critical?

1 The cultural politics of the neoconservative Right were outlined as early as 1976 when Daniel Bell, in *Cultural Contradictions of Capitalism*, blamed the counterculture of the 1960s and 1970s—students, civil rights activists, feminists—for a putative decline in public morality, cultural literacy, and educational standards. The culture wars proper—the assault on multicultural education and identity politics, on feminist gains and gay rights—followed in the 1980s, and as they raged on in the 1990s, it made tactical sense for the Right to target universities and museums. It was then that the culture wars narrowed to attacks on political correctness, which concentrated on critical challenges to the canons of Western literature and art. This is how critical theory came to be cast as a diabolical agent. In the Rightist imaginary the academy was overrun by "tenured radicals" (as Roger Kimball put it in his 1990 book of that title), engaged in the promulgation of an "illiberal education" (Dinesh D'Souza in 1991), and dedicated to "the closing of the American mind" (Allan Bloom in 1987). By the late 1990s, however, the humanities began to appear marginal even to the universities, dependent as they were on federal and corporate support of the sciences. Moreover, pundits began to wonder what the humanities had to offer to the new digital economy; less than marginal, it seemed they might be declared obsolete. For more on these matters see my "Nutty Professors," *London Review of Books*, May 8, 2003.

2 For a recent instance, see Michael S. Roth, "Young Minds in Critical Condition," *New York Times*, May 10, 2014, in which Roth, an intellectual historian who is also president of Wesleyan University, writes: "Taking things apart, or taking people down, can provide the satisfactions of cynicism. But this is thin gruel. The skill at unmasking error, or simple intellectual one-upmanship, is not totally without value, but we should be wary of creating a class of self-satisfied debunkers—or, to use a currently fashionable word on campus, people who like to 'trouble' ideas." The scare-quoted "trouble" is an implicit, perhaps subconscious, disparagement of critiques launched by gender (and other) studies, as in *Gender Trouble* (1990) by Judith Butler; the association of critique with cynicism seems more intentional.

3 Some of these concerns were already raised in the roundtable "The Present Conditions of Art Criticism," *October* 100 (Spring 2002). Also see my "Art Critics in Extremis" in *Design and Crime (and Other Diatribes)* (London: Verso, 2002), as well as James Elkins and Michael Newman, eds, *The State of Art Criticism* (Abingdon, UK: Routledge, 2008), in which the *October* roundtable in particular, and the magazine in general, are roundly dismissed yet obsessively discussed. My account here begins with a broad survey, hence the initial slippage between terms; in what follows I focus primarily on critical theory and critical art. Finally, "post-critical" had a different valence in architectural debate, where it was used to draw a line after the theoretical reflexivity of such architects as Peter Eisenman, and to announce a renewed pragmatism of "design intelligence." See, inter alia, Robert Somol and Sarah Whiting, "Notes around the Doppler Effect and Other Moods of Modernism," *Perspecta* 33 (2002). Somol and Whiting propose a "projective" posture in place of a critical one, which they choose to see as reactive and backward-looking.

4 Walter Benjamin, "One-Way Street" (1928), in *Selected Writings, Volume 1: 1913–1926*, ed. Michael W. Jennings et al. (Cambridge, MA: Harvard University Press, 1996), 476. The other negative association, too complicated to take up here, is the one between critique and *ressentiment* made by Nietzsche in *The Genealogy of Morals* (1887).

5 Others are more recent, such as "the epistemology of the search" proposed by David Joselit (more on which in the Coda), or the troping of cynical reason urged by Paolo Virno in *A Grammar of the Multitude*, trans. Isabella Bertoletti et al. (Los Angeles: Semiotext(e), 2004), or the repossessing of our neoliberal status as "human capital" advanced by Michel Feher in "Self-Appreciation, or the Aspirations of Human Capital," *Public Culture*, 21: 1 (2008): 21–41.

6 Sometimes this connection is drawn directly. For example, Luc Boltanski and Eve Chiapello charge that the "artistic critique" of the disciplinary workplace was key to "the new spirit of capitalism"—i.e., that the informality of labor advocated by the former supported a precarity of jobs actualized in the latter. See *The New Spirit of Capitalism*, trans. Gregory Elliott (London: 2004). However, what Boltanski and Chiapello meant by "artistic critique" has little to do with actual art; in fact many artists (e.g., Melanie Gilligan) critiqued this "new spirit," which was short-lived in any case.

7 See Bruno Latour, "Why Has Critique Run out of Steam? From Matters of Fact to Matters of Concern," *Critical Inquiry* 30 (Winter 2004): 225–47. Here, for example, a Bush official (said to be Karl Rove) proudly admitted to this nihilism: "We're an empire now, and when we act, we create our own reality," he comments, with the run-up to the Iraq War in mind. "And while you're studying that reality—judiciously, as you will—we'll act again, creating other new realities, which you can study too, and that's how things will sort out." See Ron Suskind, "Faith, Certainty, and the Presidency of George W. Bush," *New York Times Magazine*, October 27, 2004.

8 Latour, "Why Has Critique Run out of Steam?," 237. Also see Latour, "What Is Iconoclash? Or Is There a World Beyond the Image Wars?," in Latour and Peter Weibel, eds, *Iconoclash: Beyond the Image Wars in Science, Religion, and Art* (Karlsruhe: ZKM; and Cambridge, MA: MIT Press, 2002), and Latour, *We Have Never Been Modern*, trans. Catherine Porter (Cambridge, MA: Harvard University Press, 1993).

9 Latour, "Why Has Critique Run out of Steam?," 241.

10 See Jacques Rancière, *Aesthetics and Its Discontents*, trans. Steven Cochran (Cambridge, MA: Polity Press, 2009), 46–7. The original French publication was released in 2004.

11 See Rancière, *The Emancipated Spectator*, trans. Gregory Elliott (London: Verso, 2009). The original French publication was released in 2008.

12 Rancière, *Aesthetics and Its Discontents*, 45.

13 Rancière in "Art of the Possible: Fulvia Carnevale and John Kelsey in Conversation with Jacques Rancière," *Artforum* (March 2007): 266. We encountered this problem of mimesis as reaffirmation versus mimesis as exacerbation in Chapter 3.

14 For Latour on fetishism and its critique, see *On the Modern Cult of the Factish Gods* (Durham, NC: Duke University Press, 2010).

15 I return to this question in the Coda.

16 Jacques Rancière, *The Politics of Aesthetics*, trans. Gabriel Rockhill (London: Continuum, 2004); the original French publication was released in 2000. Defined as what can and cannot be perceived, thought, and said, "the distribution of the sensible" differs little from what Marx understood as "ideology," at least when he saw it not as the specific content of a belief system but as the structural delimitation of the same.

17 Not long ago "criticality" became a value in its own right (a fetish, if you like), which is another reason why it became a bad object for many artists and critics. This criterion should be seen in the contexts of others that preceded it. In the early 1940s critics like Clement Greenberg advanced "quality" as the key value in modernist art: to be so judged, a work in the present had to stand the test of comparison to the best work of the past. As Greenberg averred more than once, this criterion did not promote a break with tradition; on the contrary, it was an attempt to preserve such continuity. Then in the early 1960s artists like Donald Judd claimed "interest" as a criterion. As an avant-gardist value, it moved to challenge other criteria, such as "quality," that preceded it, and it did not necessarily aim to preserve tradition or even to refer to it; often just the opposite. Next, in the early 1980s a group of artists and critics asserted "criticality" as the central value; "quality" seemed elitist, and "interest" not

political enough. One could argue that the value of "self-criticism" connected all these criteria.

18 Latour, "Why Has Critique Run out of Steam?," 246.

19 Latour is unabashed on this score in *We Have Never Been Modern*.

20 In his critique of critical iconoclasm Latour seems fixed on the radical posture of the critic as presented, say, by Barthes in "Change the Object" (1971): "It is no longer the myths which need to be unmasked (the doxa now takes care of that), it is the sign itself which must be shaken; the problem is not to reveal the (latent) meaning of an utterance, of a trait, of a narrative, but to fissure the very representation of meaning, is not to change or purify the symbols, but to challenge the symbolic itself" (*Image-Music-Text*, trans. Stephen Heath [New York: Hill and Wang, 1977], 167). Note that Barthes sees this move, which Latour and Rancière still want to challenge, as doxa already in 1971. What, finally, is shattered in the attack on critical iconoclasm (which might be iconoclastic in its own way)? Could it be nothing less than the politics of representation?

21 See Jane Bennett, *Vibrant Matter: A Political Ecology of Things* (Durham, NC: Duke University Press, 2010). Object-oriented ontology or speculative realism moves in the opposite direction, that is, it attempts to bracket the subject, to give the object its due. Whatever the philosophical interest of this school of thought, it is not clear how it bears on modern and contemporary art and aesthetics, mainly centered on the subject as they are. For excellent critiques of speculative realism from different vantages, see Andrew Cole, "The Call of Things," *Minnesota Review* 80 (2013), and Alexander R. Galloway, "The Poverty of Philosophy: Realism and Post-Fordism," *Critical Inquiry* 39 (Winter 2013).

22 This is true even when the field is the anthropology of art, as in the work of Alfred Gell, especially his *Art and Agency: An Anthropological Theory* (1998), which has experienced a revival in art criticism and history alike. If Latour locates agency in the relay of actor and network, Gell finds it in the relation between person and object. As suggested above, this projection of agency

is a kind of fetishism, but, to borrow a phrase from Arjun Appadurai, it is a "methodological fetishism": "Even though from a *theoretical* point of view human actors encode things with significance," Appadurai writes, "from a *methodological* point of view it is the things-in-motion that illuminate their human and social context" (Arjun Appadurai, ed., *The Social Life of Things: Commodities in Cultural Perspective* [Cambridge: Cambridge University Press, 1986], 5).

23 See, inter alia, David Freedberg, *The Power of Images: Studies in the History and Theory of Response* (Chicago: University of Chicago Press, 1989), and W. J. T. Mitchell, *What Do Pictures Want: The Lives and Loves of Images* (Chicago: University of Chicago Press, 2005). Georges Didi-Hubermann and Horst Bredekamp also figure prominently in this tendency. In a recent conversation Bredekamp was asked directly by Christopher Wood, "Do you literally assign agency and responsibility to inanimate objects?" And he responded just as directly, "Yes, I do." See *Art Bulletin* (December 2012): 526.

24 In this regard, see the medieval histories of Carolyn Walker Bynum in particular.

25 See Isabelle Graw, ed., *Art and Subjecthood: The Return of the Human Figure in Semiocapitalism* (Berlin: Sternberg Press, 2011). For a good survey of this phenomenon, see Ralph Rugoff, ed., *The New Décor* (London: Hayward Gallery, 2010).

26 There is a related move in installation art to treat ambient space as though it were somehow sensate. Conscious or not, this, too, is a version of fetishization, and as such calls for antifetishistic critique. I have argued elsewhere that such faux-phenomenological art tends to stage "experience" as so much "atmosphere"; see my "Painting Unbound" in *The Art-Architecture Complex* (London: Verso, 2011).

27 This confusion has been characteristic of technophilia since Futurism. Rather than fetishize the commodity, why not animate the labor that lies within it? Often called dead, it is only dormant. This is the project of Alexander Kluge and Oskar Negt in *History & Obstinacy*, ed. Devin Fore, trans. Richard Langston et al. (Brooklyn: Zone Books, 2014).

28 I associate this resistance with William Blake as much as Karl Marx (also see "The Snow Man" by Wallace Stevens); my own version is no doubt Protestant at root.

29 See Peter Sloterdijk, *Critique of Cynical Reason*, trans. Michael Eldred (Minneapolis: University of Minnesota Press, 1987). Often the problem is not that truths are hidden (Latour and Rancière are right here) but that many are all too apparent; yet they arrive with an obviousness that somehow blocks response or even produces denial. On this structure of fetishism, see Octave Mannoni, "Je sais, mais quand même," *Clefs pour l'imaginaire ou l'autre scène* (Paris: Editions du Seuil, 1969).

30 For example, much twentieth-century art, from some abstract painting to most Minimalist objects, aimed to demystify, really to dissolve, the many varieties of pictorial illusionism.

31 For example, defetishization is in league with the recent imagining of new scenarios in art (e.g., Matthew Buckingham, Jeremy Deller, Pierre Huyghe) that seeks precisely to defetishize the institutional arrangements between art and its audiences. (Thanks to Rob Slifkin for this point.) See Carrie Lambert-Beatty, "Make-Believe: Parafiction and Plausibility," *October* 129 (Summer 2009).

32 Clement Greenberg, *Avant-Garde and Culture* (Boston: Beacon Press, 1961), 5. I return to this formulation in the Coda.

33 See James Elkins and Harper Montgomery, eds, *Beyond the Aesthetic and the Anti-Aesthetic* (University Park: Penn State University Press, 2013). I also return to this point in the Coda.

34 I am indebted here to Jeff Dolven and Graham Burnett, who are committed to such alternatives. Rather than opposed to the aesthetic, poststructuralist theory was received as artful in this way. See Rosalind Krauss, "Poststructuralism and the 'Paraliterary,'" *October* 13 (Summer 1980), and Elizabeth Bruss, *Beautiful Theories: The Spectacle of Discourse in Contemporary Criticism* (Baltimore: Johns Hopkins University Press, 1982). On the resistance of art to image flow, see T. J. Clark, *The Sight of Death: An Experiment in Art Writing* (New Haven, CT: Yale University Press, 2006).

35 See Jürgen Habermas, *The Structural Transformation of the Bourgeois Public Sphere: An Inquiry into a Category of Bourgeois*

Society, trans. Thomas Burger and Frederick Lawrence (Cambridge, MA: MIT Press, 1989).

36 Michael Newman, "The Specificity of Criticism and Its Need for Philosophy," in *The State of Art Criticism*, 52–3. Newman relies here on Thomas E. Crow, *Painters and Public Life in Eighteenth-Century Paris* (New Haven, CT: Yale University Press, 1985).

37 Big data might be not only post-critical but also post-hermeneutic, reliant as it is on correlation of data rather than interpretation of evidence.

38 Hans Ulrich Obrist, *Interviews, Volume 1* (Milan: Charta, 2003), 468, 892.

39 Ibid., 470, 882.

40 This suggests not a sense of confidence in the audience but rather a fear that it cannot be taken for granted; indeed, that it must be conjured up every time, which might be why relational exhibitions and events sometimes feel like remedial work in socialization.

41 Nicolas Bourriaud, *Relational Aesthetics*, trans. Simon Pleasance and Fronza Woods (Paris: Les presses du réel, 2002), 26. For the most part these artists and curators see discursivity and sociability in optimistic terms. On this issue, see Claire Bishop, "Antagonism and Relational Aesthetics," *October* 110 (Fall 2004).

42 See Jürgen Habermas, *The Crisis of the European Union: A Response*, trans. Ciaran Cronin (Malden, MA: Polity Press, 2012), and Bruno Latour, "Telling Friends from Foes in the Time of the Anthropocene," in Christophe Bonneuil, Clive Hamilton, and François Gemenne, eds, *Thinking the Anthropocene* (forthcoming). As for contemporary art, citizenship, and statelessness, see the recent writings of Ariella Azoulay and T. J. Demos, among others, as well as the recent work of the investigative project "Forensic Architecture" headed by Eyal Weizman. There is also statelessness from above, as it were, as managers and mercenaries alike become postnational, a condition recently explored in such novels as *The Dog* (2014) by Joseph O'Neill and *Laughing Monsters* (2014) by Denis Johnson.

In Praise of Actuality

1 In the art world of the 1960s and 1970s much performance was one-time-only, and this had-to-be-there-ness was deemed a signal feature of the practice (this is also implied, of course, in the earlier term "happening"). As dance is usually scored, it is intrinsically iterative, and yet, as David Levine has argued, when dance is restaged in museums, it tends to appear as performance, that is, as a visual event, a rare object—in short, an artwork. Levine distinguishes among various reenactments—"forensic," in which documentation of the original performance is foregrounded; "presentational," in which performances are scheduled at set times; and "durational," in which a performance runs perpetually in an exhibition space—and he suggests that, whereas the presentational smuggles theater into the museum, the durational is sculpture in disguise. See David Levine, "You Had to Be There (Sorta)," *Parkett* 95 (2014).

2 The zombie trope is pervasive, and not only in movies and television; see, for example, Walter Robinson, "Flipping and the Rise of Zombie Formalism," *Artpapers*, April 3, 2014. Much recent art can be described, not negatively, as undead: e.g., the abstract gestures of Charlene von Heyl, the sculptural mash-ups of Rachel Harrison, and the collage paintings of Albert Oehlen; there is even the undead artist Claire Fontaine. Perhaps the prevalence of the zombie trope in culture at large has to do with our neoliberal status as "human capital." Marx and Lukács likened the industrial worker to Frankenstein's monster, his body dis/assembled, along with the commodity, on the production line; the capitalist overlord might then be seen as a Dracula who sucks the blood of the worker. As human capital we are Frankenstein's monster and Dracula in one, not unlike zombies. On the Frankenstein and Dracula tropes, see Franco Moretti, "Dialectic of Fear," in *Signs Taken for Wonders* (London: Verso, 1983).

3 See the initial 2014 proposal by Diller Scofidio + Renfro for the renovation of the Museum of Modern Art.

4 Although it raises the question of excessive centralization in the art museum, personally I am happy to see such events there; it is the motivation that concerns me.

5 Even film is sometimes turned to this demand; see Erica Balsom, "Live and Direct: Cinema as a Performing Art," *Artforum* (September 2014).

6 See Johanna Burton, "Repeat Performance," *Artforum* (January 2006): 56. Originally performance tended to demystify the artwork; Abramović remystifies it in the form of the artist as artwork; more, she respiritualizes it (her performances sometimes suggest faith healings). An exchange of aura (or at least glamor) often occurs in this line of performance too: artists (like Abramović) become stars and stars (like Tilda Swinton, Jay-Z, or Björk) become artists. So, too, performance becomes entertainment and entertainment becomes performance: museums gain audience and attention thereby, even as they retain a slight difference from the popular culture that they otherwise imitate; that difference becomes the "art" quotient. (Thanks to Tim Griffin for this final point.)

7 Carrie Lambert-Beatty has argued that the Judson Church choreographers were already aware of this transformation of performance into document, which eventuality they built into some pieces. See her *Being Watched: Yvonne Rainer and the 1960s* (Cambridge, MA: MIT Press, 2008), especially "Judson Theater in Hindsight." This strange spectatorship is perhaps not so strange to a generation raised on the hologram world of digital video games, which can be both historical and distant in theme and present and participatory in operation. For these viewers, unlike older ones, the spectral reenactment is the primary experience. (Thanks to Peter Rostovsky and Karen Yama for the latter two points.)

8 On this problem again see David Levine, "You Had to Be There (Sorta)." Documents of performances in the 1960s and 1970s do not attempt "to structure the spectator's perception of the event," Levine argues, whereas those of recent performances are almost as scenographic as those in theater, with a clear sense of stage and audience demarcations, which is again to suggest that they are designed for reproduction as images (230). In speech-act theory the performative is structurally iterative, which can be taken to complicate its application to performance or, viewed

differently, to point to a tension between the singular and the iterative that might be fundamental to performance.

 9 *Primary Structures* was revisited at the Jewish Museum in New York in 2014, while *When Attitudes Become Form* has been revisited a few times, most notably at the Prada Foundation in Venice in 2013.

10 Jeremy Deller in Ralph Rugoff et al., *Joy in People: Jeremy Deller* (London: Hayward Publishing, 2012), 98. Much the same can be said of the reenactment practices of Hayes, Forkert, and Tribe; on the latter two see Julian Bryan Wilson, "Sounding the Fury," *Artforum* (January 2008). Contemporary novelists such as Ben Lerner are also interested in reenactment precisely for the difference it can produce; see his *10:04* (2014). Ron Clark reminds me that the theater of Brecht often involves fictive re-creations of historical figures, and a Brechtian impulse is active in much of the work mentioned here.

11 As we saw in Chapter 5, Rancière has a point here: the rhetoric around activation often assumes that aesthetic contemplation is simply passive. In the end, the binary of active and passive spectatorship is not very useful; more generative is the dialectic of attention and distraction articulated by Walter Benjamin and elaborated by Jonathan Crary. On some of these matters, see Claire Bishop, *Artificial Hells: Participatory Art and the Politics of Spectatorship* (London: Verso, 2012). That the unfinished might engage the viewer is the hope of some architects as well. Witness the remarks of Frank Gehry on his Louis Vuitton Foundation Museum in Paris: "It doesn't look finished purposely, and I think that invites people to interact with it over time" (*New York Times*, October 17, 2014). Of course, the diffuse has its purposes; it can be a way for an artwork to resist capture as an image, or even for that artwork to reconceive the image as a "situation" or an "economy" that resists its own capitalization. On this possibility, see David Joselit, "Against Representation," in *Texte zur Kunst* (September 2014). The title of this text, which treats a work by Pierre Huyghe, is telling; it suggests a fatigue with critique understood strictly in terms of representation—a fatigue we have

encountered elsewhere in this book. But is this a critique, a politics, that we should forego?

12 Another bad object, still dominant in art history at the time, was meaning understood in iconographic terms as bound to a pre-existent source. It was against interpretation such as this that critics like Susan Sontag railed, but her classic diatribe "Against Interpretation" (1964) is also now fifty-plus years in the past.

13 Nicolas Bourriaud, *Relational Aesthetics*, trans. Simon Pleasance and Fronza Woods (Paris: Les presses du réel, 2002), 20.

14 Pierre Huyghe in Hans Ulrich Obrist, *Interviews, Volume 1* (Milan: Charta, 2003), 480.

15 Another kind of activation has become prominent lately, and its value regarding connectivity is also ambiguous. If Kant asked "Is the work beautiful?" and Duchamp asked "Is it art?," our prime question seems to be "How does it affect me?" Where we once spoke of "quality," then of "interest," and then "criticality" (see Chapter 5, note 17), we now look for pathos, which cannot be tested objectively or communicated with others much at all: one person's *punctum* is another's yawn.

16 On the trope of museum as mausoleum see Theodor W. Adorno, "The Valéry Proust Museum" (1953), in *Prisms*, trans. Samuel and Shierry Weber (Cambridge, MA: MIT Press, 1981). "Activation," Tim Griffin wrote in response to this note, "has superceded the subject, or the subject is nothing but (the feeling of) activation." It is as though, as museums move to develop a virtual audience online, they want to ensure that there remains a physical audience in the galleries ("screen" and "meat" do not cancel but call out for each other). On another point, Joe Scanlan suggested to me that a fatigue with art concerned to activate the viewer has set in, as signaled, perhaps, by the renewed interest in outsider art (witness the 2013 Venice Biennale, which featured the art of the insane, as well as the large shows of folk art at Tate Britain and the National Gallery of Art in Washington). To different degrees this is art made under compulsion, with no viewer anticipated or acknowledged, which seems to defy "the primordial convention" (Michael Fried) that art exists, first and last, to be beheld. (This fatigue with subject-centric art is also

evident in the recent interest in speculative realism and object-oriented ontology.) Finally, the point about prompting and programming in museums could be extended to colleges and universities. Today, elite liberal arts institutions compete with each other in part through arts centers: it is as though every student must be activated as a performing artist.

17 Erwin Panofsky, *Meaning in the Visual Arts* (Chicago: University of Chicago Press, 1955), 24. On the dialectic between reification and reanimation in discourse on the museum, see my "Archives of Modern Art" in *Design and Crime (and Other Diatribes)* (London: Verso, 2002).

18 Amy Knight Powell, *Depositions: Scenes from the Late Medieval Church and the Modern Museum* (Brooklyn: Zone Books, 2012), 17.

19 Obrist, *Interviews, Volume 1*, 410.

20 There is also the matter of discussion as performance, collaboration, process, or all of the above, as the marathon conversations (twenty-four hours straight, days or even weeks long, etc.) staged by Obrist and others in recent years. Such a commitment to talk, and such a devaluation of thought; such a show of egalitarianism, and such a blow to expertise. It is also possible that the recent emphasis on performative-cum-collaborative activities in the museum is a partial displacement of political gatherings in the city, as if actions in galleries were the next best thing to occupations in streets. (Thanks to Karen Yama for this last point.)

21 See Georges Bataille, "Formless," in *Visions of Excess*, trans. Allan Stoekl (Minneapolis: University of Minnesota Press, 1985), 31, and Chapter 1 above.

22 See James Elkins and Harper Montgomery, eds, *Beyond the Aesthetic and the Anti-Aesthetic* (University Park: Penn State University Press, 2013).

23 See David Joselit, *After Art* (Princeton, NJ: Princeton University Press, 2012), and Laura Hoptman et al., *Unmonumental: The Object in the 21st Century* (New York: New Museum, 2007).

24 Rirkrit Tiravanija in Obrist, *Interviews, Volume 1*, 890.

25 See Raphael Rubinstein, "Provisional Painting," *Art in America* (May 2009). For an excellent analysis of how such provisional

work conforms to a casual economy, see Lane Relyea, "Your Art World: or, The Limits of Connectivity," *Afterall* 14 (Autumn/ Winter 2006). Here again there are parallels in recent novels, such as *How Should a Person Be?* (2012) by Sheila Heti, which also privileges the provisional.

26 Clement Greenberg, *Avant-Garde and Culture* (Boston: Beacon Press, 1961), 5.

27 Ibid.

28 T. J. Clark, "Clement Greenberg's Theory of Art," *Critical Inquiry* 9: 1 (September 1982): 153, 154. One of the problems of post-critical discourse (see Chapter 5) is its reductive understanding of negation.

29 "What if art's heterogeneity signals possibility instead of dysfunction?," the curator Kelly Baum asks appositely here. "What if heterogeneity is art's pursuit instead of its affliction? What if, in its very heterogeneity, art were to productively engage current socio-political conditions . . . I think what we are seeing today is art miming its context. I think we are witnessing art performing 'agonism,' 'disaggregation,' and 'particularization.' Heterogeneity isn't just art's condition, in other words; it is its subject as well" ("Questionnaire on 'The Contemporary,'" *October* 130 [Fall 2009]).

30 It is with a similar magic that Rancière declares the political and the aesthetic as always already bound up with one another. See his *Aesthesis: Scenes from the Aesthetic Regime of Art* (London: Verso, 2012) as well as my "What's the Problem with Critical Art?," *London Review of Books*, October 10, 2013.

31 See David Joselit, "On Aggregators," *October* 146 (Fall 2013).

32 However, the important work of Laura Kurgan is dedicated to the mapping of flows and networks; see her *Close Up at a Distance: Mapping, Technology, and Politics* (Cambridge, MA: Zone Books, 2013).

33 See Joselit, *After Art*. This assumption of contemplation or reification is also an undercurrent in advocacy of performative work.

34 The key text on this expanded temporality of the artwork is *Anachronic Renaissance* (Cambridge, MA: Zone Books, 2010) by Alexander Nagel and Christopher Wood. See, among other

reviews, my "Preposterous Timing," *London Review of Books*, November 8, 2012. In a first moment, globalization made some art historians more alert to the spatial extent of art history; then, in a second moment, it sensitized others to its complicated temporality. "Actuality" can be understood as the becoming present of the past, as when we speak of the actuality of an historical figure (artist, author, other), a renewed relevance that often occurs through the medium of a contemporary figure in his or her field. That becoming present of the past is also, of course, a becoming past of the present. In some ways actuality is my attempt to triangulate the claims of both anachronicity and historicity and, in so doing, to resist the indeterminacies of the former and the restrictions of the latter. For a related articulation of actuality, see Molly Nesbit, *The Pragmatism in the History of Art* (Pittsburgh: Periscope Publishing, 2013).

35 See Walter Benjamin, "Convolute N," in *The Arcades Project*, trans. Howard Eiland and Kevin McLaughlin (Cambridge, MA: Harvard University Press, 1999), and Charles Baudelaire, "The Salon of 1846," in Jonathan Mayne, ed., *The Mirror of Art: Critical Studies of Charles Baudelaire* (Garden City, NY: Doubleday Anchor, 1956), 83.

INDEX

Bold indicates image in text.

ON THE TYPEFACE

This book is set in Sabon, a narrow Garamond-style book face designed in 1968 by the German typographer Jan Tschichold. Tschichold had been a leading voice of sans-serif modernist typography, particularly after the publication of his *Die neue Typographie* in 1928. As a result, the Nazis charged him with "cultural Bolshevism" and forced him to flee Germany for Switzerland.

Tschichold soon renounced modernism—comparing its stringent tenets to the "teachings of National Socialism and fascism"—and extolled the qualities of classical typography, exemplified in his design for Sabon, which he based on the Romain S. Augustin de Garamond in the 1592 Egenolff-Berner specimen sheet.

Sabon is named after the sixteenth-century French typefounder Jacques Sabon, a pupil of Claude Garamond and proprietor of the Egenolff foundry.